Enrique Martínez Celaya

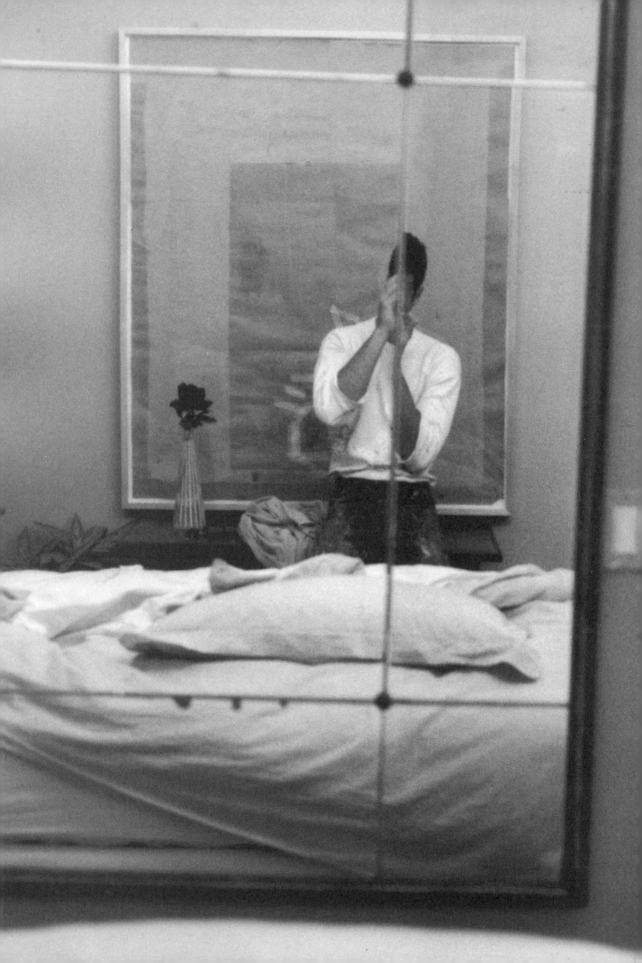

# Enrique Martínez Celaya

## Collected Writings and Interviews, 1990–2010

ENRIQUE MARTÍNEZ CELAYA | INTRODUCTION BY
KLAUS OTTMANN | FOREWORD BY JAMES B. MILLIKEN

UNIVERSITY OF NEBRASKA PRESS | LINCOLN AND LONDON

*Library of Congress Cataloging-in-Publication Data*

Martínez Celaya, Enrique, 1964–
Enrique Martínez Celaya : collected writings and
interviews, 1990–2010 / Enrique Martínez Celaya;
introduction by Klaus Ottmann ; foreword by
James B. Milliken.
    p.  cm.    Includes bibliographical references.
ISBN 978-0-8032-3474-1 (pbk. : alk. paper)
    1. Martínez Celaya, Enrique, 1964– —Written
works. 2. Martínez Celaya, Enrique, 1964–
—Interviews. 3. Artists—United States—Interviews.
    I. Title.
N6537.M3935A35 2010
        709.2—dc22        2010019379

Set in Meta and Minion Pro by Bob Reitz.
Designed by A. Shahan.

For Edilia

# Contents

ix  Foreword by James B. Milliken

xi  Introduction by Klaus Ottmann

1  Notes, 1990

4  Notes, 1991

5  Notes, 1992

9  Notes, 1993

12  A Manifesto, 1994

17  Notes, 1994

18  Notes, 1996

22  From an Interview with Christopher Miles, 1997

27  Notes, 1997

28  From an Interview with M. A. Greenstein, 1998

36  Notes, 1998

37  Berlin, 1998

38  From a Conversation with Donald Baechler, 1999

42  Notes to Anne Trueblood Brodzky, 1999

46  From a Conversation with Amnon Yariv, 1999

50  From an Interview with Howard N. Fox, 1999

55  Notes, 2000

57  Notes, 2001

58  Making and Meaning, 2001

62  From a Lecture at the Orange County Museum of Art, 2001

66  Notes, 2002

67  From a Letter to Daniel A. Siedell, 2002

70  From an Interview with L. Kent Wolgamott, 2003

77  From Twelve Thoughts on *The October Cycle*, 2003

81  Letter of Resignation, 2003

84  From a Letter to Lisa Tamiris Becker, 2003

87  From a Conversation with Roald Hoffmann, 2003

97  *Schneebett*, 2004

100  Notes, 2004

103  Letter to Leon Golub, 2004

104  From an Interview with Richard Whittaker, 2004

111  From a Lecture at the Berliner Philharmonie, 2004

117   Notes, 2005

118   Letter to the Editor of the *New York Times*, 2005

120   The Fuzzy Boundary: Science and Art, 2005

124   Shaping Language, 2006

129   Notes, 2006

130   Introductions to Projects, 2006

141   Photography as Grief, 2007

149   From *The Blog: Bad Time for Poetry*, 2007

      Sunday, August 26. *Adorno as Cliché*   149

      Saturday, September 1. *The Road*   150

      Wednesday, September 5. *The end is important
        in all things (II)*   151

      Thursday, September 6. *Criticism and Imitation*   151

      Saturday, September 8. *A New Body of Work*   152

      Wednesday, September 12. *In Favor of Speaking Up*   153

      Sunday, September 16. *Complexity and Tidy Packages*   154

      Thursday, September 27. *Reflections on a Return*   155

      Tuesday, December 4. *Tall Words*   156

157   A Personal Note on Art and Compassion, 2007

161   Notes, 2007

169   From Considering Painting and Meaning, 2007

172   Boy Raising His Arm, 2007

173   From *The Blog: Bad Time for Poetry*, 2008

      Thursday, February 7. *Santa Monica Studio*   173

      Tuesday, February 12. *Soul Searching*   174

      Monday, March 17. *A Witty Age*   174

      Thursday, May 13. *Being Cuban*   175

      Thursday, June 12. *On Looking at the Work Done*   176

      Wednesday, July 16. *The Hand*   177

      Tuesday, October 14. *Unreasonable Pursuits: Moby-Dick*   178

      Tuesday, October 21. *A Sentimental Education*   179

      Tuesday, December 2. *Radical Doubting*   180

      Tuesday, November 11, 2008; Wednesday, December 17, 2008;
        Tuesday, December 23, 2008; Friday, January 9, 2009.
        *Painting and Structure*   181

184   Art and Museums, 2008

192   From an Interview with Gillian Serisier, 2008

196  Systems, Time, and Daybreak, 2008

203  From an Interview with Greg McComb, 2008

208  From an Interview with Prue Gibson, 2009

211  From *The Blog: Bad Time for Poetry*, 2009
     Friday, January 23; Friday, January 30. *Failure*  211
     Tuesday, February 3. *Meltingly sweet, in autumn*  212
     Thursday, February 5. *Innocent Fraud*  213
     Tuesday, April 28. *You and the Kindle*  214
     Tuesday, May 12; Wednesday, May 13. *Get Rid of Your Excuse*  216

219  Art and the University, 2009

227  Notes, 2009

231  The Prophet, 2009

240  On Painting, 2010

*James B. Milliken,* President of University of Nebraska

# Foreword

The University of Nebraska's relationship with Enrique Martínez Celaya began through the university's outstanding Sheldon Museum of Art, which acquired several of Enrique's works. Former Sheldon curator and now University of Nebraska at Omaha professor Dan Siedell has continued to collaborate with Enrique. The University of Nebraska Press, in a wise decision made years ago, agreed to distribute the publications of Enrique's press, Whale & Star, which include beautiful productions of his own writings and catalogs, as well as the work of some of the writers he most admires.

I first met Enrique five years ago in connection with the installation at the Sheldon of his work *Coming Home.* I encountered an engaging, articulate, and disarmingly polite man with an unusual academic background—in physics—and an intriguing personal history. He was comfortable with conversation on any topic, especially—and, it seemed at the time, diplomatically—issues involving higher education and the University of Nebraska. We continued our conversation on art, ideas, and the modern university in many locations, including at his studios in Los Angeles and Florida and on the campuses of the University of Nebraska.

I would be happy to take credit for the decision to deepen the university's relationship with Enrique by naming him to a Visiting Presidential Professorship, but I have come to realize that the idea was at least as much his as mine. He saw special qualities at the university that he found promising, and the plan for his successful visiting professorship, with its many valuable dimensions, almost entirely his. The essential role and responsibility of universities in the exploration of ideas has informed Enrique's interest in and approach to his relationship with the University of Nebraska. At each step, he has looked for ways to challenge himself and us to think more deeply about this role we play with our students, our faculty, and the larger community. In a culture that often expects so little of substance from its artists, Enrique is a bracing breath of fresh air.

Whether one agrees with him or not—and I most often do—his is exactly the kind of challenge to comfortable and easy thinking that universities should foster.

Enrique's visits to the university have included public lectures on art and ideas; conversations with students and faculty, ranging from undergraduate class visits and graduate student critiques to relatively unstructured discussions with philosophy and literature faculty; employing students as interns in his studios in Los Angeles and Florida; and now, joining with the university to sponsor our students at Anderson Ranch in Aspen. My expectations for the professorship were greatly exceeded because of the thoughtfulness and commitment Enrique brings to anything he does. I was a fortunate and grateful junior partner in the development of the plan and its execution.

This book began with a simple idea to publish his six major public lectures, one delivered each semester of his three-year appointment, which I thought made important contributions to the discussion of art and ideas and were of great benefit for students, faculty, and members of the community who attended. Enrique's response was, of course, an improvement, and the resulting book, with its additional writings and images, is extraordinary. The University of Nebraska Press was enthusiastic about the work and offered to publish it. I hope it will reach the audience it deserves—within the university and the state of Nebraska, where people will always be reminded of the university's exceptional relationship with Enrique Martínez Celaya—but with a much broader audience as well. On a personal level, it will always remind me of a rewarding professional relationship and an important friendship with a remarkable man.

*Klaus Ottmann*

# Introduction  The Subjective Thinker

*The subjective thinker . . . has . . . esthetic passion and ethical passion, whereby concretion is gained. All existence-issues are passionate, because existence, if one becomes conscious of it, involves passion. To think about them so as to leave out passion is not to think about them at all . . . Yet the subjective thinker is not a poet even if he is also a poet, not an ethicist even if he is also an ethicist, but is also a dialectician and is himself essentially existing, whereas the poet's existence is inessential to the poem, and likewise the ethicist's in relation to the teaching, and the dialectician's in relation to the thought. The subjective thinker is not a scientist-scholar; he is an artist. To exist is an art. The subjective thinker is esthetic enough for his life to have esthetic content, ethical enough to regulate it, dialectical enough in thinking to master it.*

**SØREN KIERKEGAARD,** *Concluding Unscientific Postscript to Philosophical Fragments*

The Danish existentialist philosopher Søren Kierkegaard is never far from Enrique Martínez Celaya's mind; he is a continual presence in his art and in his writings. Martínez Celaya always reminds me of Mark Rothko, another painter who had Kierkegaard in his veins. Rothko once wrote:

> Kierkegaard has that passion for the "I," for that "I" experience, like Abraham in his *Fear and Trembling* . . . It is the "I" that I myself experience every day.[1]

According to his biographer, J. E. B. Breslin, Rothko kept a copy of Kierkegaard's *Fear and Trembling* next to his bed.

The biblical story of Abraham and Isaac is, of course, the existential parable par excellence. Moralists may be scandalized by the "case" of Abraham who placed himself outside universal law, answering only to God, but Kierkegaard recognized in the story the "paradox of faith," "that the

single individual is higher than the universal, that [he] . . . determines his relation to the universal by his relation to the absolute, not his relation to the absolute by his relation to the universal."[2]

According to Kierkegaard, Abraham is the Special Individual who finds himself mired in a *tragic collision* that ends in a "teleological suspension of the ethical."[3] The Special Individual must be *unconditionally* willing to sacrifice. The sacrifice is situated by Kierkegaard in the in-between of nothingness and anxiety, between the Imaginary and the Symbolic, the "disquieting supervision of responsibility."[4]

The story of Abraham and Isaac seems to haunt Martínez Celaya's paintings and sculptures, many of which depict only that Special Individual, represented either by the single figure of a man or a boy. Martínez Celaya is a subjective artist, for example, non-abstract, figurative, just as he is a subjective thinker in the definition of Kierkegaard. Kierkegaard's text on the "subjective thinker" was directed at Hegel, the abstract thinker, and Hegel's pretension of a "pure logic." "Pure thinking is a phantom," wrote Kierkegaard,[5] and so is pure art. All art, figurative or nonfigurative, is subjective, rooted in the concrete, and entangled in the dialectics of the aesthetic and the ethical. As Wittgenstein famously proclaimed: "Ethics and aesthetics are one."[6]

Thinking about Martínez Celaya, I am also reminded of the Greek historian and biographer Plutarch writing on the political responsibility of the philosopher. Plutarch argued, much in the spirit of Socrates, that philosophy should not stand by idly like the statues of a sculptor but, rather, inspire and exert influence over those in power:

> The teaching of philosophy is not, if I may use the words of Pindar, "a sculptor to carve statues doomed to stand idly on their pedestals and no more"; no . . . it inspires men with impulses which urge to action, with judgments that lead them towards what is useful, with preferences for things that are honorable, with wisdom and greatness of mind joined to gentleness and conservatism and because they possess these qualities, men of public spirit [*hoi politikoi*] are more eager to converse with the prominent and powerful.[7]

To be an idle thinker is as inhuman as to be an idle artist. To be human is to exist and to exist is to live and work in ethos—to be *hoi politikoi*. Ethos describes how human beings exist in the world as a community.

According to the French thinkers Gilles Deleuze and Félix Guattari, philosophy is a discipline that involves creating new concepts. Science, art, and philosophy are all equally creative. According to Deleuze and Guattari, all true concepts require conceptual personalities (*personages conceptuels*): every philosophical idea is linked to its originator in much the same way

as a work of art is grounded in the personality (or style) of the artist, and thus all artists can be considered conceptual personalities.[8]

Artists, like philosophers, poets, and scientists, seek to understand life at its deepest level. Focusing on the areas of knowledge, duty, and destiny, Immanuel Kant defined the objective of philosophy as providing answers to three fundamental questions: What can I know? What ought I to do? What may I hope for?[9] These questions, which address knowledge, ethics, and aesthetics, are at the core of all religious, philosophical, scientific, and artistic pursuits. What unites these various disciplines is the quest for meaning, for the answers needed to create an ethical ground for one's life. Some seek these answers in meditation or prayer, others in political or humanist activities, while still others find happiness in material possessions.

As an artist, Martínez Celaya is a "conceptual personality." When he theorizes about his artistic practice, he does so by speculating out of a general milieu that includes art, literature, philosophy, and science. With his writings and public talks, as with his art, he makes a case for "the artist's ethical responsibility to the world and art's potential to transform lives," so the title of his most recent lecture included in this volume, with the very Kierkegaardian title, "The Prophet." Like Kierkegaard's subjective thinker, Martínez Celaya lives his convictions (and his art) "in actuality." Since he founded a small publishing press in 1998, his studio in Delray Beach has become a creative sanctuary as well as a laboratory (before studying painting and sculpture, Martínez Celaya had pursued a PhD in quantum electronics), "a contemplative research and educational environment concerned with the role art has in life, spirit, and community":

> It compresses two very different models of such work, the scientific laboratory and the monastery. With its concepts of rigorous discipline, intense intellectual scrutiny, and service to the discovery of truth, the scientific laboratory offers a context that is precise and clear. The monastery offers a model that introduces an ethical dimension to work, making it inseparable from the worker and his or her own development as a human being . . . The studio also educates and serves the urban poor of South Florida, especially the children.[10]

Summoning Pushkin, Dostoyevsky, the Persian poet Allama Iqbal, and, of course, Kierkegaard in support, Martínez Celaya makes a case for artists to be prophets again, citing as examples Joseph Beuys, Marcel Broodthaers, and Albert Pinkham Ryder. A prophet, like the subjective thinker, is *in* the world—he exists: "The prophet, unlike the mystic, returns to the world," Martínez Celaya says.[11] For Kierkegaard, "To exist is the highest interest for an existing person . . . whereas pure thinking, in mystical suspension

and with no relation to an existing person, explains everything within itself but not itself."[12]

As an aspiring prophet, Martínez Celaya is of this world, yet he does not deny, as did modernism, that in art "the Absolute is present."[13] His work is an example of the paradigm shift from modernism to late- and postmodernity, which has brought with it a reevaluation and reconstitution of the concept of the spiritual and transcendence. Martínez Celaya's figure of the Single Individual depicted in so many of his canvases is meant as a reminder of our ethical imperative. Neither assertive nor submissive, he is rather a contemplative and modest proposition.

Unlike the major monotheistic religions that suppose the answer and construct an ethical system upon a soteriological canon, philosophers, scientists, and artists are engaged in "running against the boundaries"[14] of knowledge in an effort to come closer to the ultimate truth, which, by definition, is forever unattainable. As Wittgenstein reminded us, neither salvation nor immortality can solve the ultimate riddle of human existence:

> Is the riddle solved by the fact that I survive for ever? Is this eternal life not as enigmatic as our present one? The solution of the riddle of life in place and time lies outside space and time.[15]

Schelling, the philosopher of the Absolute, once wrote:

> Each of us is compelled by nature to seek an absolute, even those still wrapped up in finite things, but if we want to fix one's thoughts on it, it eludes us. It hovers around us eternally, but . . . it is only there if one does not have it; as soon as one possesses it, it vanishes. It appears before the soul only at the moment when subjective activity joins the objective in unexpected harmony, which because it is unexpected has an advantage over free, desireless rational cognition to manifest itself as happiness, as illumination, or as revelation. But as soon as this harmony is brought about, reasoning sets in, and the apparition takes flight.[16]

Willem de Kooning famously remarked that "content is a glimpse of something, an encounter like a flash. It's very tiny—very tiny, content."[17]

As the sublime, the Absolute (that which will always remain out of bounds, but nonetheless continuously beckons to be represented and lies at the core of the Human Condition) has haunted artists ever since the advent of the aesthetics of the sublime in the eighteenth century (with the publications of Edmund Burke's *Philosophical Inquiry into the Origin of Our Ideas of the Sublime and the Beautiful* and Immanuel Kant's *Critique of Judgment*). Some celebrate it as a *fait accompli* (Barnett Newman, foremost, comes to mind), and others strive to catch hold of it, if only for an instant (Martínez Celaya belongs in this group, together with Rothko,

Anselm Kiefer, Cy Twombly, etc.). As communication without communication, it has pushed art toward an *écriture blanche* (Sartre), colorless writing, or "zero degree" of painting (Barthes)—toward a *style of absence* (e.g., Piero Manzoni's *achrome*, Robert Ryman's white canvases, or Yves Klein's *Le vide*).

According to the postmodern theorist Jean-François Lyotard, the challenge at the core of all artistic endeavors is "to make visible that there is something that cannot be seen"[18]—the unrepresentable or inexpressible. But as the French phenomenologist Emmanuel Levinas has taught us,[19] transcendence is not a modality of essence—not a question of being or not-being—but rather an ethical imperative; it is not a "safe room" of solipsistic inwardness, but a site of responsibility for others. In the transcendental beyond, we are ordered toward the responsibility for the other. This responsibility, which Levinas calls the "otherwise than being," substitutes subjectivity (the self of the artist) for another: it becomes the other in the same.

Martínez Celaya is a serious thinker, and a passionate one, as well as a prolific writer. He is, by today's standards, an artist and thinker of the rarest kind. He possesses one of the most priceless gifts of all, an encyclopedic curiosity and a considerable knowledge about the world—something that was more common among philosophers and some artists before the end of the nineteenth century, before knowledge broke apart into countless specializations. During the Renaissance, painters and sculptors were often equally learned in poetry, architecture, and science. In the same spirit Martínez Celaya has pursued the Kantian questions of the human condition through diverse knowledge systems as well as through literature, poetry, and art. His gift is the *form* of his communication, which defines his *style*. Wittgenstein's famous dictum that "ethics and aesthetics are one" has to be read in the context of the philosopher's understanding of philosophy as a *living practice*. Ethics includes an aesthetical component, and vice versa. For Wittgenstein—as for Nietzsche before him—art and morality are closely tied. All aesthetic activity is also ethical, just as philosophy is a practice of life, a *Lebensphilosophie*. It is through style that ethical and aesthetic practices become authentic:

> The subjective thinker's *form*, the form of his communication, is his *style*. His form must be just as manifold as are the two opposites that he holds together . . . To the same degree as the subjective thinker is concrete, to the same degree his form must also be concretely dialectical. But just as he himself is not a poet, not an ethicist, not a dialectician, so also his form is none of theirs directly. His form must first and last be related to existence, and in this regard he must have at his disposal the

poetic, the ethical, the dialectical, the religious. Compared with that of a poet, his form will be abbreviated; compared with that of an abstract dialectician, his form will be broad.[20]

### NOTES

1. J. E. B. Breslin, *Mark Rothko: A Biography* (Chicago: University of Chicago Press, 1993), 393.
2. Søren Kierkegaard, *Fear and Trembling/Repetition*, ed. and trans. H. V. Hong and E. H. Hong (Princeton: Princeton University Press, 1983), 70.
3. Søren Kierkegaard, *Journals and Papers*, ed. and trans. H. V. Hong and E. H. Hong (Bloomington: Indiana University Press, 1978), 6:6718.
4. Kierkegaard, *Fear and Trembling/Repetition*, 156.
5. Søren Kierkegaard, *Concluding Unscientific Postscript to Philosophical Fragments*, ed. and trans. H. V. Hong and E. H. Hong (Princeton: Princeton University Press, 1992), 1:316.
6. Ludwig Wittgenstein, *Tractatus Logico-Philosophicus*, trans. C. K. Ogden (London: Routledge & Kegan Paul, 1981), 6.421.
7. Plutarch, "That a Philosopher Ought to Converse Especially With Men in Power," in *Moralia*, vol. 10, trans. H. N. Fowler, The Loeb Classical Library (Cambridge: Harvard University Press, 2002), 31 [776C].
8. Gilles Deleuze and Félix Guattari, *What Is Philosophy?* trans. H. Tomlinson and G. Burchell (New York: Columbia University Press, 1994).
9. Immanuel Kant, *Critique of Pure Reason*, trans. N. K. Smith (New York: St. Martin's Press, 1965), 635 [B833].
10. Enrique Martínez Celaya, "The Prophet," this volume, 239.
11. Martínez Celaya, "The Prophet," this volume, 234.
12. Kierkegaard, *Concluding Unscientific Postscript*, 313.
13. Theodor W. Adorno, *Aesthetic Theory*, trans. R. Hullot-Kentor (Minneapolis: University of Minnesota Press, 1997), 103.
14. "Man has the drive to run against the boundary of language." *Ludwig Wittgenstein und der Wiener Kreis: Gespräche, aufgezeichnet von Friedrich Waismann*, ed. B. F. McGuiness (Frankfurt am Main: Suhrkamp Verlag, 1984), 68–69.
15. Wittgenstein, *Tractatus Logico-Philosophicus*, 6.4312.
16. F. W. J. Schelling, *Philosophy and Religion (1804)*, translated, annotated, and with an introduction by Klaus Ottmann (Putnam CT: Spring Publications, 2010), 7–8.
17. Willem de Kooning in conversation with David Sylvester. In *Theories and Documents of Contemporary Art: A Sourcebook of Artists' Writings*, ed. K. Stiles and P. Selz (Berkeley: University of California Press, 1995), 196.
18. J.-F. Lyotard, "Answering the Question: What Is Postmodernism?" in *The Postmodern Condition: A Report on Knowledge*, ed. R. Durand (Minneapolis: University of Minnesota Press, 1984), 78.
19. Emmanuel Levinas, *Otherwise Than Being: Or Beyond Essence*, trans. A. Lingis (Pittsburgh: Duquesne University Press, 1999).
20. Kierkegaard, *Concluding Unscientific Postscript*, 357.

Enrique Martínez Celaya

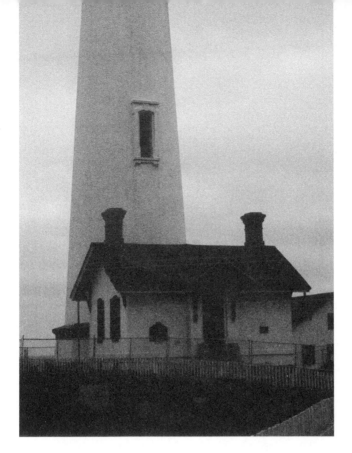

Pigeon Point,
Pescadero,
California, 1990

## 1990    Notes

November 1–5 (Pescadero C A). Excerpts from *Pigeon Point*. Basic control can be learned by doing your work, whatever it is, and by being humble while working on your own self-assurance. Seek the honor of the house chores. It puts you at peace with yourself by forcing you to spend time with yourself doing something that definitely benefits you and others. Seek the usefulness of your life, even if it is of the simplest kind. Same at work, by doing what needs to be done you get rid of possible ways to cut yourself down or stress yourself without reason.

Passion is strength. Human effort. Passion is not rage or violence; it is control. Avoid consuming feelings that swallow passion and erode your fundamental belief in yourself. Trust passion. Nurture your ability to be

*In early November, EMC went to Pigeon Point, a lighthouse fifty miles south of San Francisco, to decide whether or not to continue the PhD program in quantum electronics at the University of California at Berkeley. For five days he wandered the beach and wrote. Upon his return to Berkeley, convinced he should be an artist, he abandoned the PhD program.*

passionate and, for as long as it lasts, go all out. Go beyond what you think possible. Passion is belief in something. Be passionate about your belief in man and his ability to transcend body limitations.

Is this true for all men? I do not know if for all men. I have sampled but a small section of the world. Yet, only few people strike me as passionate. But I suspect it is like colors. There are many but you prefer only some. I am sure that value is relative to whoever is doing the valuing.

Let us think about painting. I am concerned about the making of art but am I being simplistic by not being mesmerized by the process? I do not think it is the process what means the most but what is "being said." It is also true that what is being said is also in the process, but by aiming painting at some middle ground something like truth emerges.

How do I go about doing this? Well, I try to obey my instincts, my impulses, and the accidents. This is how far I will go toward process.

How about image? I need image right now. I am basically a narrator. I need to make stories (is this true?).

What I do not want to do:

1. Paintings where all the strength is in the story.
2. Make paintings that only I can understand.

Hegel's Tomb, The
Dorotheenstädtischer
Friedhof, Berlin,
Germany, 1997

GEORG
WILHELM FRIEDRICH
HEGEL
GEB. D. XXVII AUGUST
MDCCLXX.
GEST. D. XIV NOVEMBER
MDCCCXXXI.

## 1991    Notes

May 21 (Barcelona, Spain). I write this now so I do not forget. Being a young and unknown painter sucks. You walk from gallery to gallery. No one exhibits anything like what I do. Furthermore, no one cares about it. Young painters (and unknown older ones) walk from door to door like traveling salesmen. This city has a lot of pretentious people.

Date unknown (San Francisco CA). As usual, I am trying to sell works at the park. Compliments come and go but it is hard to remain positive when money is necessary. I do not want to be in this situation anymore. Life could be harder but the weight of these days is making me feel old. And more than old, tired. There must be an outlet out of this place. But am I prepared to find it?

Studio, Oakland,
California, 1990

*From EMC's sketchbook notes.*

## 1992  Notes

September (Santa Barbara CA). During the past three months, there has been a lot of confusion inside of me. The clarity of my paintings has given way to disjointed and undirected works. However, somehow, I feel this period has been completely necessary to reevaluate painting. Why am I doing it? What does it mean to do it? Why paint what I paint?

In this process, my paintings have become simpler and, at least temporarily, more oblique; something which I like right now.

*From EMC's sketchbook notes.*

Studio, Oakland,
California, 1991

October 12 (Santa Barbara CA). Yesterday I worked like crazy on the rape painting. When confronted with my feelings, the painting became chaotic and unappealing but I guess correct. The side panel is still in the works. I miss the figures in my work. They gave my paintings a certain energy. However, I cannot put them in and feel they are genuine, at least not right now. Maybe soon.

Something seems to be very different. Painting. Life. They echo, feed, and kill each other. This period is clearly the end of something or the beginning. Whatever it is, it's a cliff. I cannot find images easily. I want to paint all the time but each painting is questioning. And then the results do not give me energy.

I try to make the best paintings I can but then I cannot tell if they shine or not. If they communicate or not. It could be that my taste has to catch up with my feelings or that I am making bad paintings.

Studio, Oakland,
California, 1991

Studio,
Santa Barbara,
California, 1993

## 1993  Notes

April (New York NY). Looking inside oneself is to find doubt and lies. Thoughts hide carefully behind layers of delusion. At best we get glimpses of our thoughts, and with that, a fast, fleeting sense of what we could be. Despite their momentary nature, these "moments" contain both the motor and the fuel to propel us forward. These glances promise the whole and, for me, they are the main motivation to paint. Every once in a while I get that full feeling; a sense of enlightenment, if I can say that. Soon, it is gone, and I move on.

In each painting, Rilke says, "I ask myself, must I do this?"

This question is complicated in painting. I have done it for so long that I can feel the force of habit. Of course, there is much more. Painting is hard and frustrating. To be a painter is a difficult life—one that certainly requires much effort. Perseverance comes out of love.

*From EMC's sketchbook notes.*

9

In *Letters on Cézanne* Rilke asks questions about his desire to research Cézanne's quality; that magic he sees in Cézanne; that rage where each blue is new; where each thing is felt and placed.

The part I did not like was Rilke's idea of work beyond anything, even beyond the funeral of the mother. I believe structure is a tool to convey something beyond it, and with this belief life becomes not something to avoid but something to fully engage. The artist needs harmony between seclusion and involvement. Solitude should be the ground from which the tree of relationships grows. Love cannot develop but in interaction with the world. Paintings and life work best when they are involved with living.

The more I see, the more I realize the key to life is harmony and balance. Peace is reached in the struggle for quietness, in the embrace of contradictions and love. Fulfillment is reached, like Rilke says, "in loving the questions themselves."

May 7 (Santa Barbara CA). Perhaps my paintings are in a developmental stage. One always wants for them to be there and not just on the way there. But either way, I sense some of the work I am doing is authentic.

It is true there are many influences. This is a hard issue. I surely take things, objects, images, processes, from everything around me; from art and from life. I am trying to figure out everything. I might be a liar or just a bad, untalented artist.

Studio, Pomona,
California, 1994

installation environment

nothing left to take
to make paint...

reconciliation

glitter, penis
& butterfly.

Painting
for a secret

two roses
on end

Garden

March 21·95

alibi - in the arms of my best friend
wife

Living is ... n of not
being sure, not knowing what
or how. The moment you
know how you begin to die ...
the artist never
really knows. We guess.
... may be wrong, but we
... leap after leap
... the dark.
— Agnes DeMille

FENCE IN MENDOCINO 1973
Photograph by IMOGEN CUNNINGHAM
The Imogen Cunningham Trust 1964

GRAVITY

Enrique Martinez Celaya
300 S. Thomas, Suite 201
Pomona, CA 91766

LOVE

fait...

3/15/95 I enjoyed our
visit.
The concern of the artist

*your actions faithful*

## 1994    A Manifesto

The spiritual and qualitative life of our society has been waiting for an evolution that is yet to arrive, and as we approach the end of the millennium, I feel our culture is missing something no one seems to know when or where it was lost.

Through technology and globalization we have been able to satisfy our cravings like never before, and the result has been an unprecedented control over our natural resources. Despite or because of these accomplishments, we live threatened by environmental disaster and in spiritual confusion. Our apparent domination of a servile world makes us feel separated from it, and this alienation brings with it desperation and the mechanization of choices.

It seems more sad than ironic that in the process of mastering our destiny through technology and global reach, we have lost our respect for nature and our sense of belonging to something larger than ourselves. Without that context, culture and whim have become the usual refer-

Studio,
Santa Barbara,
California, 1994

*A version of this writing first appeared as EMC's thesis for his master of fine arts program at the University of California, Santa Barbara.*

12

ences, which would be acceptable if the evolution I have suggested would have been accompanied by an equivalent development in our psyches. Yet there is little proof our instincts, needs, and desires have evolved much, if at all. The new culturally based world might give a temporary sense of purpose to our lives, as well as new ways for us to interact with each other, but despite these advances, the great needs and problems of the human condition remain essentially the same.

It makes sense that in an environment that nurtures whim and control, we have become narcissists infatuated with image, but when our narcissistic life appears absurd to our hearts, we feel the uneasiness as a personal failing rather than as a societal condition. Accepting the failure as personal, we hide and become more distant from each other, more desperate—even as technology keeps shortening our virtual separation. This desperation is embedded in much of what is now written or created, but neither the intellectual elite nor the artists have offered meaningful alternatives. Most of them seem to be highly sympathetic to the status quo, which mostly means sympathetic to and complicit with money. By not providing alternatives, they have placed art at the fringes of irrelevance.

A few artists emerged in the mid-eighties who seemed to care about these issues and who strived to understand the cynics as well the advocates of social and artistic responsibility. The attempts of these artists at social consciousness, however, were neither especially penetrating nor particularly responsible, and frequently they were mediocre and pamphletist. Their "rebellion" was sectional and myopic and had a tendency to evolve with prevailing fashions, suggesting those rebels belonged to the cultural apparatus. In retrospect, it appears their oppositional stances functioned as pressure releases, which ultimately hid real social tensions and converted dissension into distraction.

An uncomfortable number of artists working today don't even have those pretensions. Many of them have severed their ties with the world using the scissors of capitalism, entertainment, and false authority. It is not hard then to understand why the art they produce is desperate and desolated. If the only hope left is to become a jester in the court of high culture, artists become afflicted with cynicism and bitterness.

Cures for these maladies have been spoken by many and carried out by few. In "Bridges, Translations and Changes," William Cleveland suggests ways to correct some of the problems that affect the artistic community. His description focuses on pragmatic aspects of construction of community and regeneration of ties with the overall society. He asks us to "consider the arts as an essential human need as we reframe our missions."[1]

Despite the merits of Mr. Cleveland's argument, he fails to provide immediate ways for the individual inertia to move into action. His ideas

are politically charged, but without momentum they will not challenge what Thomas Lawson has described as "an age of skepticism and the suspension of belief," where even self-expression is institutionalized.[2]

For change, the role of the artist must be transformed and not merely on appearances. Artists must evolve internally and deepen their connection to the world and to life. The revolution we need is a revolution of the individual that can also help us see ways to provide the artist with a meaningful role in our world. Historically, the individual has been placed in opposition to the community or the collective when, in fact, self-respecting individuals find in others their own humanity. Jacques Barzun writes,

> I quite understand how we are driven to live statistical lives, but I repeat that it is the duty of art to make us imagine the particular; to make us understand that the rights of one human being are not a fraction of the rights of more than one, and at the same time that in any situation of collective evil, the suffering is felt by no more than one person; only one feels the bitter agony of injustice, only one dies.[3]

The artist should accept a position of responsibility toward establishing and maintaining an environment incorporating Barzun's vision. He or she must help destroy or at least soften the elements of oppression that prevent that vision from emerging; a vision that extends the goals of an artist beyond the propagation of culture or the creation of visual delectations. New reasons for making art must be discovered and old ones resurrected, and as artists we must speak for our beliefs. We must also learn to distinguish between authenticity and naïveté, and our verticality should serve as a beacon of possibility in an age so frequently defined by shrinking expectations and abuse of our surroundings. Artists must develop their ideas with conviction but without losing sense of the real and the needed.

Studio, Pomona, California, 1994

**NOTES**

1. William Cleveland, "Bridges, Translations and Changes: The Arts as Infrastructure in 21st Century America," *High Performance* 58/59 (Summer/Fall 1992).
2. Thomas Lawson, "Last Exit: Painting," *Artforum* 20, no. 2 (October 1981).
3. Jacques Barzun, *The Use and Abuse of Art* (Princeton: Princeton University Press, 1973).

Skowhegan,
Maine, 1994

## 1994    Notes

July 16 (Skowhegan ME). Pat Steir was in my studio today. She liked the work. She is quite an interesting person. Honest, direct, somewhat rough in the exterior, and intelligent. The most significant aspect of this visit was her presence in my studio. Sitting on my chair looking at my paintings. She liked most the new painting with the strawberry. I am glad it is my latest as well as the one I am most curious about. She also liked my drawings.

*From EMC's sketchbook notes.*

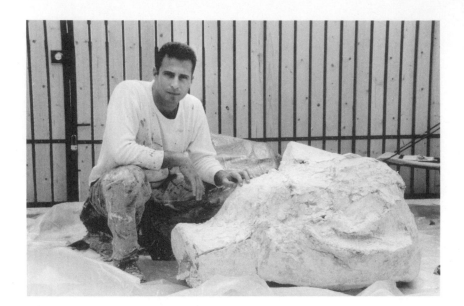

## 1996  Notes

April 4 (Pomona CA). On the issue of Object-Image. First of all I cannot immediately figure out why is the objectness of the work so valuable to me.

1. Do I enjoy "non-object" image-based work? Not really. An image-based work, such as a Bouguereau is beautiful, even compelling, and yet it fails to engage me at a visceral level. Only some image-based paintings work for me. For example, Velázquez, but that was a lot to do with the rigorous architecture of the work that seems to bring the surface forward and grow in tension, therefore strengthening the object. A surface under tension references the edges and activates the whole plane. Resonant image-based elements (verticals, horizontals) only echo the edge but, in principle, also maintain that edges and elements have a very different nature. In particular they say the edges only crop, not that the edges are a direct force on the image. Of course, I am speaking very loosely. Examples can be found that dismiss this.

2. Is this desire for object a hang-up or a strength? From the beginning, even doing figurative work, I have valued the iconic. Scene based paintings with a strong narrative (as opposed to poetic) presence have never appealed to me. It is maybe difficult to explain this. I suppose it seems

*From EMC's sketchbook notes.*

(and seemed) a bit ridiculous to put a little story in a work because that can be done better elsewhere. Further, it never seems too direct (with exceptions, "May 3rd"). It always reminds me of where I cannot be. The image contains its own denial.

On the other hand, the icon is. It never tries to act like it is not an icon. It acknowledges the separation between the viewer and itself. It is often self-contained. Usually, the icon depends on the object (i.e., thirteenth century) and therefore closes the loop that makes everything count. Further, and perhaps most important, an icon is often simpler. Since I was a kid I have liked simplicity: concertos over symphonies, simple foods, simple clothes, simple people, simple artwork.

There are three things to consider in thinking about this: 1.1. What do I mean by simple? 1.2. Is the desired simplicity a hang-up or a preference? 1.3. Image vs. object.

1.1 By simple, I do not mean reduction to absurdity, although someone may argue that this is what my works do. I mean simplicity where the mystery emerges from a few means and without bombastic décor. I have used décor in my work but it has always been at the service of unveiling, undermining (often the inevitable) of subverting expectation. Never to prettify—decoration as a self-conscious gesture that is aware of its problems and leads not to "appealing" arrangements but to horrific yet interesting thoughts; décor that distracts and therefore makes the mystery less expected.

1.2. I cannot tell the difference between a hang-up and a preference. I would like to say that my need for simplicity comes from an observation about life; certainly it is very personal since it is not the way of my parents or my culture.

1.3. What is the relationship between image and object? This is, of course, the question.

Let us divide this question into three parts.

1.3.1. Scale of image to painting.

1.3.2. What is an image?

1.3.3. Kitsch, sentimentality, quietness, and painting oneself into the corner.

So far I have resolved the image problem by making the image small, which does not compete with the object of painting. This solution also affords some problems and some successes.

June 21 (Venice Beach CA). The longest day. I am worrying about house loans, architectural issues, catalogs, shows, moving, teaching. And life. I guess all that is life.

Today I saw my father's arm leaning against his knee. It looked thinner than I remember. He's aging.

Directions, clarity, awareness. Right word. Right action. Something that allows a simple flow through life. So many sources are colliding with me since I moved south. So many ideas seem to lead to, to push for, "looser, freer" ways of being. But I do not trust that they are looser or freer. I do not see anything transcendent coming from these people. I do not see the beautiful emerging from them. I do not see wisdom. I do not see largeness of presence.

Not that they care. They most likely do not. But I suspect there is too much facility in their premature Zen-ness, which leads them to be full of air, light individuals.

Well, even if I am wrong, their lightness, their looseness, is not comfortable for me. I have seen too much to accept this shortcut. To me, life seems to be fuller, more complex, heavier, richer—intellectually and emotionally.

But there is no argument that can prove a superficial approach to life is less valuable than a profound one; unless, of course, outside values are brought in. There is only the subjective. To say that life, for me, acquires value and dimension insofar as I confront it fully. That my growth can accept liberation but cannot pretend liberation. That a revolution of my insides, like the French one, needs to preserve the sensitivities and values that articulate my vision.

No shortcuts. No shortcuts. No certainty.

Painting is light and love is the light of painting.

In this world, where nothing is clear and nothing more valuable than anything else, I have to respect my intuition that, for now, Henry Miller and the "liberated ones" are not the answer. Liberation without terrifying beauty is incomplete. It means to surrender to the wish without being there.

July 7 (Venice Beach CA). In reading Drucker's *Post-Capitalist Society*, I find one central flaw. Mainly, he believes the secret for efficiency relies on specialization. He fails to acknowledge the possibility of knowledge and technology across fields. Something only possible in meta-disciplines.

Studio
Venice Beach,
California, 1996

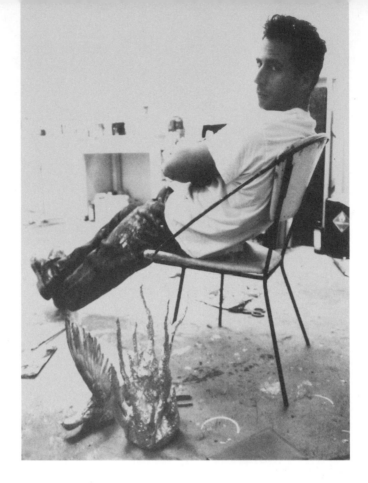

Studio,
Venice Beach,
California, 1996

## 1997    From an Interview with Christopher Miles

Christopher Miles: Your recent works on paper contain numerous suggestions of memory or the passage of time, as well as references to Latin American culture. It there a connection between the two?

Enrique Martínez Celaya: There is a whole tradition in Latin American art and literature dealing with nostalgia and melancholia, the remembrance of things, work like that of Jorge Luis Borges or Gabriel García Márquez. I'm not so interested in the idea of recounting memories negative or positive in terms of a forgotten past. But as someone who left his country and moved from place to place, that past—in terms of a personal history—always becomes something to contend with when looking at a larger history.

CM: So time, for you, is understood in terms of place?

EMC: In my family, conversations about memories always were prefaced with

*Originally published as "A Conversation with Enrique Martínez Celaya,"* Artweek. *Christopher Miles is a Los Angeles–based writer and critic.*

"when we were in Cuba," or "when we were in Spain." For people who leave places behind, time has a quality that has to do with exile, about having to move forward. Gabriel García Márquez suggests that the past is something you are constantly romanticizing or attacking, but you rarely get back to what it really was. For me, this always has seemed especially true.

CM: So the past becomes a construct.

EMC: It does, and this is what goes on with nostalgia, melancholia, but I'm not so interested in a particular nostalgia. I'm more interested in looking at nostalgia as a cultural and personal construct and in looking at the tension between what is remembered and what was. I try to collect all the different versions of stories and look for that one thing that can send you back to a different place and time. I've really fought hard not to be nostalgic or romantic about it.

CM: Though you certainly use the trappings of nostalgia and romance.

EMC: When I've looked at who I thought were the best thinkers, and not only Latin Americans, regardless of whatever emotional or intellectual power they possessed, their models and ideas were usually constructed from very simple cliché experiences.

CM: So clichés can be looked upon as tools?

EMC: Yes. When I moved to the United States, and particularly when I came to Los Angeles, I started paying attention to how people conveyed the stories of their own lives and I found that even when people were expressing something very genuine, even when talking about something very difficult, there was often an element of glamour, which suggested the way people think about themselves is built from models. Directly accessing emotion is so hard that most of us have to resort to a library of clichés so we can process our feelings. We're supposed to dismiss clichés, but they're still very powerful.

CM: Though they also run the risk of being trite.

EMC: I think whenever you're talking about memory you run that risk. We all have stories that are embarrassing and filled with clichés, but they're true and oftentimes they're moving. Even paintings of crying harlequins—a lot of people find them moving.

CM: Do you?

EMC: No, but I see potential in them.

CM: Potential for what?

EMC: Potential to start over, to flip. I believe that some things become so full on a constructed, superficial level that they can't hold anymore and they become in a way empty again. I try to catch things on that edge.

CM: Do you see your work as being of the moment?

EMC: Historically or personally?

CM: Is there a difference?

EMC: It gets tricky because my work refers to a lot of things from the past and I am certainly influenced by history when I'm making the work. Lately I've been looking at baroque art and it affects my work, but I think the work is current in terms of where people find themselves in the world. I think feelings of displacement and remoteness show through in current art, literature, and cinema. Even in the most conceptually rigorous work, I'm seeing a lot of nostalgia and a desire to reach for resolution on an emotional level. I'm not really interested in that kind of resolution—in a pop psychology sense—but I am interested in the process.

CM: How is this interest playing itself out in your current work?

EMC: I'm interested in making work that will become clearer over time. You can see something similar in the experience one has in churches, where all sorts of elements are brought together in what seems like a hodgepodge of disparate things. Together they create an experience that is larger than the sum of the parts. You also see this sometimes in installation work, though they often reduce back to the individual parts—they never collectively get beyond what they're about individually. I'm interested in painting and sculpture and drawing because people tend to view these as being complete in themselves. I want to make work that might be confusing right now but becomes clearer as viewers move from one work to the next or see one show and then another later.

CM: So you're depending on the long haul.

EMC: Yes, which is difficult because when working, I want to think I'm making my best work, but, for me, the success of my current work is at least partially connected to work that is yet to come.

Studio,
Venice Beach,
California, 1998

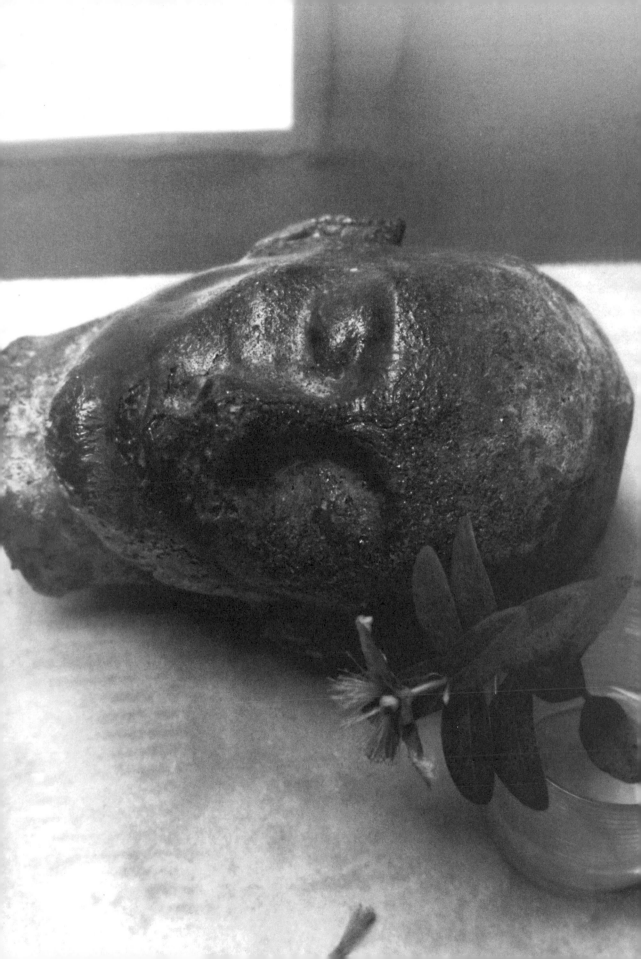

Studio,
Venice Beach,
California, 1997

Notes

July 3 (New York NY). New York City Public Library. This trip to New York and then London finds me at an interesting time in my life. This morning I met with Massimo at the Robert Miller Gallery. The gallery's response was good but it was not definite. Who knows what they want? Who knows what they have in mind? This kind of meeting is disconcerting; positive but inconclusive.

On painting. I have noticed that my concern with the physicality of the painting has not been as overt as before. On second thought, the unstretched, transparent paintings are physical in a way the solid canvases are not.

In Miami I should do a show that is challenging. Not a lot of pieces but good ones (of course).

Why work with relics of saints? What intrigues me about them? Their belief. Not faith itself but the wonder of someone who moves through the world with direction. I see none of that around me.

The heads of Saint Catherine emphasize the area of dismemberment and yet these heads are not fragments but full consciousness. How does individual belief and historical trajectories reconcile? Maybe they do not. I should let the work resolve this question.

The Saint Catherine heads should take their names from Hegel's stages toward absolute knowledge.

*From EMC's sketchbook notes.*

27

## 1998    From an Interview with M. A. Greenstein

**M. A. Greenstein:** Given your recent return from Germany and your visit to Hegel's tomb, let's talk first about the German and specifically Hegel's influence upon your work. If you're going to choose a cornerstone of German philosophy, why pick Hegel, why not Kant?

**Enrique Martínez Celaya:** For Kant the ideas of transcendence and belief can only lead to confusions and are to be avoided. Hegel tries to reconcile the limit Kant places on rational ideas with what he calls "Spirit." I am interested in Hegel's ideas of reconciliation of opposites, the dialectic, which influences my disbelief in partial truths.

**MAG:** What do you mean precisely by "disbelief in partial truths"?

**EMC:** I enjoy Hegel's ambition, even if problematic, to write the philosophy of the whole. Especially that part of Hegel's where the move toward absolute

Studio,
Venice Beach,
California, 1997

*Originally published as "Why Hegel? A Conversation between M. A. Greenstein and Enrique Martínez Celaya,* Enrique Martínez Celaya: Berlin, The Fragility of Nearness (*Venice* CA: *William Griffin Editions). M. A. Greenstein is an internationally recognized author, blogger, and lecturer as well as a Los Angeles–based art theorist and critic.*

knowledge is grounded in a possible communion with a higher entity. I find it interesting, in Hegel's case, that there is a mixture of rigorous analyses and critical engagement, while holding this very fuzzy concept of belief.

MAG: Let me see if I understand you. Are you telling me you're using Hegel because he articulates a practice, a philosophical practice, that enables one to accept the metaphysical?

EMC: Right.

MAG: Curious. Let me ask the question another way, if Hegel gives you a method of entertaining metaphysical thought, what does painting, as a physical operation, enable you to do in that vein? I mean here we have to enter the paradoxical ground of searching for the metaphysical through the physical. Is it the paradox you're after or is it the representation of a metaphysical realm that you strive for?

EMC: I am not interested in any representation or illustration of the metaphysical. It is the epiphany I am after, not imagining what it will be like. I like the physicality of these objects but always as a vehicle. The physical aspect of these works and what they evoke generates a third state. This third state or quality is the reconciliation of the physical and the spiritual as intellectual clarity. This is the solution to the paradox that you mentioned. However, let me clarify something. I do not like the word "spiritual" because it conveys too many meanings that do not interest me. By spiritual I mean of the spirit, of that which is beyond appearances and which completes the feeling of the appearances. I'm not saying that my painting can mediate these profound levels, but in a great work of art one can be in a realm where rational knowledge and spirit can coexist.

MAG: Are you saying the viewer can?

EMC: Yes, the viewer can.

MAG: And in the midst of painting, can the painter?

EMC: Yes, the painter can exist in this realm. However, the act of painting is often delusional and the painter must edit within his or her rapture. The elation or euphoria that often happens while working does not guarantee a higher plane of experience. It will be nice if it did.

MAG: So do you see yourself commenting on the problem raised by other painters regarding what has been called "the mystical," or do you see yourself embarking on another path of inquiry?

EMC: I see myself embarking on a different path. In many ways it draws on the experiences you refer to, but I try to reconcile views that belonged in the past to different camps. I think many of the traditional dichotomies about the nature of painting, and art in general, stem from the Judeo-Christian polemic between mind and body, but it's their synthesis that seems more applicable in understanding experience. I believe that the dichotomies

between the emotional and the intellectual or the physical and the spiritual have been made confusing by polarizing them. It's analogous to what happened in physics when people fought over the nature of light. In trying to decide whether light was a particle or a wave, physics was confused for about two hundred years. It was saved from these limiting views by the reconciliation offered by quantum mechanics. This can be applied to art and thought where constant oppositions are set up without any intrinsic reason to do so.

MAG: Meaning that the bifurcation between physicality and metaphysicality is false?

EMC: Well, they are certainly less separated one will assume by hearing the debating sides. Their contradiction emerges in superficial thinking but seems to vanish in more profound analyses. In my own experience I find that things are more real when they oscillate between the physical and the metaphysical. To the point that what I call "real" is a testimony of the experience of this oscillation. If something remains either permanently physical or metaphysical it ceases to be real, or to be a thing fully accounted for.

MAG: Now with respect to your new paintings, you chose the human head, rather than say, the trunk or the feet, as a primary sign. Does the head become the sign of this reconciliation of the paradox, meaning, a body part that could most likely bring people to the recognition of this realm you're describing?

EMC: I think there is an immediate recognition of a head as a consciousness without raising the theatrical problems of the full figure. A figure seems to transform the painting into a sort of stage. The head is also the strongest association with the memory of someone, and sometimes with memory itself. I'm interested in the first read of these paintings, their evocative quality rather than their symbolism, like the head being understood as the bed of thought or any of these historical views of the head or the other parts of the body. It is like trying to get at the feeling of thinking of the head of my mother, for example. I'm interested in a direct signifier to the person without the trapping of illustration.

MAG: That makes a lot of sense when one thinks about the head as that aspect of the figure that embodies parts that are, if you will, relational, parts that enable us to connect to other people—kissing lips, gazing eyes, ears that perk up upon hearing that special voice. The head, as I am thinking about it in your aesthetic vernacular, is not only a sign of making memory but a symbol of desiring communion, a trope of the subject who wants love—love in the sense of intimately communicating with that which is "out there" and beyond. In other words, the head, rather than say a toe or a knee, is that normative sign of subjectivity and psychological relations. Am I getting too abstract here?

EMC: No, it makes sense. The difficulty of this conversation is in part due to the terms we are using. We are talking about ideas that we could call "soft" because they are imprecise and difficult to define. People have seen this lack of precision as a symptom of the lack of validity of ideas like the ones we are discussing, and most critical theories have consequently avoided them. I think this is a mistake. These heads and the feelings they present are my way to make images that insist or oppose that which the paintings establish. Sometimes they are intuitively produced and sometimes they are not, but they are always precipitated by the act of painting. Sometimes they hold opposites together, like violence and serenity, that seem to reconcile in the physical work. The compression of these opposites brings forth different levels of awareness, and these, in turn, take physical form. In this group of works, the visual works and the poems, heads have been prevalent. But I also use birds, arms, legs, and hands. I think these images are not fixed, although they respond to my present needs. In my paintings there is a constant battle between decisions that predetermine the visual and spontaneity. My paintings are central, iconic, physical, and referential. This really limits the kind of images that can exist in the works. That is, which would be capable of maintaining a conceptual equilibrium in the work. I find insight in this rigidity. So my role is to search through the predetermined ideas to find the ones that are truly evocative.

MAG: What are some of the ideas that you have left out of paintings, ones that aren't as evocative to give us a sense of what is evocative. For instance, we have heads, we have birds and bodies that are fragmented. We don't have "airplanes or cars"—

EMC: I have used airplanes before but I am not interested in technology or culture as an inventory of experience. As technology changes people's engagement with a work will change; it becomes obsolete by relying on the ever-changing surface of interest. I come from a background in science. I think most physics labs have much more engaging technology than any art gallery. The art gallery technology gets its novelty because it is accessible; you are allowed to see it and maybe you have never seen little motors moving. But the marvel of scientific art does not compare to a nuclear accelerator. This is true of culture as well. I'm only concerned with culture as an external signifier pointing to internal universes. As a foreigner, I have seen the interest of cultural elements change from one country to the next. I, however, in the ways that are most mysterious, remain fundamentally the same. People around me also seem the same. The veneer of culture, which provides many answers to contemporary thinkers, seems to me to have little relevance in the questions that matter. I'm interested in culture only as it relates to the specific feeling of a specific individual, and often how it is empathized through me.

MAG: Right, because the last time we spoke you said you were interested in the poetics of experience.

EMC: Right. But not in the way that a musical play is interested in the musicality of experience. I do not want to sing the poetics of experience. Instead, I'm moved by the poignant poetry that is present in experience.

MAG: Consequently, you're not interested in critiquing experience per se. Rather you are determined to use poetics that would suggest a play with meaning, specifically meaning that is, let us say, subtextual or inferred. Somehow in listening to you speak now it almost sounds as though culture in the poetic sense is to be understood as that which cannot be reduced to mere logical explanation or analysis.

EMC: Right. For example, in discussions about the dichotomy between culture and self, and the related dilemma of which one is the creator of the other one, little progress has been made. I do not necessarily find these debates uninteresting but I do not think that I will find my answers there. I am interested in what is felt, by which I do not mean sentimentality or some sort of melodramatic display. I mean emotion inseparable from thought— deep emotional empathy. I do not know the way to speak of a distinction between thought and emotion that is fundamental and not merely circumstantial. The best thinkers and writers always display a poignant emotion and a sensitive intelligence. In them, the dichotomy outlined in many critical debates is not present. This concentrated emotion or spirit is most interesting to me. Its mysteriousness is surprisingly clarifying, although not in the polarizable form of partial ideas. It is a synthesis where one oscillates from belief to disbelief; the oscillation is the force and the secret.

MAG: In summary then, would you say you are grappling with an area of human understanding that has been forgotten or doesn't fit with what either an old-fashioned positivist notion of rational analysis or the more current post-structuralist idea of criticality?

EMC: Yes. I think that what is underlying here is the idea of a "complete thought." This compared to making distinctions between rational and emotional thoughts. While they are different circumstances of the mind, these partial understandings lead to apparent discontinuities. In these discontinuities consciousness seems to have a glitch, or time seems to fracture. Just like in mathematics, these discontinuities can be understood by taking a more global, a more encompassing view. This, if you think about it, is the opposite of the conventional approach to analyzing discontinuities. Intellectual, emotional, or experiential discontinuities are often studied in gross detail by most contemporary thinkers. This may be pleasurable but is not productive. There is nothing to understand in a discontinuity.

MAG: Let's think about this in terms of a specific painting of yours; for instance,

the one you have in the dining room that contains a fragment of a hand in a beak of a bird [*The Fragility of Nearness*, 1998]. Now I understand fragmentation but I would have to ask myself what do you really mean by discontinuous, because there is an image before me in the present and it's not discontinuous with my experience, that is, if discontinuous means "doesn't follow with." What are we talking about?

EMC: I'm glad that you are asking that. First, what I mean by discontinuity is not at all in the language. Second, this is an iconic painting following in the fourteenth-century tradition of having a central motive with almost no doubt as to what is important. It may seem very continuous upon first read; nothing too layered. Concentration should quickly destroy its concreteness, its continuity. Someone might think of discontinuity as the work of Lari Pittman, for example, where repeated visuals layer fractionary aspects onto one another. This is an extremely continuous illustration of the confusing layers of experience. It is like when a time travel movie shows you two distinct centuries and you say, "Wow, this is crazy." But on your couch you have not managed to dislocate your time and experience— the illustration did not generate the experience, but it was entertaining. I'm pursuing the exact opposite position. I'm after a work so empty yet so dense that in engaging it, the act of becoming is generated. A moment when two colliding aspects of mind seem to throw light in all directions and the viewer is simultaneously validated and destroyed in its presence. This for me is clarity broken with time itself.

MAG: Ordinary time?

EMC: Ordinary time. For example, when you go to your parents' yard and you see the gardenias your mother liked. In the moment you smell them memory does a strange thing. In that moment maybe the trip to the yard is fractured in time. Layered in two times at once but felt simultaneously, compacted. How would you describe that experience? But I am not interested in describing it. I am interested in going through that experience to the state where those two moments can coexist at once.

MAG: Let me back up a bit and return to the issue you raise about expanding the field of inquiry to allow for discontinuity. You claim your paintings are iconic: heads float in large space. That simple point of particularity in empty space. Is that a visual metaphor for what you're describing as scoping out the larger picture? Or maybe you're not talking about a one-to-one relation between the paintings and your ideas.

EMC: There is not a one-to-one correlation between the space of the paintings and actual space. Paintings need different strategies to extract truth from experience than those that the physical universe presents. Paintings are products of the mind in physical form. Their rules and their powers are based on components of the mind, without a one-to-one translation

beyond itself. This is why illustrations always fail; they impose the logic of the things as they seem to objects of the mind. My paintings are simple. There is not much going on, but they are not about reductivism. If you engage them, maybe, something may be clear or mysterious, or both. Loss and gain, emotion and thought, longing and acceptance compress themselves by means of a good work. My works value this level of engagement but whether or not it's reached by them is hard for me to say in an absolute way. Even by saying this now and presenting these opposites, I mislead the discussion. These concepts do not apply as fundamental but only as functional distinctions. If you speak about these fragments of the whole, you mislead. The whole cannot be fragmented if one is to be rigorous about it. All the fragments are partial views with their associated obscurities of the larger question. The larger question is consciousness, and that is why I started with Hegel.

The
Dorotheenstädtischer
Friedhof, Berlin,
Germany, 1997

Studio,
Venice Beach,
California, 1998

## 1998    Notes

August 14 (Venice Beach CA). Life is all we know. Fear of being branded a simpleton stops life. In the art circles, as in most intellectual life, need has given way to fear. We are afraid of falling to clichéd thoughts or to reveal vulnerabilities and needs. And yet life moves freely beyond these fences of intellect. It ripples and crosses unaware of the boundaries set by consciousness.

It is not that grappling with the nuances and offerings of life can ever be out of fashion. It is that the struggle seems futile for minds bred in fear. My mind is one of these. I have been groomed by a system of education where quality and authenticity are relics of the past. Have we squandered our fortune with cynicism and arrogance?

In this climate I am the first to fear ridicule, shame, and abandonment. But I continue to struggle. Not because I am a hero but because life constantly forces itself into whatever sterile and slick argument I construct. The climate of the visual arts is tyrannical and petty. It is a climate brought about by self-righteousness, which labels its critics antiprogressive. Unfortunately, the critics often come from their own hardened value system. The future of art is prostrated between these two rigid positions of servitude to their own self-interest. To allow a new age would mean to admit their pettiness, their unimportance. In time they will, but not willingly, and in this way they will follow a long tradition of powers who became obsolete.

*From EMC's sketchbook notes.*

The Weissensee
Jewish Cemetery,
Berlin, Germany,
1997

## 1998　Berlin

**Time and the Window.** I have been taking photographs for some time but usually as reference for my paintings and drawings. After a while, I started to become interested in the photographs themselves. As I pinned them to my studio wall I started to develop a relationship with them as objects. From this emerged a way of addressing time and the problems of self-containment, which is different than the photographs that I have seen. I like pictures where their moment does not have a before or an after. Time can then be generated by photographs instead of documented by them. I try to have photographs that contain everything that matters to them (object-wise but not conceptually) and that have no beginning and no end.

**The Ephemeral.** I am trying to fix that which is inherently fugitive in time. These photographs are scattered pieces of events, memories, and narratives. At times they feel like ruminations over scrapbooks that do not belong to me, but which I am in charge of organizing. The imagery is mostly of monuments to belief: tombs, religious statuary, and fragments of people. These monuments are constructed in defiance of time and, as such, they are profoundly tender in their futility. It is this futility that I find moving; it is insistent beyond the reasonable but carried out in a systematic and insightful way.

*Excerpts from "Notes," in* Berlin: Photographs and Poems *(Los Angeles: Stephen Cohen Gallery and William Griffin Editions).*

## 1999    From a Conversation with Donald Baechler

Enrique Martínez Celaya: I think of your paintings back in the eighties with
figures and the suggestion of the landscape. Those were powerful and melan-
cholic and almost had a Caspar David Friedrich feeling to them. Not only in
the obvious part of the landscape but in the sense of largeness about them.

Donald Baechler: I know what you are talking about. Yes, I was interested in
Caspar David Friedrich and the Hudson River School—the figure isolated
in the landscape, the figure alone in the world. But then at a certain point I
started to want to fill things up a bit more and crowd things in a lot more.
So maybe that sense of melancholy went out the window with the empty
fields. I don't know. Enrique, your paintings certainly seem melancholic
in their use of black and the kind of poetic line that you employ.

Venice Beach,
California, 1998

*Originally published in Anne Trueblood Brodzky,* Unbroken Poetry: The Work of Enrique Martínez
Celaya *(Venice CA: Whale & Star Press). Donald Baechler is a New York–based artist whose works
are in the collections of the Museum of Modern Art, The Whitney Museum of American Art, and
Centre Georges Pompidou, Musée National d'Art Moderne, Paris, among others. David Minnery
was EMC's studio assistant.*

EMC: The problem with the character of melancholia is that it can completely override a painting. It can completely undermine it, so I try to keep melancholia and nostalgia at bay. I think that is where they are most subversive, most interesting.

DB: Hopefully kept at bay. Melancholia evokes awful emotions, actually. Awful sentiments in some sense.

EMC: Right. But putting a certain amount of rigidity against melancholia somehow creates an interesting struggle within the painting and refreshes a painting constantly. Paintings that are deliberately serious are often very predictable. I like to find seriousness in unexpected places.

DB: I have an attraction to melancholia and also to a kind of ridiculousness and absurdity. I like to mix the comic and the serious into one sort of big soup. I don't know if it works or not, but I think sometimes it does.

EMC: I think it works. I think it works in your paintings.

David Minnery: The work of both of you contains figurative and non-figurative elements. With regard to the surface of your paintings and the images you use, do you find there's a tension between the imagery and the surface of the painting?

DB: I hope so. I construct the sort of surface that I paint on—that I've been painting on for the last ten years or so—to intentionally deflect the line and prevent the line from being too perfect. There is this dialogue going on between two different types of painted elements. One of which characteristically would be the kind of heavy black line and then something naturalistically painted like a vegetable or some sort of species of post-supremacist abstraction. A kind of dialogue between two different types of line making or image making in the same painting. In the past I have said that it represents man's uneasy relationship to abstraction and to the natural world. For me it is a simple desire to kind of churn things up a little.

EMC: In your surfaces, you have materials put on them such as fabrics and erasures. Are those part of the constructing process of the paintings or are they premeditated?

DB: Some of it is premeditated, some of it is part of the painting. Certainly in my case what you see on the canvas is never how the painting began. There is a lot of doubt and a lot of change that goes on in the process. But there is also this false archeology that I construct to begin with by layering on all this crap on the canvas before I even start painting on it. For me that's just preparing a ground. But then on top of that there is this other sort of history going on with erasure and change and doubt.

EMC: I think we share many ideas but I think I have a more troubled relationship with surface and marks. I end up with complex surfaces by pasting stuff, painting over parts as I am trying to get to a better painting. I am willing to sacrifice anything for a painting that will be moving. I do not

try to make an interesting painting. I am trying to make a painting that is resonant, and because of that, I end up destroying a lot of work, and the surfaces accumulate some of that history.

DB: Destroy a lot of work? You mean you actually destroy them, or you just paint on top of them?

EMC: I do both but I was referring to painting on top of them. But I do have an uneasy relationship with all the signifiers or all the things that reference emotion like erasures or transparencies or drips. They only survive in the paintings after a lot of internal reconciliation.

DB: I think that's clear in your paintings. There is nothing that looks false in those paintings. I know exactly what you mean. I think maybe that's the difference between a good painting and a bad painting; it is that level of conviction with which the painter can bring, just exactly, what you call signifiers. It's easy to drip and it's easy to scribble something out, but it's really hard to do it in a way that means anything.

DM: How do you know when a work is finished?

DB: I think de Kooning answered this question once on a radio interview. He said something like, at some point I just paint myself right out of the painting. I feel that. Certainly there are artists whom I admire greatly, like Peter Halley, who I think goes from point A to point B and then to point C and then he is finished because it was mapped out before he started painting. But for me, and I think maybe for Enrique also, the painting evolves in an intuitive way and just at some point, there it is. It's done.

EMC: My feeling about finishing work is similar to yours. I think there is a moment in which a painting feels perfect, and it usually has to do with the moment in which the painting seems truly moving, direct, and unencumbered with stuff that is not necessary. I do not usually say intuition, but it is a good way to describe it. The painting seems to connect to paintings that I respect and love.

DB: Are you saying that sometimes in your own paintings you experience something that's equivalent to other paintings that you know?

EMC: Yes. An equivalent feeling, not a familiar look.

DB: That's interesting, because I think sometimes that pops into my work as well.

EMC: I have this repertoire of paintings and painters that I think about, like Giorgione, and I think of what emerges out of those paintings. I am not interested in copies or mannerisms, and I have different preoccupations than those whom I admire, but I pursue some of the feelings that are in those great paintings. Sometimes that feeling comes from a great writer like Melville.

DB: I only think of Melville as maybe the quintessential American novelist, and it's interesting that you're attached to him.

EMC: I am very interested in American literature and American art. There is something about Americans that I didn't understand before I lived in this country. Americans have a distance that is very necessary to them for surviving with their artwork. They need to create it and then fight against it, and there is a no-nonsense quality to it that I enjoy. Take John Single-ton Copley and compare him to the English painters of the same period. Their work had fuzzy landscapes, and then suddenly you see Copley and you see his paintings having this beautiful direct sharpness. There is no fuzziness, but a balance with nature, an ascetic romanticism. This is true of American literature also. There is, of course, Russian, German, Spanish, and Latin American literature, which is beautiful, strong, and clear, but there is something about the American tradition that I really like. It feels simultaneously familiar and foreign.

## 1999    Notes to Anne Trueblood Brodzky

The question of where does the consciousness or the spirit lie is, of course, a very old question. In some ways, at least tangentially, it is involved in this work. I try to understand why the birds and all those other images came into my work. I think they came in because I didn't want to make figure paintings. This is part of the dismemberment aspect; when you have a full figure in a painting, it somehow forces the painting to become something of a theater. I think that when you look at a painting with a figure, you look at the figure and you empathize with the figure like it was an actor on a stage. You feel through the actor some larger message. A painting is always like a stage, an intermediary. Yet I want to be as direct as possible. The formal constraints that I impose in my work allow me to then hold things in place. Relying on the rigidity of these choices, you can then take some liberties with what you can do in the painting.

If you look at a photograph of something and you try to understand everything that is involved in the image, the subject will remain elusive.

*Notes EMC sent to Anne Trueblood Brodzky. A version of these notes were originally published in Anne Trueblood Brodzky,* Unbroken Poetry: The Work of Enrique Martínez Celaya *(Venice CA: Whale & Star Press). Anne Trueblood Brodzky is a San Francisco–based writer and curator.*

Studio,
Venice Beach,
California, 1998

In a similar way some memories do not easily offer themselves and they have no specific answer to "get." Say, my grandfather coming out of his dental office and sitting down in his rocking chair in a dark room; there's no answer there because we don't know what the question is. But obviously something meaningful is there.

The hummingbird itself is this sort of defiant little animal that when you hold it, it's as if nothing was there. It is so insignificant in weight, but its flight makes you aware that it is very alive. There is a contrast between its definite presence of life and its evanescent quality of weight, and this contrast makes it a living metaphor for consciousness. So on one level the hummingbird is that. It can also be a manifestation of the spirit. I like the fact that hummingbirds collapse the distance between the sentimental and the transcendental. Everybody has them on their refrigerators because they're cute. There is kitschiness in hummingbirds that introduces a wedge into much more serious considerations. I think that, somehow, the marriage of sentimentality and detachment implies a heightened poignancy, which is much closer to the way I experience life. I like the fact that the juxtaposition of banality and seriousness can coexist within the image of a hummingbird. It is a wonderful surprise to find a very serious painting with a four-foot by five-foot hummingbird . . . much more surprising than a Campbell's soup can.

It's like if you take two kinds of rice and mix them together and shake them. You can identify there are two different kinds of rice in the bowl, but they are so intermixed they are inseparable; you cannot just simply pour one out. Reality is like this. Unless you go for the whole, you don't have any part of it.

EMC and his wife,
Alexandra Williams,
Studio, Venice Beach,
California, 1999

## 1999 · From a Conversation with Amnon Yariv

**Enrique Martínez Celaya:** Sometimes when people ask me about my science background and its relationship to art, the question of faith and intuition comes up. In your scientific work is there room for faith or intuition?

**Amnon Yariv:** Most of us that are doing research are at the boundary between the known and unknown. And the boundary is kind of fuzzy. Everything here is known perfectly well, and from here on, not at all. There's that gray area in between. But you are roughly at the boundary. And that's what the search for definition is. And you have to make guesses. And the guesses are intuitive guesses, about what things are going on and what kind of experiments you are going to conduct. I think this boundary, although we keep pushing it, will never get to the end. The barrier between the known and the unknown is infinite. There will never be an end to it.

*Originally published in Anne Trueblood Brodzky,* Unbroken Poetry: The Work of Enrique Martínez Celaya *(Venice CA: Whale & Star Press). Amnon Yariv is the Martin and Eileen Summerfield Professor of Applied Physics and professor of electrical engineering at the California Institute of Technology.*

Marina Del Rey,
California, 1999

EMC: I like the mystery in this boundary between the known and the unknown. Despite the vastness of this infinite territory of the unknown, one can make incursions or probes with imagination and insight. Intuition is not the only quality that relates science and art. When I talk about science and its relationship to art, questions of language and translation often come up.

AY: Language . . . you know, mathematics is the language of physics and I really don't think that you can convey it in any fashion short of learning it. That's why I think that laymen don't really understand science. Mathematics is one of the crowning pieces of human achievement and it is the language of physics. This is a difficulty and a disadvantage of science. People can appreciate the beauty in art. People can come to the museum and see your work but I can't describe what I do to my friends. The language, the consistency, the logic, the beauty of the language or experiences are not transferable.

EMC: Well if you think of this description as a translation, art is not so different. Most people do not understand or relate to contemporary art. You can describe what you're doing in physics, but you cannot actually do the physics at the level of description. You have to ultimately use the language of physics, mathematics, and so on. Art is very similar in the sense that you can explain the issues that you understand in the work, you can explain some of your ideas and part of the context in which it is created, but ultimately the meaning is embodied in the way it was made. And if you try to break it down and translate it, you end up at the level of description similar to a physicist. You cannot make art at the level of that description. You cannot make art by just the combination of interesting ideas that you may mention in a description.

AY: Well, art must be much more subjective. I mean, take physics. Take two professors who will teach, let's say, very advanced general relativity. One in the United States and one in China. They will essentially use the same language and say the same things more or less . . . convey the same picture. While two artists describing the same piece of art will probably say very different things. There is a certain elemental objectivity to physics, which, I guess, maybe doesn't exist in art because it is so subjective.

EMC: I do not completely agree. In physics you test your calculation to see if the solution is right. By contrast, many are of the opinion that every position is equally valid in art and that "correctness" is not the issue, that there is no test. While subjectivity is intrinsic to the choices of artists and viewers, it is not the whole picture. You see a tree painted by Mondrian and a tree painted by Leonardo. The embodiment of the idea is very different. Very different trees. But when people describe how these trees evoke feeling and thoughts, they will say very similar things. It is true that describing your preference for a visual experience is an aspect of subjectivity. But two

well-painted trees seem to often speak similarly to their audience despite descriptive differences. Of course, what I am making here is a simple argument for essence—what physicists might describe as the basis of nature. Maybe it is something hard to name without naming those parts that you can see on the outside, but there is something they are all going around. Does that make sense?

AY: It sounds a little strange. Because as a physicist, you talk about this common core, but I really do not know what it is and I am not convinced that it does exist. I know you could not prove it exists, and that is why it is art and not physics. I thought until I spoke to you that art really was much more intuitive and subjective. I think, in my opinion, that trying to find maybe a common utopia, a logical element in art the same way that you do in physics, is maybe trying to force an artificial constraint on art. It may not be necessary. I mean you know, probably, that most artists don't ask these questions ever, right? Something is pushing them. They are driven by something which probably they cannot express.

EMC: I do not think that many interesting contemporary artists ignore these questions. I believe in the clarity and power of emotional insight as a component of the work. But I also believe in a certain amount of other factors involved. The landscape of contemporary art has changed significantly, and many simply detest the idea of the artist working from inspirational effort devoid of reflective insight. Being conscious of what you're trying to do does not strip away the emotion, validity, or directness of it.

AY: But probably there are many different ways of telling stories, which are all equally valid.

EMC: That is the question, whether they are all equally valid. Ultimately what makes an approach valid is whether it leads to a good work.

AY: By moving other people. By making them feel something.

EMC: Right. A painting is its own argument, a defense of its own validity.

AY: Suppose you painted a work about your grandfather, the relationship you had, his love for animals, birds. The audience may just see a picture of an old man feeding a bird and some of them will be moved, but maybe not for the same reasons that moved you to paint it.

EMC: Right. But it is the same as in any other field. You might construct something and the knowledge and information used to construct it does not show. The object can be opaque to information about its motivations. As long as the object works, maybe it does not matter. I need full investment in the elements involved in order to make the works meaningful to me. It helps me get up every day and work. It also helps to strip away the inconsequential issues. It is not uncommon for me to paint a dozen times over a painting.

AY: You go over it and start again?

EMC: Yes. I start again or cover parts. Sometimes a visitor comes to my studio and likes a painting, and then two weeks later they call me about it but the painting no longer exists because it didn't survive.

AY: It didn't pass your test of authenticity, of being real. Well maybe what you sense then is its truth. But you could have painted your grandfather on a different day when the sun was not sunny but cloudy and you had just watched an accident in the street, so you would have been in a completely different mood and because of that would have painted different paintings—still truthful. You would have wound up with a different painting, which would have passed your own test possibly.

EMC: Possibly. But most likely those two or three different kinds of paintings, all of which passed the test, share a large number of constants, and I think that is the issue for me. I think there are some things that remain constant and you can always recognize them in the work of an artist. Not only because of a certain look, but because of a specific sensibility and the choice of certain parameters. So much of art is also what you leave out and choose not to include, the kind of economy you use.

## 1999    From an Interview with Howard N. Fox

Howard Fox: I have a sense that "science"—in the ancient sense of knowledge and human understanding, and the attempt to discern truth—in some way relates to your work. I was reading an article by a mathematician who was speculating on whether mathematics is an invention of man or whether it exists in nature, independent of humankind. In other words, a kind of ideal order, or natural law, if you will—very abstract concepts that seem to intercept physical reality. Does this, in any way, inflect or inform your art?

Enrique Martínez Celaya: Nature is a building with an invisible exterior, and we live on the inside. Science and mathematics are a scaffolding that facilitates investigations on the structure as well as one of the best things we have to make any inferences about its shape. The scaffolding is made by us, but as

*Originally published as Howard N. Fox, "Interview with Enrique Martínez Celaya," in* Enrique Martínez Celaya 1992–2000 *(Cologne, Germany: Wienand, 2001). Transcribed and edited from a program at Griffin Contemporary Exhibitions, Venice, California. Howard N. Fox was curator of contemporary art at the Los Angeles County Museum of Art.*

it becomes finer and more flexible it resembles the building that is not constructed by us. It could become difficult to distinguish between what reveals the building and what inherently is the building. These questions profoundly affect my work and they are very relevant in contemporary art.

HF: So much of contemporary art often looks theoretical, as if it were an exercise in an idea about art that is carried out almost as a clinical pursuit, not unlike a scientific inquiry in a laboratory. Many artists position themselves to respond to something that other artists have said before to advance to the next phase in a critical dialectic. But this is not the kind of "science" I'm describing in your work. For you there seems to be more of a search for some intuitively discerned higher or deeper truth that's not about some current discourse in the art world. So much contemporary art that is formulated as a specific response to critical discourse seems hermetic. And I think that to many viewers such art appears, rightly or wrongly, to have very little to do with the world at large or what they experience in their own lives.

EMC: Many people involved in contemporary art think that the construct of culture is not only the means but also the end. Most scientists, on the other hand, think that the tools of science are a construct but the end is not.

HF: I think that your work mediates those realms—the very worldly and whatever is not worldly. Let's talk about some of your paintings. These pieces [*The Empty Garden*, 1998, and *Pena (Sorrow)*, 1998] suggest mortality, possibly violence, anger, the intrusion of some rude force into the way life is lived. Is there struggle in your work? Is there anguish?

EMC: Most of the time, pursuing a resonant and moving work is a struggle. And because of this, there is violence and anguish, not only in the images, but also in the process. I am trying to hold violence close enough to remain urgent but distant enough to see it and, in the process, make objective what is extremely subjective. Memory, for example, is one of those ideas that is violent, difficult, and subjective. I want to know what memories do, how time erodes them, and what or who is the "me" that is doing the inventory of the past.

HF: You mean, not specific memories, but the activity of the imagination, just left alone to contemplate itself?

EMC: Yes, but I do not usually think of imagination as involved in this process. I am seeking a clearer vision and that leads me to objectify and separate the subjective from myself. This is neither about sentimentality nor about detachment; both of those positions are very easy to understand but not very revealing.

HF: The fact that your paintings resist very specific interpretation is exactly the response that you are eliciting from the viewer.

EMC: Yes, but this is because the works are an experience that is not readily available as a simple pointer. It is not about confusion.

HF: It's wonderment, not confusion.

EMC: Yes, but focused. This preoccupation started for me with religious paintings. In religious paintings, the entire human being was the destination for the work, not the mind or the heart. The religious work wants to suggest some experience that is extremely clear but unnamable.

HF: I think you intend something very similar to happen to the viewer. We have some questions from the audience.

AUDIENCE: I understand this as a sort of spirituality that you're seeking. Does any of this have to do with the revolution in Cuba? I mean, in the view that this experience happened, is that part of this anguish and violence?

EMC: When I left Cuba, I understood what that meant to other people, and later, what that meant to myself. The exile facilitated the possibility of the world at certain costs. It is a persisting struggle to remain unexplained as a foreigner. Everyone seems to know better. I do not long for spirituality or reason as an answer to my condition of exile. Culture and politics are not directly the subject of my work. All the issues of culture and politics always have their struggles in the individual. I am interested in the person. If you wish, you can see all my works as an examination of the idea of self-portraiture separated from the autobiographical. In the process of working I disappear.

HF: As long as you're talking about disappearance, let's talk about your palette, the almost bleached faint feeling that your images often have, as if they're fading into a space or time or they're just coalescing out of it. You do have some use of bright and saturated colors in your canvases, mostly associated with blood red. But most often you have a very grayish, ashy white or a dark, inky black. Sometimes the whites are ethereal and can almost "snow-blind" you, while the blacks are often dense and unfathomable. Everything seems to fade in and out of vision. At least that's how your palette works for me.

EMC: In 1990, I was trying to reinvent painting for myself. The fastest way I found to dismantle the way I worked was to take out what people said was interesting about paintings. I took out drawing, I took out color . . . took out what people had complimented in my paintings, to see what was left. I was left with black and white, and red, which seems like a form of black and white. So I have tried to keep the options in these paintings very rigid on purpose. I think that if you keep the structure of the paintings very rigid, then you can take huge liberties within them.

HF: You've described "reinventing" painting for yourself and working within a rigid structure. I get the impression, in looking at your work, that structure is like a visual language with its own vocabulary and syntax—a language

that is personal to you yet rooted in Western art and iconography, so that it has resonance for viewers. Is this a fair impression, that your painting strives to the condition of language? Does language somehow edify your art?

EMC: Language exists in my work, in the books that are published and the poems that are included in the exhibitions. But I do not think of my visual pieces as a language, or even as constructed in language. Instead, I see them as objects, concepts, and images that exist as experience. This experience is not a private language nor is it translatable to language. Images and gestures reappear in the work but not as parts of a hieroglyph. They, perhaps like trees in a forest, are different and the same in each encounter. Some of the ideas in my work have interested many people before me, and that is why my exploration seems to connect with the Western tradition of art and literature, and even folklore.

HF: Speaking of paintings in terms of language also underscores another impression that your art is very literary—"poetical" and "lyrical" are words that many people have used to describe your art. And you are a poet and a great reader of books and a literary publisher in addition to being a visual artist. Is your painting and sculpture steeped in literature? Who are the writers or philosophers who've influenced your art?

EMC: I did not look seriously at anyone's paintings other than Leonardo's until I was twelve. I was not interested in art. When I started painting I did it to understand myself. In contrast, I read everything I could find. It was through literature that I began to understand the world. Literature became a much better model for my work than visual art, and it was more or less free of the burden of commodity and "look." I sought physics and philosophy to better understand where I was, but I always came back to art and literature as a way to internalize and to clarify experience. And about your question of influences, I am in debt to a very long list of writers and philosophers but naming them often misleads more than reveals. I have not figured out a way to talk about these things in a way that is useful.

AUDIENCE: Your paintings, and also your drawings, are absolutely elegant in the way you painted them. It's just a formal thing, but you're very conscious of the kind of surface, are you not, that the paintings have?

EMC: Yes.

AUDIENCE: Very careful use of accidents.

EMC: I work with accidents in all the works. I create situations for them to occur. But once they occur, I spend a lot of time deciding whether I could live with them or not. I am conscious of the surfaces and everything that ends up in these paintings. And often, they are more superficially appealing before I finish.

HF: How so?

EMC: They have more of what people often seek in paintings. A moving work is sometimes encumbered by the issues of the visual, and paintings have the burden of being caught up in the decorative.

AUDIENCE: What is the relationship that you're looking for between the images of the head and the tree in *Quiet Night (Marks)*?

EMC: Well, in general, the objects in my works are elemental: trees, birds, heads, the sky, figures, arms, mirrors, water. They are fragments of the forest, which I mentioned earlier. These are the fundamental building blocks of experience. So in the juxtaposition between the birches and the head something new will emerge, something that was maybe hidden by appearances. So the relationships between these things are not really intended to be poetic, as in "flowery," but as in essential to some truth.

AUDIENCE: I'm curious why you don't leave in the emotional side . . . you just leave the chronic, the violent. Could you comment?

EMC: I leave the emotional side. But the emotional side is not the same thing as the sentimental side. The sentimental is not specific. What's left in emotion once you remove affectation from it? I am after a state that breaks the barrier between intellect and feelings.

## Notes

Date unknown (Venice Beach CA). The work I am doing right now is about a forest. Is it about painting? It is always about painting.

I want to make the paintings more physical but also clear and magical. Magical is not the right word. What I mean is the feeling of that which exists beyond what is. But nothing surrealistic, nothing fluffy. I am talking about the spirit of being—consciousness; what is left once everything relevant has been accounted for.

What things are left? Lemon blossoms.

*From EMC's sketchbook notes.*

Mount Baldy,
California, 2000

Notes

October 17 (Los Angeles CA). Our daughter will be born soon. Strange times. After all the panels and critics talking about my work in the museum show, I should say something. I would like her to know what I thought. I would like to know it also. I'll write it as a dialogue. A fictionalized "interview." With whom?

*From EMC's sketchbook notes. This note led to Enrique Martínez Celaya,* Guide *(Los Angeles: Whale & Star, 2002).*

57

## 2001 Making and Meaning

For me the relationship between making and meaning is integral to and inseparable from the value of the work. Without the struggle and uncertainties of the process of making the artwork, the investment of me in the work is significantly reduced. In earlier years, I struggled between the importance of making art and the problems inherent in fetishized work. Since then, I have found the problem is not in the making, and the related concern with objects, but in the critical position I might take about making.

Fetishism has many variations but the one I find most problematic is being seduced by process, which often leads to an inability to see meaning

*Excerpt from EMC's writings.*

Studio,
Los Angeles,
California, 2001

distinct from making. When art making becomes a narcissistic endeavor, making is always at the service not of itself but of a glamorized version of itself. Making in this condition becomes an ornament, a preexisting and generalized convention of the way making may embody meaning. On the other hand, making as a substantially utilitarian enterprise unfolds quietly the poetic of structures and the challenge and limitations of the physical.

In my work I explore the relationship between the subjective and the objective in experience. With this conceptual tendency, making is a way to keep the work from becoming philosophy or poetry. Different that an intangible object of the mind, by means of making, consciousness and reflexivity are embodied in the experience of the artwork. Meaning, in this approach, is not only threatened by but depends on questions of directness and staging, and perhaps, of authenticity and futility.

Every artwork is ultimately a theorem about the connection between making and meaning. Every artist, consciously or unconsciously, gracefully or clumsily, is exploring the fragile relationship between the art object and its meaning, and between the audience and him- or herself.

I am interested in how meaning can exist in painting, poetry, photography, sculpture, and drawing and then dissolve and reappear in between them and beyond them. Art, for me, is an unstable wonder. Meaning flickers between what is facilitated and embodied by the making as well as by the experience that seems to hover outside or beyond the making.

Studio,
Venice Beach,
California, 2001

## 2001     From a Lecture at the Orange County Museum of Art

My childhood was one of relative privilege for a Cuban boy born after the Revolution, then it collapsed in Spain into one of exile and poverty. In the ensuing loss, confusion, and domestic unrest, I sought art as a way to organize reality. I tried to use it to make an inventory of experience as an antidote to disappearance; the same motivation that led me to study physics and philosophy. Since those days my life and work have changed, but I still look to art as a source of clarification.

People do their best work about what they know. Faulkner wrote about the South, Velázquez painted a declining Spain, and Beethoven composed the end of the German Enlightenment. What I consider mine is not a

*Originally presented at the Orange County Museum of Art, Newport Beach, California. An earlier version was presented at the University of Hawai'i at Mānoa, Honolulu, Hawaii, September 4, 2001. Both lectures were given on the occasion of the traveling exhibition, Enrique Martínez Celaya: 1992–2000.*

country or a specific culture but a collection of parts, ideas, and attitudes coming from many places and unified—or somewhat unified—by what is individually felt. I do not think my ideas come from an accumulation of cultures. Instead, they are the result of friction, elimination, and contradiction in a process that softens nationalism and leaves me without a sense of belonging but conscious of my subjectivity. The tendency of the homeless is to wander, and in this wandering art can be a guide, a beacon.

But do we see a lot of art that can function as a beacon? With some wonderful exceptions, most of what I see are irrelevant artists, critics whose writings are not serious, curators who cater to trends and administrative pressures, galleries selling ornaments and status, and collectors wanting to be timely and interesting. In this environment it is easy to become a cynic, and it is near impossible to be convinced of the relevance of one's point of view.

I have tried to keep these ideas in mind while working, but as I look at the survey at the Orange County Museum, I am reminded of Kokoshka, who claimed all his works were failures.

But what is the work? It is not a painting or a sculpture or the environments or the poems or books. It is the spirit emerging through the compilation of all these aspects. Each piece is but one facet presenting and obscuring the whole.

I didn't always have this view of my work, but I think the intention was always there. When I abandoned science, I wanted to rebuild art on my terms and from the ground up by eliminating from my paintings what through years of apprenticeship and education I had been told was good. I tried to resist the temptation to be clever, dismissive, or timely, as I sensed these attitudes were facile. I wanted for my work to have the internal consistency of philosophy and the expanding capacity of art. I stopped looking at visual artists other than Velázquez and Giorgione and looked instead at poets and writers. But I don't want to give the impression that my evolution was tidy. If anything has defined my work, it has been struggle, confusion, and dead ends.

The show at the museum begins with paintings mostly concerned with the friction between presence and reference as well as the fragile area between nostalgia and sentimentality. It was, and still is, my desire to have some objective understanding of subjective experiences, not in an attempt to solve the mystery of experience but to hold it close. In the second room in the museum, memory and redemption found resonance in a divided bed and in the head of Saint Catherine, who was martyred for her beliefs. These pieces influenced subsequent works where memory inhabited the body as violence. My original preoccupation with presence, theater, and reference, in painting, led me to sculpture, where physicality verges on

the relic. Later on, I pursued reference through photographs, which are intrinsically distant and nostalgic.

The third room explores a time when I sought collisions between different pieces. I reintroduced materials into my practice, like tar and feathers, and rediscovered my connection with paper, which allowed a different balance between the object and the imagery. I attached objects and lights, like Santería altarpieces, to empower the paintings and sculptures—this is one the few clearly Caribbean influences in my work and probably one of the most misunderstood. In the fourth room, I used the forest, the sky, and the ocean as setting. I have become more interested in how does one understand being with the world, rather a being in the world.

Let me end this talk by asking a question that I often ask myself. If I am uncomfortable in the art world and there are inevitable failures and uncertainties in creating, what keeps art meaningful for me?

There is a picture by [Albert] Pinkham Ryder at the Metropolitan Museum [of Art] where a small vessel crosses the dark ocean with the moon as its only witness. Much can be said about this picture, and yet it remains resistant to translation. It is a painting of mystery, like *The Tempest* by Giorgione. Its mystery is not the conventional mystery of riddles but its exact counterpart: a state of clarity to which we have limited access and merely allowed awareness of its poignancy and resonance. The evocative power of this painting emerges from our intuition of what is being engaged. It is extremely ambitious, but it is ambition with economy of means. For me, the experience brought by Pinkham Ryder keeps art meaningful, the day-to-day work exciting, and the challenges bearable.

Market Street Studio,
Venice Beach,
California, 2001

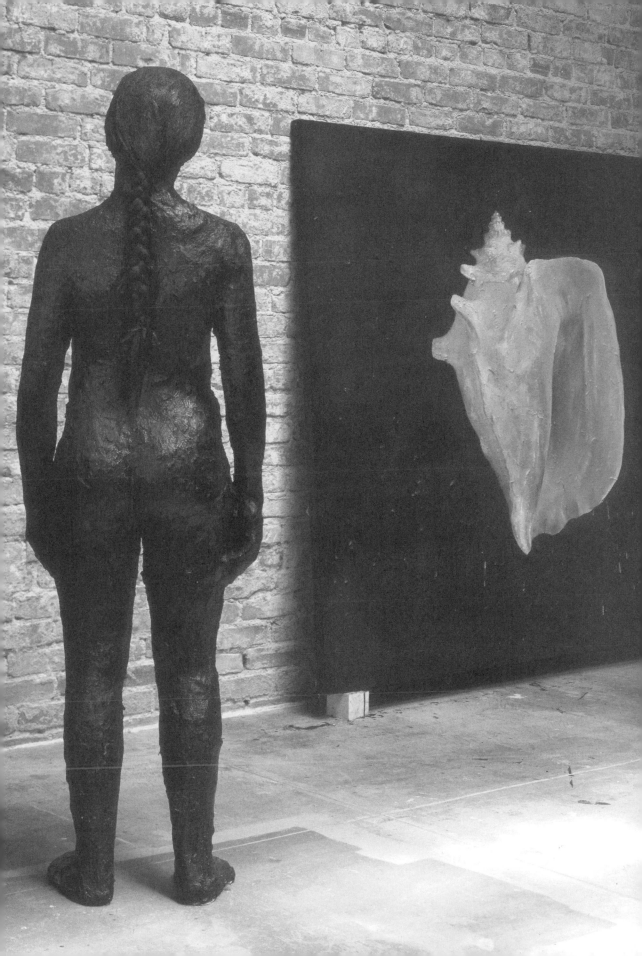

## 2002    Notes

October 28 (Los Angeles CA). Citibank has now an extensive billboard campaign with slogans like "Smiles turn as many faces as expensive cars," and so on. The hypocrisy is so blatant it becomes a form of cynicism.

Humanity is a huge chicken coop. Some chickens are flashier than others—more wing flapping, more chirping. What's sobering is that most people feel they are doing what they wish: eat the corn, shit, flap wings. What lets us see beyond the coop? Only love.[1]

**NOTE**

Studio,
Los Angeles,
California, 2003

1. Originally published in *Enrique Martínez Celaya: "The October Cycle," 2000–2002* (Lincoln NE: Sheldon Memorial Art Gallery and Sculpture Garden in association with Marquand Books, 2003).

*From EMC's sketchbook notes.*

66

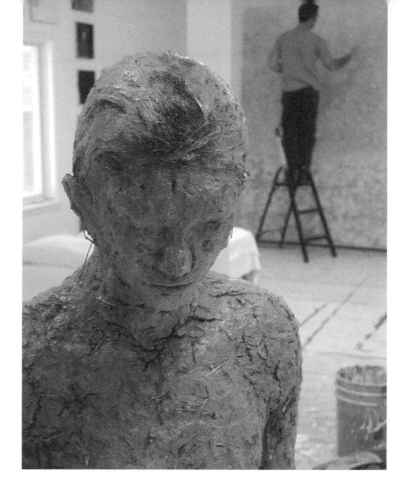

## 2002  From a Letter to Daniel A. Siedell

Myself and the people I knew growing up in the Caribbean had their feelings framed by kitsch and I had to start there in 1997. *Thing and Deception* comes from this time. Growing up, I was inundated with images of the harlequin crying; the Caridad del Cobre as a water fountain; the movie of the dwarf who dies whose name I can't remember; the novel *María*; a caravan of the *Corolla Club de Bayamón* following a wedding; the priest drinking the wine before everyone else and the whole congregation seeing him swallow; plastic flowers on the tombs of Loiza; beauty queens speaking through loudspeakers from the back of trucks; snowmen made of plastic cups; garden statues.

*Excerpt from a letter about the painting* Thing and Deception *(1997), on the occasion of its acquisition by the Sheldon Museum of Art, University of Nebraska–Lincoln. Daniel A. Siedell is an art historian, curator, writer, speaker, and associate professor of art history at the University of Nebraska at Omaha.*

Instead of rising "above kitsch" or becoming part of it, I have wanted to have kistschy images hover without any confessions from me about how I see them. The flickering between charge–no-charge and meaning–no-meaning present in kistch is a strong force. That flickering of meaning is maybe the only way left for recharging feelings. For this painting I chose a seemingly banal image: a chocolate bunny rabbit with all its reference to childhood, treat, and wish.

The bunny is magnified until it is larger than a human and then it is shattered, with visible seams. The rabbit by itself is both sentimental and resistant to sentimentality. The red veil makes it, to me, both safe and threatening. The veil is delicate but suggestive—maybe blood—and it reveals and hides. The rabbit and the veil exist in the whiteness of the canvas. Shadows of buried images can be seen. It is painted with a mixture of paints to give it a powdery consistency, and over the years it has developed cracks. The fragility and aging of the object interacts with the image as well as with the suggestions of memory and mortality that are invoked by the covered rabbit.

As I have thought more about this painting, I have come to see it as a work about mortality. I originally thought it was more related to sentimentality and memory, but now I see it as a work of premonition and finality.

*Quiet Night (Permanence)*, Private Collection, London, United Kingdom, 2003

EMC with
Donald Baechler
and Allen Ginsberg,
Skowhegan,
Maine, 1994

## 2003  From an Interview with L. Kent Wolgamott

**L. Kent Wolgamott:** Tell me about the Cowboy Junkies and Margo Timmins . . .
**Enrique Martínez Celaya:** For years, I liked them and thought at some point or
another we'd do something together. In 2002 I invited Margo to sing at the
opening of *The October Cycle* at the Griffin Gallery, which was in Venice.
Then, when she visited my studio, I showed her the works I did, inspired
by Allen Ginsberg when he was at Skowhegan—a small birch bark work,
which has written on the bottom "for the Cowboy Junkies and a Southern
Rain," which is one of their songs. It was nice to show her something I've
done for them before we met.

*Transcribed from a radio interview by L. Kent Wolgamott. Excerpts published in "A Premonition
of Winter: Enrique Martínez Celaya's 'The October Cycle' is a contemplation of time, memory,"*
Lincoln Journal Star, *December 7. L. Kent Wolgamott is a Nebraska-based writer.*

70

KW: You knew Ginsberg; I did too.

EMC: He had come as part of Skowhegan's effort to bring master poets and artists to interact with the students. At my studio, he liked the materials I was using and the words I had written on the walls. I gave him one of the bark notes and kept the others—the Cowboy Junkies piece was one of them.

KW: Since we're on the subject of poetry, how do the two relate? Most visual artists aren't real adept with words, and you seem to be able to put both of them together.

EMC: As I moved into contemporary art I found few role models. Soon I realized I was more interested in talking to poets and writers than to artists, and so poetry became a good sounding board for the work that I was doing— whenever I got stuck I would go back to poetry looking for a door. So, still, when people ask me "what are your influences," I talk about literature.

KW: So is there a direct association? Between the poem "October" and *The October Cycle*, was that an intentional association you made when making the work or was it something that seemed to be appropriate after you were done?

EMC: They're closely connected.

KW: Introspection, contemplation seem to be key elements in these paintings. Is that where it starts, do you know you're making an image that is aimed in that direction?

EMC: I don't think so. My paintings often come from unfinished business—without plans, without aims. The introspection and contemplative quality of the work is really an outcome of my need to have so little in the work, often by means of sacrificing many things I like. Everything distracts me. The system in my work—if there's such a thing—is a system of silencing distractions.

In *The October Cycle* and the poem "October," introspection is brought forth by the impending winter. Winter is a time to go back to nothingness, to find oneself in a barren landscape.

KW: That led to the black?

EMC: *The October Cycle* was influenced by two events—the birth of my daughter and the writing of *Guide*. Usually, my work are environments that include painting, photographs, and sculpture, but the forces of these events and whatever else was going in my life led only to painting—and only to black paintings. Everything was very narrow.

KW: I had written next to this [KW notes] "children" because it strikes me that was a key, that you became a father and lots of things changed for you.

EMC: They did. My preoccupations about memory, time, and the temporary became more acute around the birth of Gabriela—they took a new embodiment. Suddenly, what was a preoccupation about time in relation to memory and the past became a concern for the present—I realized my time

with her was short. In a painting like *Gabriela I*, where the sketchy traces of a figure throw a baby up in the air, trust and risk rub against hope and fragility—against the temporary.

KW: The time aspect is also apparent. I thought of *Slaughterhouse-Five* and the idea that you can't stay in one place in time. It struck me that was what a lot of this series is driven by.

EMC: Time is the central issue, I think. Time is an insurmountable gap only negotiated through memory, remembrance, regret, longing, love. I think we are rarely blessed with the ability to see the present for what it is—all that there is.

KW: That took care of memory and mortality, which I had written down next to each other. Is there anything to the use of tar that is specific to the more philosophical elements of it? Or is it just a material you found interesting?

EMC: At first I was interested in the viscous problems—and history—of tar and feathers. Then I discovered the way it stained the oil colors and I liked this interference into my process and my wishes.

KW: That element of the tar is just something you have to figure out as you go along?

EMC: Yes, I never know how it's going to act up.

KW: That's what we talked about yesterday, about the colors and how they seep in there and how the new work is layer upon layer upon layer. Is that a material you're going to continue to work with?

EMC: I have gone back to using techniques I'd put away a long time ago—things I learned in the academic years, like glazing, which allows control of the way the tar stains.

KW: It seems to me there's a lot of importance given in the paintings to light and reflection, what reflects and what doesn't. So you're dealing with "I want the tar to look this way here and this way there," which leads into the feeling of the piece.

EMC: I believe in the possibility of painting, but I try to undermine it—to figure out its boundaries and how far it will go. Reflections destroy the image and often nudge the painting to exist near self-destruction.

KW: In the painting down here [*Thing and Deception*], there's an obscured word in there.

EMC: But I'm not trying to create a puzzle. The process destroys things—even for me. I can't tell you what's behind the paint. The process is a burial.

KW: Is there some sense of finding beauty in this material people think is the ugly smelly stuff you put on your roof or on the street?

EMC: Often what people call the beautiful is really the pretty. The beautiful is seldom charming. The tar surprises me, but I exert effort against its charm so that it doesn't become a whimsical thing. At the end, I like when the

painting pulls away from its methods and hardens into something inevitable. That inevitability is in the direction of what I'd call the beautiful.

KW: That kind of turns the classic "the good, the true, and the beautiful" on its head. I think that's one of the reasons people have some difficulty with contemporary art—they don't understand that ideas can change from Renaissance painting.

EMC: There are limitations to the measurement of art in terms of craft, particularly today when most people, including those in academia and the art world, are not very good at discerning skill. I cringe when I see what passes for academic drawing at the universities.

KW: Some people are going see your painting of outlined figures and are going to think of them as ugly or simple. My usual answer to that is you go in your garage, get some tar, and come up with that.

EMC: Maybe they will do a better job than me, but can they sustain it? Reproducing something is not difficult, but sustaining the intellectual consequences is very difficult. Minimal work often elicits the most stupid responses—"I could do that." But few can because leaving the black square alone is not easy. That's one difference between art and physics; in art, everyone is an expert.

KW: On the idea of art and physics: it seems to me that some of your art is almost rational inquiry as a scientific method. But you're asking questions that there's not going to be a specific answer—there's not going to be at some point a right answer. That has to be interesting for somebody who has a scientific mind.

EMC: Rationality is efficient and often the most useful approach to most questions, but there's a boundary beyond which it doesn't work. That's where art begins. Art is a leap in consciousness, but its workings are mysterious, unspoken.

KW: Which leads right to this—I have written down "Can art be explained." On some level the answer is yes, but if it's real art, I don't think it can really be explained.

EMC: If we mean a definite explanation then the answer is no. Of course, we can say a lot of things. We can even sound like we're really knowledgeable. But the nugget of what makes the painting great is not being talked about.

Some historians make me feel that painting is just a matter of knowing the references, the symbols. But that's not the case. Madonnas by Cimabue and Giotto may have the same iconography, but they are not very similar. The issue is that the key distinctions between those two artists don't make for good papers because quickly—within three sentences—one begins to sound like a fool. So it's better to talk about semiotics and iconography, which are safer.

KW: But you run yourself in a circle with that.

EMC: Yes, but it's a circle many people like.

KW: You stand in front of one of your paintings and you have an experience. But you can't turn that experience into "this is what this meant."

EMC: That's why I talk about my point of view, without attempting to explain the work. I speak about what motivates me.

KW: At some point yesterday one of us said something about people not necessarily being that interested in art. I was thinking about that and I think it is because they engage it and they don't know what they've engaged with.

EMC: I think that's true.

KW: Does that make any difference to you? Do you make this work for an audience or do you make this work for yourself?

EMC: A poet friend of mine talks of his desire for a "third reader"—we have ourselves and, usually, somebody we know that shares the work, but that third person is not easy to find. I think this is a good and modest way to think of audience.

   I would like for others to have a relationship with my work, so I try to bridge the distance with talks, interviews, books, and so on. I'm interested in that bridge. But there are restrictions and limitations to that. Access, often a unit of socially committed work, is not my goal. No one is more accessible or popular than Thomas Kinkade. But we know he's no revolutionary. All I'm trying to do is work I can believe.

KW: As you have come more into the art world so to speak, have you had to keep that more as a central priority? Is there the possibility of getting sucked into the business or becoming a star?

EMC: It's always a possibility. Corruption is always around the corner and I don't feel like I'm above it. I keep reminders everywhere in my studio and I try to look at alternatives to the lightness of the art world. Also, I try to make sure that my kids don't see a "sell out" when they look at my paintings. And to make sure of that sometimes I have to go against my own hand and the people who feed me.

KW: Eventually those lines intersect, and it could get real ugly, real fast.

EMC: If one is lucky enough to have any type of success, every new offer comes with dangers and with possibilities, and it's not always easy to tell which is which.

KW: You do photography, sculpture, and painting. Do you expect to continue that?

EMC: I'm interested in the dislocation of my own expectations. I don't want to know myself as a look. Instead I want to get closer to the consciousness doing the looking, and in that it's helpful to have the painting collide with the photograph, with the sculpture, with the words. That's what I like about Beuys—the inclusions and the collisions.

KW: You've anticipated my last question—again.

EMC: Beuys blurred the line between art and life. Actually, I'm not sure if that's true—I don't know enough of his life to know if it gained something from the art. In any case, he has been an important influence on me.

KW: It's probably as much attitude as it is imagery. The accident, the idea of "here's what it is," the life/art no separation, those things come through whether they're explicit in the rainbow over there to a person who wouldn't know Joseph Beuys from a box of rocks.

Do you feel like you're at an interesting, pivotal point? With your two kids now and your life going that way and your art profile increasing and your art changing? Do you think about that explicitly?

EMC: Yes. In retrospect it's easier to say, "That was an important turn of events," but it's more difficult to realize what's happening in the present. I've spent the last year and a half trying to figure out where to move. That idea of a move is really a question of what kind of life do I want to have in relation to my family and my work.

*The October Cycle*, as Dan [Daniel A. Siedell] highlighted in his essay, was a turn in the work. Superficially, it shares qualities with work I did before, but it's definitely an evolution as well as reinvention. It's almost as if I thought I was a different artist.

KW: I think with a lot of artists that would be the case. You can see five different artists that shared the same body.

EMC: I would like to always remain an amateur, keeping my freshness like Marsden Hartley—"I'm just kind of getting it now."

KW: Otherwise, you would be commercial, or whatever word you want to use.

EMC: When the market is primed, it's easy to become a product.

KW: And you're this far away from Thomas Kinkade.

EMC: You're already Thomas Kinkade—it just looks different. I think right now there's a lot of money in the art market, more than there ever was. That has put a lot of pressure on artists, dealers, and curators. The avant-garde has given way to novelty—fashion and shock are the qualities sought by society people.

KW: There's no "there" with Damien Hirst. I can take you to East Campus and show you every one of his dissected animals that they've had out there for seventy-five years. There's no avant-garde. There's no Steiglitz Circle anymore. But people don't want to give up on that.

EMC: Because there's a lot to be gained by keeping that idea alive. The rebellious gesture has great appeal for the establishment. Art rounds up the universe of fur coats, board meetings, and cosmetic surgeries.

KW: To me that's where it becomes interesting, how art deals with this corporatized society. In many ways, your paintings over there don't fit real well—they're not shocking, they're not pretty, but there's an essence, a

meaning you engage with those pictures. I'll see some artists do that, but I see most have just sold right into that system.

EMC: This is the sad way of things. That's why one of the most exciting aspects of my visit here was to look at the [Albert] Pinkham Ryder in the next room. Here and there one can still find something of substance. There are people out there—probably a relatively large number—that haven't bought into the diminished expectations of our times.

KW: I'll give Jeff Koons this. He saw that and said, "I'm in."

EMC: Oh, sure. He's in.

Studio,
Los Angeles,
California, 2003

## 2003    From Twelve Thoughts on *The October Cycle*

My work consists of poems, paintings, photographs, works on paper, sculptures, performances, and writings. My process owes as much to recent artists like Joseph Beuys and Marcel Broodthaers as it does to earlier artists such as Albert Pynkham Ryder and Ferdinand Hodler. My approach to art relies on my interests in science, philosophy, and literature. Although I began to paint early, I intended to become a scientist. It was through Schopenhauer and Wittgenstein as well as Melville, Borges, and Paul Celan, none of whom are artists, that I realized I wanted to be an artist.

*The October Cycle* is an extended metaphor exploring the relationship between the seasons and the transitions in human life. The emulsified

*Originally published in* Enrique Martínez Celaya: "The October Cycle," 2000–2002 *(Lincoln NE: Sheldon Memorial Art Gallery and Sculpture Garden in association with Marquand Books). Also reproduced in* Enrique Martínez Celaya: Poetry in Process *(Boulder CO: CU Art Museum, 2004).*

tar on canvas combined with oil paint and solvents makes a surface with colors ranging from blacks and browns to warm, rich tones of amber and rose. These sparse paintings do not read as somber or funereal, to me. The imagery (trees, the human figure, falling snow) emerges as notations of experience—as traces.

The paintings begin as emulsified tar on canvas—a material plagued with accidental history and an unpredictable capacity to interact with paints and solvents. Over these surfaces, the drawn, or even painted, imagery seems like notations. The paintings, works on paper, and poems that are part of *The October Cycle* were started a few months before the birth of my daughter and completed just before her first birthday.

The paintings are in dialog with poems, the first of which is titled "October," originally written in 2000. Simultaneous with the creation of the artworks and the poems, I worked on a book called *Guide*. The book, part meditation and part fiction, is structured as a conversation between an old Franciscan and myself, as we drove north along the spectacular California coast.

Originally, I thought of naming the series Boatboy. Boy? Vessel? Memory-Consciousness-Container? Who or what does it carry? The name changed but the preoccupation with Boatboy is still in the paintings.

Paintings are a testimony of having lived (not always a strong testimony).

Maybe *The October Cycle* is not something, maybe it is a hole. A blind spot.

If Thomas were writing, he would say:

As human beings we're always vulnerable amid the uncertainties of life, and no manipulation of our external situation can protect us completely from the possibility of sorrow; only internal peace can bring us relief.

Studio,
Venice Beach,
California, 2001

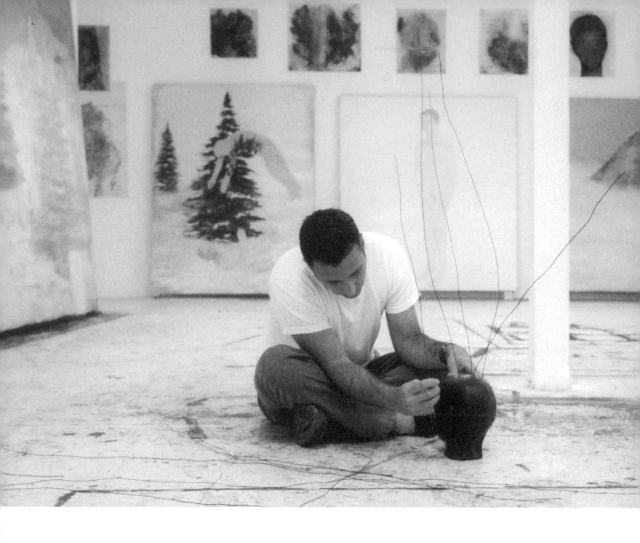

Los Angeles,
California, 2003

2003    ## Letter of Resignation

I am thankful to Pomona College for the opportunity to teach here, grow, and meet good colleagues and students along the way. For people like me, who are not pleased with the condition of the art world, teaching is a great opportunity to make a difference.

Unfortunately, some universities see the arts as a civilized offering mostly intended to round up future doctors, engineers, lawyers, and scientists. I hope you can keep Pomona away from this shortsighted and dangerous view. I think it would be better not to have art in universities if all we can encourage is dilettantism. The experience of art is the antithesis of dabbling. Instead, it demands that we surrender fully as we struggle to eliminate conventions and limitations. In art, there are no shortcuts, no getting-a-flavor.

*Excerpt from a letter EMC wrote to Pomona College, Claremont, California, upon resigning from his position as associate professor of art.*

My students have been intelligent, academically gifted, and capable of understanding post-structuralism and mathematics with ease. But courage, desire, risk, and belief have been scarcer. I hope future admissions can put more emphasis on these qualities. During my tenure here, I have seen a few dozen students take the difficult road of honest work. Most of them gave up after a while, but a few continue to struggle despite many failures and very little rewards. These are the ones we need.

The strength of an institution depends on its traditions, its students, and its faculty. The latter needs to measure up to the highest standards if we are to trust our system. Genuine quality is also what we need. There is something very dangerous, cowardly, and unproductive behind our complicit acceptance of anything less than great. The lack of excellence we see around us is not a justification for our retreat. Instead, we must pursue, without compromises, the best teachers for our college. There should be no room for mediocre faculty at a great institution. I recognize mediocrity is not always apparent. I encourage you to be on the lookout for those who camouflage shortcomings and those who through intimidation neutralize merit evaluations. But above all, beware of faculty with weak character and clouded standards who are willing to put their seniority and clout behind mediocre appointments to satisfy private agendas.

Studio,
Los Angeles,
California, 2002

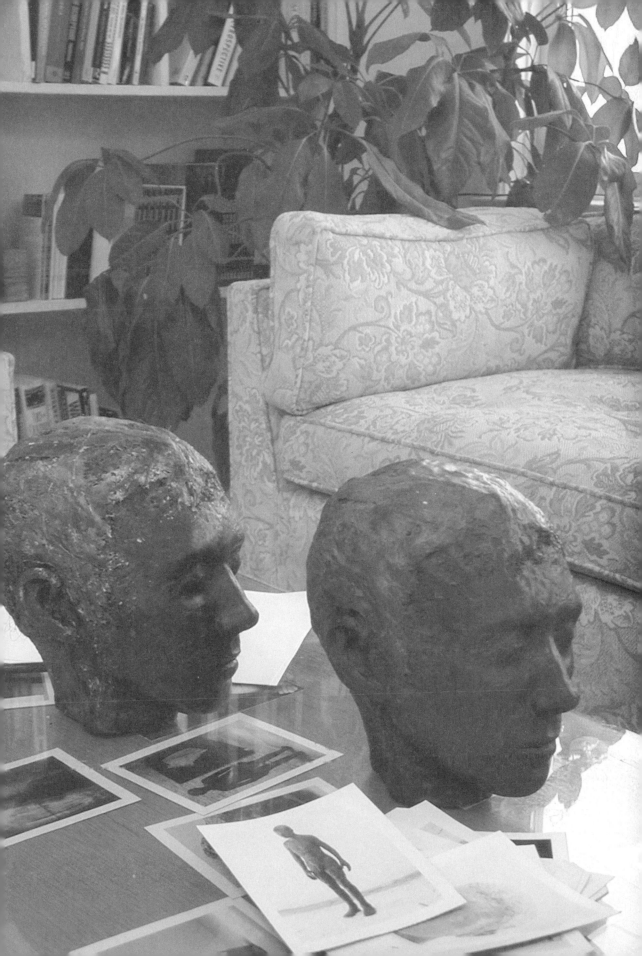

# 2003 From a Letter to Lisa Tamiris Becker

The following compilation represents my first attempt at showing the full range of my interests as well as the interconnection between objects, ideas, and writings.

Nothing is complete, nothing definite. Just some pointers toward something that seems relevant.

As you can see, the role of the books and the writings is very central. Also, I feel strongly that the books I have produced—Beuys, Baudelaire— through my publishing house, Whale & Star, are part of my work and the way I interact with the world—my take on social sculpture and community involvement. The immediate concern that comes up with the strong presence of words is, How do we show them in a museum? Or better said, How do we show them well in relationship to the rest of the works? So far, I had not worried much about this question, but it seems it's going to dominate our thoughts as we move on.

The works presented here are in near chronological order but not exactly so.

*Parts of this letter were also published in* Enrique Martínez Celaya: Poetry in Process *(Boulder CO: CU Art Museum, 2004). Lisa Tamiris Becker is a curator and director of the Colorado University Art Museum in Boulder, Colorado.*

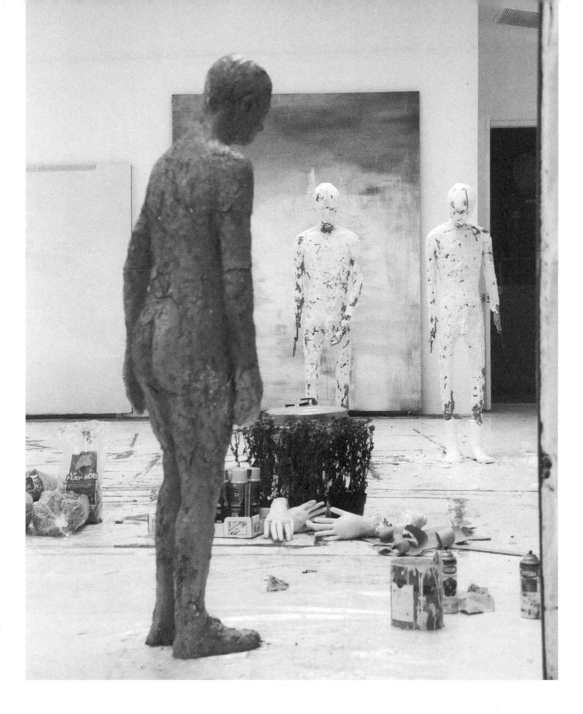

Los Angeles,
California, 2003

Refrigeration
facility, Brea,
California, 2004

From a Conversation with Roald Hoffmann

Enrique Martínez Celaya: It's not necessarily a contradiction, but it's none-theless surprising to find so much optimism in someone who spent his childhood in fear. What allowed you to overcome the gloom of the Nazi atrocities and the killing of your father?

Roald Hoffmann: Simple survival, Enrique. There seemed to be such an urge to get on with life among my family and others. People married right after the war—my mother married another survivor—and had children at a record rate. I think even as a child I felt that surge of life around me. Was it not in some way like that for the Cuban émigrés in this country, for your people?

EMC: Yes, I think it was a similar experience for my family, but unlike the Holo-caust émigrés some us felt ambivalent about what was left behind. For some, the Revolution was a tragedy that destroyed Cuba. For me, the real tragedies were the separation of families, the loss of continuity, the displacement of language, and the irreversibility of the events that follow leaving one's country. Probably because of these, I'm more concerned with

*Originally published in* Enrique Martínez Celaya: Poetry in Process *(Boulder CO: CU Art Museum, 2004). Roald Hoffmann is a poet, philosopher, and the 1981 Nobel Prize winner in chemistry.*

the consequences of loss to the individual, and less so with broad political statements. To be an exile is both a common thing and a profoundly specific existence. Do you consider yourself an exile?

RH: No, not really. I was an immigrant to be sure, and by virtue of that forced to learn ever-new languages, to be an outsider, a watcher. But this was also consistent with being an only child for seventeen years. Not a lonely child, but one who learned to be alone.

EMC: When did you realize that you had a gift for chemistry?

RH: Sorry to disappoint you, in two ways. First I don't believe in gifts for chemistry, or, for that matter, for poetry, or for politics. Do you hear ever of any children who write great poems or are super chemists or politicians? Math and music and art are different. . . . For these it looks like you have to have talent, there is precocity.

Second, I fell into chemistry by mistake, starting as a premed, then getting up the courage to tell my parents I didn't want to be a doctor. But not having enough courage to pursue the world of humanities opening up around me, I learned to love chemistry. It's just wonderful. I think I was not sure that I was good in chemistry until my very last year in graduate school, when I was twenty-six.

EMC: I know that your work at Brookhaven National Laboratory [a government research laboratory on Long Island] was important in keeping your interest in science. Brookhaven also fueled my own interest in physics. I worked with dye lasers during the day and went jogging around the lab in the evenings. The lab was a good place to learn and be alone. I will always have great memories of those summers.

RH: Oh, it was wonderful to get on a bicycle from the Cosmotron—what a name!—and rush the sample down to the lab. I was carrying a thousand atoms of carbon-11, and when I got to the lab, there were only five hundred left! That was magic.

EMC: What did it mean to win the Nobel Prize?

RH: A joy for my family, and for the Jews from Zloczow who survived. A sadness when one thought of so many children who didn't live. We cried, I cry, for them. It meant a lot too because my wife was Swedish, and I knew the culture and the language. In chemistry, it didn't matter much—you know, our field values what we do right after it is done. The Nobel Prize comes long after community recognition.

EMC: You have described the language of science as a language under stress and therefore poetic. Could you tell me more about this?

RH: The practice of science demands precise meanings, which must be defined in beautifully imprecise words. Mathematical equations and chemical structures are required to be explained in words. All the time, new concepts, begging for new words, force themselves on us.

EMC: What about the importance of aesthetics in science. Is the concept of beauty of significance in science?

RH: The concept of beauty is extremely important, even as you're not allowed to talk about it in our stock-in-trade, the scientific paper. There's an associated problem in that beauty gets confused, especially in the minds of reductionist physicists, with simplicity. So some say, This equation must be right because it's beautiful, simple. But the world is beautifully complex, and the problem is how to find beauty in messy complexity.

EMC: Faced with complexity, the hold of a simpler world is hard to resist—a simpler world where everything can be resolved with solutions that are familiar. Where everything that looks different can be reduced to something I already know. Perhaps, there are only two kinds of philosophical approaches: looking for sameness in things that look different and looking for difference in things that appear the same.

RH: It's one of the great dualities, perhaps the most important one. And, subconsciously, the question of identity powers chemistry. This is why I entitled one of my books *The Same and Not the Same*. When I was younger I was more inclined to see the likeness in things—using one theoretical approach to explain all molecules. As I got older, I found ways to favor difference.

EMC: Do you think the removal of mystery a condition of science?

RH: I think so. Science is a process of demystification. But not desacralization. One finds new, wonderful, deep things.

EMC: Discoveries that enrich your relationship with the world.

RH: Yes. Knowing how a hawk's wings work aerodynamically adds to admiring its soaring flight. Science does make you think of intrusive tests of understanding—if I want to know how this works, let me trap that molecule, perturb the system in some way. This intrusiveness is sometimes problematic.

EMC: When is it problematic?

RH: When it is overtly invasive, as in dissection [I said I escaped being a doctor . . . ]; even when that may be the only way to learn how things work. It may also be that intrusive science encourages a too mechanistic view of the world.

EMC: Perhaps science is at its best when it keeps mind of the whole while working the part. But even accounting for its shortcomings, isn't science an intrinsically good bridge between nature and mind?

RH: A most natural bridge, uncovering how nature works. But does one need science to ponder a sunset or think about olives and their need to be cured?

EMC: Is your relationship to the world different as a poet?

RH: Sometimes. I let nature, holistic as it is, come in. I don't find science a way to express myself about emotions, love and grief, loss and gain. Poetry

can be like science, observational. But more than science it can be reflective.

EMC: I long for holistic reflection, but most of the time, I find myself working with fragments of experience.

RH: That sounds like a scientist at work!

EMC: An uncomfortable scientist . . . for me, the only thing that seems to reconcile the whole and the fragment is art. In that unity I begin to find what others describe as spirituality—like in Celan's poetry. Do you find spiritual content in chemistry?

RH: Sure, beautiful molecules, intricate functions, the splendor of variety—substitutions. The way a synthesis could reach a goal, the intuitive leaps in a structure determination. The logic of catalysts and intermediates. Just knowing how things work.

You've asked me, Enrique, about the spiritual in science. Let me invert the question: if it is a given that art is spiritual, where is the material in it?

EMC: It's not a given—especially not in the contemporary climate. For many, a claim of spiritual content in art has become a sign of confusion or obsolescence. These arguments often come from a mistrust of the possibilities of art compared to other disciplines, and it seems that their proponents would like art to do what science, philosophy, and entertainment are already doing well. I don't think there's anything to gain from this insecurity. For me, where these other disciplines end or fail is where art begins. Once we depart from this point, there is little guidance and we have to engage things that resist explanation. And that's all we can say about that.

Your question about materials is an interesting one, because it's very related to what I am talking about. I think the role of the materials is to ground the artist by bringing the earth into the art. Without materials, like in a purely conceptual piece, one can become very free, but also very confused. You work in a theoretical manner—equations, models, simulations. What do you use to ground yourself when you find yourself lost in your head, confused or without direction?

RH: No different than when I feel depressed. I would focus on one thing or several, routine, mundane, and follow that through, see what a calculation gives. Even if nothing striking comes out, the existential act of working it through and writing it up would lead me out of confusion. You mentioned Paul Celan, who also appeals to me, in part because he comes from near where I came from. In one poem, called in English "The Straitening," he has a couple of lines: "Do not read any more—look! / Do not look any more—go!" These are also ways to overcome what pulls you down.

EMC: These lines are a demand to go back to the world, which immediately makes me want to ask you about models. Models are abstractions of reality

and science's paradoxical way to get intimate with the world by idealizing it. Do you see art and poetry also as abstractions of reality?

RH: Models in science are also part of the struggle to get closer to reality. So rather than abstractions they are realizations. So in poetry and fiction: not just an abstraction, but a creation of a universe.

EMC: But there are differences. Perhaps the biggest one is verification—the ability to verify one's theories or intuitions.

RH: It's just that the conditions or categories that one wants to "verify" are different. In science one touches with reality—of matter—all the time. There are checks. The grounds of poetry are the emotions, and the sounds—of a language. One has always to run checks on poetry, but its verification is in its feeling: "This sounds right." "This is a poem!" So one verifies poetry in the souls of the reader.

EMC: I find it refreshing that you speak of feelings so unself-consciously. For many contemporary intellectuals, avoiding talking about feelings is a sign of mental rigor.

RH: I know, Enrique. One day I spoke at a conference full of modern-day humanists and talked about the beauty of a molecule or a painting. I was told that beauty had died in the nineteenth century. And I had not heard of the demise!

EMC: I thought that as a scientist you were spared these annoyances. I am grateful that, unlike some other people, you have put your understanding at the service of communicating rather than isolating.

RH: Well, it's all about the importance of teaching, of reaching out across the spectrum of audiences, from freshman to other scientists. So why is it important for me to teach? Maybe something in my Jewish background— *avinu morenu,* "our fathers, our teachers"—those were rabbinical scholars back there. Maybe it's just caring that others understand. And not being afraid to introduce the personal—teaching as not distancing.

EMC: You have been teaching at Cornell for almost four decades. I wonder if you would have stayed on "the hill" this long as a poetry professor. I think teaching art and poetry is difficult because many of the limitations that the students need to overcome cannot be addressed within the university. Rather, they're limitations of experience and spirit.

Do you think that you could or would want to teach poetry in the future? And can the teaching of poetry and science aim at the same level of success?

RH: I could teach poetry, no one has asked me to—I rise to what's asked of me. Actually, I wish they would ask, my colleagues in the literature department. Teaching is an act of awakening in a person the ability that is in him or her to learn; the facts I teach are of little relevance. I feel I open doors, I empower. I think that is not very different from science and poetry.

People will write poems that they could not imagine—and neither could I—they would write. I love it when that happens, or when a light goes on in a chemistry student's eyes.

EMC: That act of awakening is one of the great rewards of teaching, but it seems to be more a function of subjective sensitivity to the needs of the student than anything else. So, it doesn't surprise that you are an effective teacher—you move between objective analysis and sustained subjective engagement with rare grace. I think this is partly because you don't seem afraid to examine the intangibles and immeasurable qualities of life that may intimidate some scientists. In fact, in your poetry you often go where the currents of subjectivity are most dangerous—to the most difficult moments in your past.

RH: I suppose I could try therapy for those [smiling]. I chose to write. The writing is empowering. When a poem works, when a phrase seems complete, I feel in touch with other human beings who make things. The writing, as difficult as it is, is a spiritual if not religious experience. And since I'm not conventionally religious, poetry and essays are a substitute. A way to the spirit.

EMC: The content of the poems in your recent book, *Memory Effects*, moves freely between history, personal memory, and nature as seen by science. Do you feel that there is something that unifies these ideas? I know that you consider a sense of unity important in scientific work. Is a sense of unity in your art important?

RH: At times I long for a unity. But I think that the only unity is that I have written these poems. They are dispersed attempts to deal with a world of love, science, memory, loss. And laughter. Perhaps there is an underlying unity—in my science and in my attempts to do other things. This is a belief that everything in this world is connected to everything else. I think it's that way for many poets, for instance Pasternak.

EMC: Pasternak wrote, "Creation calls for self-surrender." This requirement of surrender is one way in which writing may be different than chemistry. Perhaps you want to be known in a way that you can't be known through science—without protection.

RH: Well, part of the bargain is that I do reveal more of myself if I write poetry. So I certainly have to be brave enough to do that.

EMC: Do you think that your fame as a scientist limits or expands the appeal of the poems?

RH: I think others have to answer that. Occasionally, I know I worry too much about getting the science right in a poem, as if that is what mattered most. I think I'm worrying about my colleagues looking at my poems, criticizing them. But as long as I'm honest to the science, I'll be okay.

EMC: In my own artistic career, my few patents and publications in science have been sources of interest and a rare currency in a market constantly search-

ing for something special. Do you ever feel that your fame as a scientist may create an aura around the poems, which prevents an honest read, or worse yet, make the poems into curiosities?

RH: Perhaps, in small part. As far as I can tell, submitting my poems on chemistry department stationery has no effect at all on their being read or accepted. The poems about science do a little better in getting accepted than the others. I don't think they're better. So maybe they have some curiosity value.

EMC: What is poetry giving you that you can't get from science?

RH: The answers of science, as beautiful as they are, I see as answers to a set of questions that admit only of delimited answers, of solutions. But much of the meaning of life, the questions we face, are in a way impossible—they do not hold open the promise of solution, only of resolution. And that for a short time only. Don't you feel something like that in your art?

EMC: I would like to be satisfied with the little I know, but I haven't been able to give up my desire for solutions—for answers—to those fundamental questions that you speak about. I approach my work as a way of clarifying life. For Kant, the first condition of art is that it is disinterested, but for me, art is connected to need.

RH: Well, Kant and much aesthetic theory is off here, in stressing disinterest and not allowing utility to enter a judgment whether an object is beautiful. I think art comes from deep interest—involvement—with the object. And utility can be transformative.

EMC: Yes, and utility can also guide what can and cannot happen within the work and in turn define the way it looks. For me, the "face of the work" is more or less defined by some ethical criteria that are not distinct or separable from beliefs I hold in the rest of my life. For you, I think, form is more organic.

RH: The poems each take on some form. Sometimes it is simply that what I have to say is prosaic, or emerges as such, and I need to fragment it into lines, gaining strength from that. Every poem just seems to generate its own form. I suspect it is similar for painters.

EMC: Each artwork does exert some pressure on its form, but, for me, that pressure would have to be great in order to expand the ethical band in which the work can exist. Although I think that way about my poems as well, in painting and sculpture, matter is very influential.

You mentioned earlier that in science one touches with reality all the time. I understood this to mean that matter is a constant reality check for the scientist. And I think it is the same way for many artists. Practically speaking, even the time that it takes to master materials influences form by narrowing the typical range of artists.

Which makes me wonder if we could make a similar sort of comparison between the typical range of the experimentalist versus the theoretical scientist?

RH: I think so. Though there is much of simple labor in theory. The ideas somehow get solid, and so do the figures and pictures that a computer gives you, and the mathematical techniques one used to represent reality. I think there is a grounding even in the realm of theory, in ideas.

EMC: You have spoken about the value of poets and poetry in a society enamored and intimidated by science. As a scientist and a poet, you're in a privileged position to see the similarities and differences between them. One telling difference, I think, is the way they encompass progress.

Your own scientific contributions will be superseded as more research unveils new knowledge. But no one will supersede your poems or their spirit—they can't be engulfed or improved by anyone else. The understanding of electricity and magnetism is better today than at the time of Maxwell, but we couldn't say the same thing about art or Manet, because art doesn't evolve in the way science does. I think art has no history; it's all a continuum.

RH: You're right, Enrique. This is one of the differences between art and science. Even as I believe that science creates, as much as it discovers. So what does art discover?

EMC: Art discovers the artist before dissolving him. Sometimes, it also reveals what experience may be in its fullness. At least these are my incentives and what keeps me looking—what keeps me intrigued about my future work.

Roald, for someone that has given form to electron orbitals and days without mercy, what could be left to do—what's in the future?

RH: Oh, so much writing. I want to write about telling stories in science, about my land between poetry, philosophy, and chemistry; I want to write plays, of collective and individual guilt, of Marie Curie and Paul Langevin. I want to write poems which are not sad; I want to write a libretto to an opera about Mme. Lavoisier; I want to see the tree growing through the temple in Angkor Wat . . .

Sculpture in process,
Los Angeles,
California, 2002

*Schneebett* in
process, Compton,
California, 2003

## 2004   *Schneebett*

*Schneebett* (Snow-bed) is the third and final part in the Beethoven Cycle, a three-part project exploring the final period in Beethoven's life. The work, which examines authenticity and regret from the point of view of the bed-of-death, is also a catalyst to confront exile and foreignness.

*Schneebett* is a room in memory. Probably not our memory, but the room's own memory recorded in the patina of objects and replayed in each smell and sound. The point of departure for *Schneebett* is the room where the dying Beethoven spent his final illness and ultimately his last hours. At first, I was interested in the hero as a bedridden man with sores on his back, but, over time, my interest shifted to self-confrontation mediated by a bed that evolved from a place of surrender to a floating white island between heaven and hell.

It is important to say that this is not a re-creation of any sort but rather a primary creation. *Schneebett* is an invitation to walk into a memory—a memory perhaps all the more haunting because it contains the anxiety of death.

*Schneebett* is also something more concrete. It is a space with some objects in a room at the Berliner Philharmonie and, as such, it is also a

*Originally translated into German and published in a booklet for the presentation of* Schneebett *at the Berliner Philharmonie, Berlin, Germany, October 17, 2004–January 1, 2005.*

monument of futility—a "diorama" where the scene depicted is so far from Beethoven's or our specific confrontation with loss and life that whatever feelings it evokes are necessarily projections. Projections magnified by the nearby music and shone upon inert materials, not necessarily to unveil a room in Vienna in 1827 but more likely our own room.

During the creation of this work I struggled with the question of whether or not something can be learned from the death of others. After all, the death of another, Beethoven in this case, is always learned externally, so not in a genuine sense. However, I came to think that, like Tolstoy in *The Death of Ivan Ilych*, I was not constructing an allegory or an illustration of someone's death, but a work of art that departs from an examination of forces already in the act of living.

For me, Beethoven's room is held in tension between the bed and the window—a horizon of disclosure rapidly limiting its offerings. From his bed, Beethoven must contend with his own transientness against an impassive—and nearly permanent—sky. The window is the world, which frames the visitors, the music, and the landscape at an unreachable distance—a distance of space and, especially, time.

The rooms of *Schneebett* are rooms of silence. Rooms without music. It's proper that the installation sits deep within a space, a building, built for music. The friction between absence and presence of music at the Philharmonie, ultimately, is the spirit of the work. *Schneebett* is, at least for a music layman like myself, the expectant and remorseful silence between notes.

The refrigeration
system for
*Schneebett*, 2004

## 2004 Notes

February (Fort Lauderdale FL). You may read other things about *The October Cycle*: but you shouldn't trust them including whatever I've said. *The October Cycle* is a failure, those of you who dislike this work already know that and those of you who like the work should see to quickly understand its futility.[1]

October 16 (Gulf Stream FL). To move on I have to visit the boy in Caimito. The light here, the clouds which always hover over the horizon, all this is the landscape of melancholia. Fundamental. Lost. The virus-machine. Some think of this landscape of melancholia as fancy. There is so much to understand. A1A—biking along the ocean reminds me of Caimito. Why is the horizon so significant?

Berlin to Gulf Stream is an interesting transition. But not culture. *Schneebett* showed me how important art and music are but how insignificant culture is.

**NOTE**

1. Transcribed by Daniel A. Siedell from handwritten wall text at the reinstallation of "The October Cycle 2000–2002," Museum of Art, Fort Lauderdale, Florida. Published in Siedell, "Enrique Martínez Celaya's *Thing and Deception* (1997): The Artistic Practice of Belief," *Religion and the Arts* 10/1 (Spring 2006).

*From EMC's sketchbook notes.*

Los Angeles,
California, 2004

*Portrait of
Leon Golub*,
Delray Beach,
Florida, 2005

Letter to Leon Golub

Your drawing is now at my studio, and seeing it reminds me of you and our friendship. It also reminds me there is more to the art world than the funhouse we have talked about. Your gesture was very generous, and I will always remember it.

*The Acrobat* is a good metaphor for all of us. Twisting. Trying to find something to hold on. The blotches of black. The big flips. How many stick the landing? Not me. For the most part, I am barely trying not to make it embarrassing.

Unfortunately, the picture we took together at the restaurant did not come out. We will have to take another next time. Give my best to Nancy.

*In the spring of 2004, Leon Golub invited EMC to his studio to select any drawing he wanted as a gift. Leon Golub (1922–2004) is one of the leading postwar painters whose works are in the collections of the Metropolitan Museum of Art, the Whitney Museum of American Art, the Museum of Modern Art, and the Tate Gallery, London, among others.*

*Boy with a Skate*
in process,
Delray Beach,
Florida, 2005

From an Interview with Richard Whittaker

**Richard Whittaker:** So when you were apprenticing to a painter, how old were you?

**Enrique Martínez Celaya:** I was around ten or eleven.

**RW:** Would you talk a little about your apprenticeship?

**EMC:** At first I did many still life drawings, pastel portraits, and copies of Leonardo's paintings—not very well. As I got older that interest in academic drawing continued, but it took the form of narrative paintings—allegories of what was happening around me. I still have a few of those paintings, and I like some of them.

*Originally published as "A Conversation with Enrique Martínez Celaya: Self and Beyond Self," in* works + conversations *9. Richard Whittaker is the founder and editor of the art journal* works + conversations *and is the cofounder of the nonprofit Society for the ReCognition of Art. Whittaker holds degrees in both philosophy and clinical psychology, and his photography has been published in the* San Francisco Magazine, *the* Sun, *and several other magazines.*

By my mid-teens, expressing my feelings didn't seem good enough anymore, so I devoted more time to physics, which was appealing, partly because it gave me access to an emotionally simpler world. Physics held the promise of an orderly life.

The summer I turned sixteen, I worked for the U.S. Department of Energy and built a laser. But I continued to paint and read and was fortunate that at my high school everyone was encouraged to explore all disciplines.

RW: What was this school you're describing now?

EMC: It was a school founded in the 1920s by the University of Puerto Rico as an extension of the College of Pedagogy. By the time I was there, it had evolved into one of the best schools on the island.

RW: What a great stroke of luck!

EMC: Yes. It was. My life would not be the same had it not been for that school, especially its bully and its principal. Back when I enrolled, it was a custom for the upperclassmen to grab new students by the arms and legs, like pigs, and humiliate them by forcing their butts onto a pipe located in the middle of the courtyard. I got the treatment three times, so I modified a kitchen knife to stab the ring leader, a bully named Chelo, next time he tried to bother me.

Luckily I laid the knife on the desk of my high school principal before I could use it. And that exchange, which could have gone many ways, started a relationship that lasted the whole time I was there.

RW: With these gifts, sometimes one feels the wish to give something back.

EMC: Yes, when I started teaching, one of my motivations was to give back some of what I had benefited from; to put myself out there, to be honest and to be interested.

RW: You're an art professor right now, although you've tendered your resignation—something I'd like to ask you about later—but a basic question arises; you must have thought about this: what is of value—potential value—in the pursuit of art and art making? I don't see our culture as particularly supportive of the fine arts, and yet you are teaching that; and that is what you yourself are deeply involved in. A big question.

EMC: Many people want to change the world in a big way, but that's difficult to do in art or in teaching. Broad political work is better done in the streets. In the classroom, or with an artwork, the transformations are one at a time. And if in ten years you touch twenty students, that's great. Maybe some of them will push forward and make something out of it.

RW: Driving out, I was thinking about this thing we call "art." We say "art" and have an idea, vague, but an idea of what that means. Art is something, right? But the concept of it we have today is not old, historically. What? Four or five hundred years old?

EMC: About that, maybe less.

RW: So we read that whatever we now look at and call "art" was totally integrated with some societal, institutional form in the past. Then, at some point, the phrase appears, "art for art's sake," which, in a way, defines this separation—that art stands alone. Can art really have some kind of meaning without integration in some other structure?

EMC: I think this separation you are referring to began with the Enlightenment; the proposition that art must be disinterested should be reconsidered. Only art for life's sake makes sense to me. And by that I mean art as ethics—a guide clarifying one's choices and life.

RW: You've made a connection there between ethics and the process of clarifying for yourself, your own life. I've never heard it put that way before. Ethics and coming to a clearer understanding of oneself. Can you say anything more about that connection?

EMC: I don't see any useful distinction between understanding of oneself and understanding of one's duty. I think that much of what we are shows up in how we view what's right and wrong and how consistently we live by that view.

RW: "What is the Good?" In a way, that's the foundational question, as I hear you. And it's not an abstract question, right? It cannot be an abstract question. When the question becomes abstract, when people speak of "the Good" and there's no connection with a real person, it becomes dangerous, it seems to me.

EMC: Being ethical away from the world is easier than in the world. I think some people see the path of abstraction as pure, uncompromised, but it could just be avoidance. Artists who insist on removing their work from human struggles take a tidy path, which seems especially wasteful for those whose lives are in turmoil and confusion.

RW: Intuitively, it seems to me that among artists there's some form of the wish—if not always consciously—to find what truly comes from one's self. The need to find my own thought, my own step, my own perception. It's a profoundly difficult thing to do, really to come to "my own step." But when one has that experience, does that not, in itself, give meaning to one's life?

EMC: To find one's self in a gesture or in an artwork, even if vaguely, invigorates life with a sense of purpose. Of course, these discoveries don't happen every day, but struggling against one's limitations is often good enough to give meaning to one's life.

RW: There's always our egoism—I don't mean that pejoratively, it's just a fact—but intuitively, one knows that's not the whole story of "who I am." So isn't it confusing to say, "What the artist can discover is him- or herself?" Maybe that's not so clear. Would you agree?

EMC: Much confusion comes with the "am" in "who I am." There's much in oneself

that has little to do with individuality, per se, but which instead is part of a much larger continuum—to discover one's self is also to discover one's connection to the world. As one recognizes these connections, a prison sometimes becomes apparent; the prison of what we've established or imagined ourselves to be. For instance, wouldn't it be nice if something were to come out of my mouth that I do not expect? Of course. But it's unlikely.

RW: Oh, yes. Now the students at Pomona College are a pretty high-level group, and I don't know if they're representative of this, but I get the impression that among young people today, and in the culture at large—do you find that "deep questions" are thought to be unacceptable? They're cornball, or something. Do you know what I'm getting at?

EMC: Yes, big questions can be exposing and ungraceful and many students stay away from risks like that, and if a student is not willing or capable of taking risks, there's not much one can do as a teacher. Nothing that matters can be solved with "put more paint on the canvas" or "let's talk semiotics." But it's not just them. I think we are evolving into a society afraid to pose certain questions because we're too embarrassed about the implications.

RW: I was reading a post on an e-mail list where discussions often got pretty interesting. In a philosophical exchange, one fellow wrote, "Courageously—grin, grin, face burning with shame—I'll admit that I'm interested in meaning." It's a curious thing, this cultural milieu where one would feel this sort of apology is necessary.

EMC: The average person still says, "I'm interested in meaning." It's only among the intellectual elite that the need for meaning has become a weakness.

RW: Sometimes it seems there's almost an attitude of pride among the most rigorous reductionists: "I'm strong enough and smart enough to take it."

EMC: Many people are enamored with science's authority and want to make themselves into scientists of the arts and humanities, which mostly leads to fancy terminology, detachment, and those attitudes you mentioned. Of course, there are works, or thoughts, that are "too soft" because they have no emotional tautness or intelligence. But there are also works and attitudes that are "hard" in a very facile, predictable way. The look of objectivity—the arcane language, the pseudoscience journals, the hard expression in the eyes—only points to what science is not.

RW: Yes. Clearly, one sees this. That's well put.

EMC: I remember the first time I saw *works + conversations*. I was curious, but not very hopeful. As I began reading I was surprised by your courage, surprised that somebody was taking risks. I think you're going exactly where people need to go if they want to change things. But doing that requires a certain willingness to not wear the badge of the "cutting-edge" intellectual.

RW: That makes me think a little about the avant-garde. In the art world, being

identified as avant-garde allows the artist to feel located in the place of highest respect. Now I know that for quite a while the whole concept of an avant-garde has come under question. But there's still this tendency to aim for shock value, an old avant-garde strategy. This has long since become a convention of the academy. I think what you're saying has some relationship to this.

EMC: The idea of the avant-garde has become a convention of the ruling class it once disrupted. Now, the bourgeois collectors, institutions, and galleries are out there looking for the new, the different, and the shocking.

RW: That's amusing, but it's a very good point. I've said before that what would be radical and shocking nowadays would be something that's quiet and that doesn't call attention to itself, something that requires your time and attention. That'd be shocking. Do you know what I'm saying?

EMC: Yes, I think you're right. Anything that demands serious and sustained engagement is revolutionary today. We are in the age of entertainment. I don't think the last century will be remembered as the age of computing or nuclear power, but the age when entertainment finally took over our consciousness. Now, most other fields—art, politics, war—are defined through, and in relation to, their entertainment appeal.

Not even Orwell could have imagined that in our time, control and uniformity would be accomplished without the built-in cameras and microphones, but with family programming and by cultivating interest in all superficial things. And unlike *1984*, it's hard to see a way to rebel, because dissent is now part of the rules.

RW: *Dissent*—I wonder if there are other words, which would also be worth thinking about? That's a word that points you in a certain direction just like the word *subversive* does. But to *become more present*, to find something *more real*. The system doesn't care, one way or the other, I'd say. Language is problematic.

EMC: I understand what you're saying; it's uncomfortable to speak this way, but it's a battle against loneliness, against the dissolution of the idea—problematic as it is—of quality.

However, language is problematic. Every time I give a talk there's someone in the crowd who says, "Yes, I know exactly what you're saying." And as they continue to speak, I realize that they misunderstand me.

RW: Well, yes. I have to say I struggle with this myself in pretty much the exact way you describe it; this problem with language. In so many areas the available words are essentially dead. One searches for alternatives, mostly without much success. "The middle ground" for instance; it's not as dead as a lot of phrases, but still, it's burdened with dismissive associations . . .

EMC: . . . and it's always heard as some sort of compromise between the two sides.

RW: Exactly. And you know, there should be some pretty good associations with "the middle." The center. Balance. If you're off-center, eccentric, which in the art world, I suppose, is thought to be a virtue, it means you'll fly off in some direction. A high level of energy combined with a lack of balance isn't so good.

EMC: "The middle" is difficult. It usually rubs against the edge of language, which leads to confusion and misunderstandings.

RW: It comes to me that there is a word that bears a deep relationship with some of the things we're talking about. *Being.* Now that's a term we don't hear used too much. One thinks of Heidegger here. It occurs to me that when one is connecting ethics with the pursuit of art, as you described earlier, as a search for clarity, clarity of one's self first, would you not also be willing to say that it's also a search for *being,* for one's own being?

EMC: Yes, I think you're right; Heidegger's ideas are helpful in thinking about the connections between self and world.

RW: Yes. Anyone who loves so much of Heidegger's thinking, as I do, is dismayed by the Nazi connections, and yet I cannot reject the quality of his thought—so much of it. Do you ever feel hamstrung about that?

EMC: Not really. Our lives, unlike fairy tales, have contradictions that resist resolution, and to insist that these shouldn't exist is to invite falseness. Heidegger's mistakes and weaknesses don't cancel his contributions, even if some people try to argue that his Nazism was already brewing in his philosophy. I hope that the value of my own work is not measured by my human frailties.

Even more challenging than Heidegger, in this regard, is Wittgenstein. He wasn't a Nazi, but he was both saintly and cruel.

RW: Well, Wittgenstein pretty much reduced what we can say to *language games,* right? No deep questions need apply, I guess. But with Wittgenstein, there's this category of "that of which we can not speak." And he also said, "That which can not be said, sometimes can be shown." That is pretty interesting, don't you think?

EMC: Yes. And life, like art, is one way to show. Wittgenstein wrote about logic, mathematics, language, color, but the concerns that seemed most important to him—*ethics, belief, spirit*—he lived. And as a moral man, he struggled with himself and judged his actions by standards that he often failed. Maybe this goes back to the beginning of our conversation. To talk about ethics, to talk about what is good or bad is interesting, but somewhat useless, academic. To live life with integrity is the thing. And the purpose of art is to support and clarify that endeavor.

RW: That certainly does remind me that you've tendered your resignation—of a tenured position, too—at one of the best colleges on the West Coast. I wonder if you want to say anything about that?

EMC: It was a hard thing to do. My approach ultimately failed, and that is, partly, why I quit. I couldn't teach in the environment of the institution as it existed and be happy about it. To give up a tenured position in the fickleness of the art world is a huge decision and, possibly, a stupid one. But I felt I was moving in the wrong direction by staying there.

RW: This is not the first time you've made a big change like that. You were on the verge of taking your doctorate in physics and you made a big turn there, didn't you?

EMC: Yes, and that decision was especially difficult, because I knew it was going to hurt my parents. When I told them "I want to be an artist," I couldn't offer any assurances of success. I definitely felt foolish, careless, leaving the promises of my research at Berkeley. But I still did it.

RW: Maybe it's the only way. It brings me back to your concern with ethics; a life in which one embodies what one represents. Wouldn't you say that we face these questions and that we don't know the answers? It's necessary to take a step sometimes in order to find out.

EMC: Yes. And also it's an added motivation when the one direction has shown it has no answers. I might not know where the answer is, but I know where it isn't. To realize that there's no answer in something is an important breakthrough. Then it's just a matter of coming to terms with the personal sacrifices one has to make. There's nothing unclear in that. There may be pain. But that's different.

Refrigeration
facility, Brea,
California, 2003

## 2004    From a Lecture at the Berliner Philharmonie

I have approached art not as visual pleasure or creative whimsy but as a philosophical inquiry. This has not been the result of intellectual ambition but of necessity. In speaking to my mother, watching my daughter, or just looking at a tree in the light, I often feel I am missing what is most important about the moment, so I have sought the assistance of art. I see my work then as utilitarian.

I began looking at art as a way out of the confusion in my early teens, at about the same time I discovered science. While art was tied up with my life, science was like wearing a costume that made me feel less conflicted. I kept my interest in both, but while pursuing a doctorate in physics, I realized the questions science can answer were not the questions that were pressing on my mind.

At that time, the discovery of Joseph Beuys and Albert Pinkham Ryder were influential as guides out of the frame in which I have placed myself. They represented a landscape beyond science but didn't fall into the void of art for art's sake. Without understanding what I was doing, I sought to learn from artistic approaches where aesthetics were not separated from theology and ethics.

*Slide presentation followed by a question and answer section. Originally offered at the Berliner Philharmonie (co-sponsored by the Stiftung Berliner Philharmoniker, the Forum Zukunft Berlin, and the American Academy in Berlin), Berlin, Germany.*

The concerns of domesticity and violence led me to try to explore the territory around what we remember. I was not interested in my memories but in memory itself as a gap between who I was and who I am—as a gap between being and self.

In 1997 I traveled to Berlin on what was to become a very important trip. I was influenced by the writings of Paul Celan and I came to Germany to try to find him and to understand how collective longing affects a city. I photographed monuments, government statues and houses but my central subject became Hegel's tomb. In that tomb I also saw Celan as well as myself. It confirmed that something of mine waits somewhere in the past for me to come back.

After Berlin I began to construct environments of paintings, sculptures, and photographs where one of the goals was to have interactions between the individual objects. One of my first environments was done for the Burnett Miller Gallery, who allowed me to do whatever I wanted. The space was big, and I placed four seemingly disparate works: a transparent painting of a hand, a Cuban river painted on a figure sculpture hanging on the wall, twenty small paintings of hummingbirds, and a white painting of a head throwing up. I wanted for the works in the exhibit to collide with one another, hoping that through these collisions the visual aspect of the work would be extended or even cancelled. Once the visual is cancelled, the subtler aspects—a consciousness, a sensibility—could have been seen. Unfortunately, most people thought the Burnett Miller environment was a group show.

### QUESTION AND ANSWER SECTION

AUDIENCE: Why Celan? And, can you talk a little bit more about the indecipherability of the poem on the wall of the *Schneebett*?

EMC: I found that my feelings resonate with Celan's work. Through his references to the Jewish experience in Germany, I was able to deal with my own exile and displacement. I have felt, often unconsciously, that a direct exploration of the displacement of my family and culture could not be done at this time.

The illegibility of the work is incidental but maybe important. While reading the poem our shadow covers part of the words and the poem goes into darkness and disappears. This might be right.

AUDIENCE: Your art is always mediating between art and philosophy. Can you talk a little bit more about the dual role you have as an artist and a philosopher in your career?

EMC: When I was studying science, I thought—naïvely—that if I knew physics well I would understand the fundamental nature of the world. Of course,

I was wrong. When I tried to understand things that were not as concrete as the physical world, I realized I need fine distinctions, so I turned to philosophy to help me with distinctions. I read Nietzsche and Kant with a desire to have things explained better than I could explain them myself. Eventually, I gave up on that desire. Philosophy influences the way I make decisions, that's all.

AUDIENCE: Do you feel that your work is related to [Anselm] Kiefer?

EMC: I'm glad to be asked this question in Germany. In a similar way, in the United States people used to asked me if Rauschenberg influenced my work. I like Kiefer, especially the work from the 1970s, but the material, the embodiment, and the transgression of my work has a greater allegiance with Santería, the Caribbean religion. Growing up I saw images of the Virgin Mary bound with hair and flowers. I saw the heads of roosters caked with flies and decomposing near a tree. I heard the songs and saw the objects thickened with time and dust.

More than materials, what relates my work to Kiefer's is that he's also interested in words, in Celan, and in myth. But Kiefer is a historical painter and my own interests are related to the individual as he or she has always been. Also, there's irony in Kiefer, and I am not an ironic artist.

AUDIENCE: I find the material you use in your art very interesting. How did you find tar and feathers and what do they mean for you? And, the snow? Is it related to feathers?

EMC: I was interested in the history of humiliation of tar and feathers. In art, humiliation is often a reasonable place to start. The problem with these materials is that they have a fetish quality that can become sexy in its own right. That is why I started making photographs. I am interested in rubbing against the sensuality of the tar and feather pieces with the reference of photographs. Tar and feathers are all presence. I am interested in that duality. When I finished the *Schneebett* installation, I felt it was not complete. It was not authentic. I looked across the street and saw the Tiergarten and decided to bring it inside the Philharmonie. I picked up a few birch trees and threw them in the room. For me, the discovery of materials comes from exploration. I am interested in materials that have a history, like blood or vomit. Snow is remarkable also—there is nothing there. In the case of *Schneebett*, it comes from cool metal and air. This is a nice opposition to tar and feathers.

AUDIENCE: What does time mean for you? A memory of a room, how does that relate to the presence of the moment?

EMC: *Schneebett* is one embodiment of a possible final moment. Sitting on that chair might become an inducement for immediate action, which is where authenticity comes from—authenticity is the confrontation of being with what is.

AUDIENCE: What is the relation of your art to religion?

EMC: There is a thought from Wittgenstein, which I think is very applicable to my own experience; he said something like, "I am not religious, but I can't help but to look at life from a religious point of view." A religious point of view is that point of view concerned with mortality, morality, good, and evil. What is missing in my work is a particular organized belief system.

AUDIENCE: I am a little bit concerned by the modus operandi of a scientist compared to that of an artist. . . . I feel very often the way artists talk about their subject matter is very different than the way scientists talk about their subject matter. In that they always must be very precise and absolutely proven. Did you ever find a conflict between those two ways of looking at the world? And those two ways of working? And was that ever resolved?

EMC: Yes, I found conflicts. Science is elegant and seductive, but, after a while, it didn't seem right to leave my personal concerns at the door of the lab. As I got older this felt like a great luxury. Often art is described as a luxury and science as a need. But it didn't feel that way to me. There might be a disconnection between science and the questions of living. In the second part of your question, you were making a distinction between science and art. Yet, the good scientists I know and the good artists I know share a lot in common.

AUDIENCE: It is interesting that you talk about interdisciplinary things. I am actually a political scientist, and I am here with an artist. Some things you were saying—exploration of identity and of self and other—resumes with the field of anthropology and political science and especially if you look at the social formation of these things, the encounter between self and others and how we define ourselves as opposed to the other. I was interested to hear more about exploration of identity and formation of identity and how the two are juxtaposed and formed. How does that relate to the occupation of identity?

EMC: Identity has become a concern for many people in the arts. I have tried to make a distinction in my work, namely that the concern for identity is not psychological or anthropological, but philosophical.

Studio,
Delray Beach,
Florida, 2005

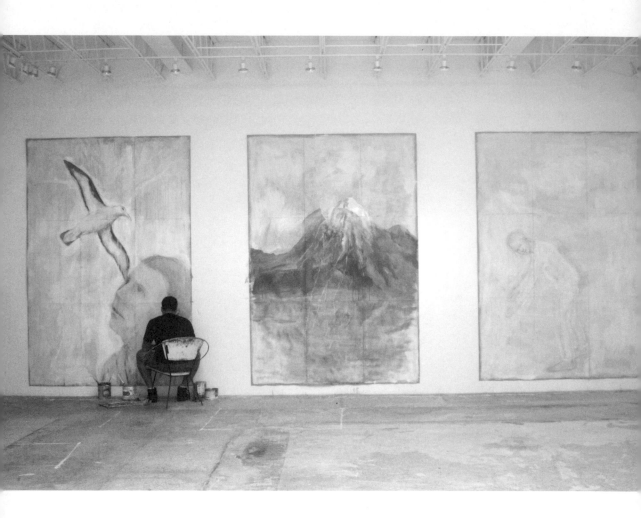

Studio,
Delray Beach,
Florida, 2005

Notes

March 24 (Delray Beach FL). What is the boy? The boy reconciles future
and past, the boy is the possibility of the man. Is the boy a religious paint-
ing? Where docs a cycle like "paintings of redemption" fit in the work
now?

I still consider the cycle a fundamental unit capable of revealing motions
that might be hidden in one or two works. My works seem to oscillate
between two different approaches—diagrammatic and "scene." When I
go too far toward representation I often feel a twist in my desire: I like it
and I don't.

As I think about it, the work I have liked the most is the recent three-
part watercolor which has simple drawings of the figure with a soft wash–
suggested landscape. Why? The color is very delicate on the landscape but
complementary—not softened. It is also diagrammatic but its multiple
"take" reaffirms a story.

*From EMC's sketchbook notes.*

## 2005    Letter to the Editor of the *New York Times*

I write regarding a review you wrote in September 2003[1] but that I read for the first time this week.

In it you refer to the "wholesale appropriation of past and present styles and ideas" followed by an interpretation of my photograph as some derivation of Ana Mendieta's work.

While I agree with your assessment of the frequency of appropriation, I believe you applied this judgment in a "wholesale" manner to my work—other than a country of origin and a few shared preoccupations I don't consider Mendieta's work at all. If you were to research my work, you would see its iconography is related to philosophical investigations, which have little to do—other than a superficial resemblance—to issues of identity and autobiography, as it is in Mendieta's case.

The reason why your review was particularly bothersome to me is because you lumped my work and my attitude with the very banality I detest, but the reason why I am taking the time to write to you is because I found in your writing insights and sensibilities worth the note.

**NOTE**

1. The review was published by Benjamin Genocchio, "ART REVIEW; An Ethereal World, Explored Breath by Breath," *New York Times*, September 21, 2003, New York edition.

Studio,
Delray Beach,
Florida, 2005

EMC and his
daughter, Gabriela,
Studio, Delray Beach,
Florida, 2005

2005    The Fuzzy Boundary: Science and Art

Before I begin my talk, I would like to touch on two points in response
to what has been said today.

If few people are naïve enough to expect artists to wear berets, many
are likely to consider art as an emotional or decorative practice rather
than a critical process, and these expectations necessarily influence their
educational perspectives and their views on creativity. So as we consider
the question of currency for the knowledge economy, I ask: What are
our goals? Who is the citizen we're trying to create? What is the society
we're trying to shape? I think it is worthwhile to keep our goals and our
prejudices in mind as we approach the question of effective education.
Education will not reach its potential if we insist on separating the spheres
of art and science.

*Originally presented as a slide lecture as part of a panel at the Education Summit, Hope Center,
Richmond, Virginia.*

I also want to address something that was said earlier about people being hungry and that being the main incentive for work. Hunger is usually an incentive, this is true, but I don't think we can artificially create it from a position of affluence—from choice. But it might not be necessary. I don't believe it is hunger that generates great scientists or artists. Many people work hard to get out of poverty—hunger fuels the struggle for a dignified living—but striving for something beyond making a living requires love. If you would like a student to continue to do math and to eventually be a Nobel Prize winner, like some of our panelists, she needs to love the subjects she is learning. And the teachers have to love what they're teaching. This is not a function of hunger.

Now, let me begin my talk, whose title is "The Fuzzy Boundary: Science and Art."

Before the Enlightenment, science, art, and ethics were part of a holistic view of knowledge. After the Enlightenment, prevailing philosophies aimed to separate these three spheres, but, fortunately, the rupture left porous or fuzzy boundaries that allow flow between the different endeavors.

The type of fuzziness that I'm talking about is not what is often described as interdisciplinary approaches, which deal with appearances—art criticism with the style of science, for instance. Interdisciplinary endeavors tend to have the look of science or the look of art or the look of ethics, but structurally they remain within their initial knowledge-sphere. I have an example here [referring to slide] from Rosalind Krauss where the difficult terminology and syntax aims to sound scientific, and to the right of her writing, we have Damien Hirst's *Mother and Child Divided*. In these two examples, the relation between science and art remains static; science being a mere scent of authority laid onto an artistic production.

Instead of these superficial engagements of art and science, I will point to a few structural and operational similarities between science and art that might suggest ways in which they support and enhance each other.

The first of these is the problem-solving nature of creativity. The serious artist, like the scientist, relies on previous discoveries, logic, and reflection to arrive at a juncture where the creative gesture can be most effective. This systematic process of going from the known to the unknown is, unfortunately, not taught enough in high schools and universities, which is probably why art is seldom considered a serious inquiry. Nonetheless, it is easy to see how the machinery of creativity is functionally independent of whether it is applied to science or to art, hence offering the possibility of retooling by simply moving from one sphere to the other through their fuzzy boundary.

A second concern that pertains to science and art is the challenge presented by language. The practice of science has its natural language in

mathematics, but as science must also describe things in words, its use of language is often under stress. Similarly, artworks resist words, and translations of art into language push against the edge of what can be said. This friction between language and meaning, which comes partly from the need or desire to "translate" difficult distinctions into accessible words, creates challenges that tend to reintroduce the sphere of ethics into the discussion. Judgments on the value of communication and the importance of community are fundamentally ethical.

A third connection between science and art is their shared struggle with the notions of simplicity and complexity, and also that other great duality, the tension between similarity and difference. I have seen scientists and artists ponder these dualities with equivalent intensity, and I have also seen many of them, over the course of their lives, change their minds. A good friend of mine began his career as a chemist thinking that differences were superficial, that everything was ultimately similar, and now he feels that this is, in fact, not the case.

The realization that both science and art are challenged, and sometimes overwhelmed, by the great dualities suggests the importance of considering science and art as models of reality. To me, modeling-of-the-world claims to truth reveal that at their foundation, science and art are two facets of a dialectic between idea and world. And while as models-of-the-world they differ radically in their approach to utility and interest, this is not a structural need of the knowledge-spheres as much as a convention. Science is, of course, interested, but art in the Kantian view—and in much subsequent thinking—has been defined as disinterested, yet I think this "requirement" was merely a way to avoid the complexities introduced by purpose into notions of the sublime and the beautiful. My own view of art is one of involvement and interest. Art only makes sense to me when it's interested and when that interest is directed toward life. Art is an inquiry, a tool in my engagement with life.

The "fuzzy boundary," then, is more properly a space than a boundary; a space defined by the intersection of the clouds of concern of science, art, and ethics. It is a space in which the pursuit of knowledge might begin in art or science and end in ethics, or vice versa. It is a space where creativity is at work without isolating connections to this or that sphere; where communication is at the edge of what can be said in language; where great dualities sparkle with ontological consequences; where models of reality not only compete but show themselves to be different facets of the same inquiry.

Studio,
Delray Beach,
Florida, 2006

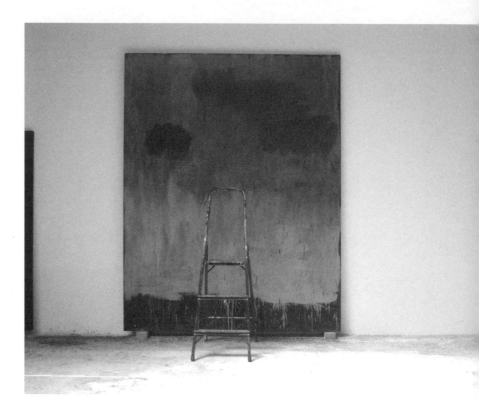

## 2006  Shaping Language

In Madrid, when my brother Carlos and I pretended to speak English, we slurred our Spanish words and spoke fast. English, for us, was a wispy buzz that carried prestige and mystery. Far away from Vietnam and Watergate, in the Spain of 1972, English was the sound of the happy children we had seen, dressed as witches and pumpkins, in an album of stamps called *Children of the World*. I knew I was way ahead of my brother because my nickname, Henry, was already in English. A few years before, in Cuba, my father took some English lessons and bestowed upon me the honor of being, at least by name, a child of El Norte. Carlos and I found time to slur and to affect gestures of those unknown ghoulish children as we

*This essay was published in English and Spanish; "Shaping Language," in* How I Learned English: 55 Accomplished Latinos Recall Lessons in Language and Life, *ed. Tom Miller (Washington DC: National Geographic, 2007); "Conformar un lenguaje," in* Como Aprendí Inglés: 55 latinos realizados relatan sus lecciones de idioma y vida, *ed. Tom Miller (Washington DC: National Geographic, 2007).*

moved from apartment to apartment in Madrid, but our version of English became a sham when we arrived in Puerto Rico. In San Juan most children were acquainted with the real thing, and many of them had been to the United States or had family there. Nonetheless, we tried to reform our secret language but the magic was gone. We knew we were making things up. In school, our English skills were far behind the other students. I remember tackling Steinbeck's "The Red Pony" with dread. I loved to read, but there was no pleasure, no discovery, in drudging through metaphors and sentences I didn't understand. In the insecure fashion of colonial countries, one of our teachers felt that fourth grade was the right time to assign Sir Walter Scott's *Ivanhoe*. Fortunately, I was interested in archery and was able to make a one-page report on the book based only on the cover illustration and my knowledge of bows and arrows.

Those years, the seventies, are coated with memory dust and much of it came from the *English This Way* workbooks: small white pages filled with incomplete sentences, multiple choice exercises, and reading comprehension; lonely books for an unsettled time that seemingly held the first key to love, because in my early teens all the girls I liked were masters of *English This Way*. By the end of high school, I knew enough English to do well on standardized tests and to perform the rituals of the language lab taught by a woman whose teased hair, to this day, I associate with English.

But my skill depended on being able to see the words on the page. Spoken English was a different matter. As I flew to Cornell for a summer program before my freshman year, I wondered about my fate. In the plane, between New York and Ithaca, a girl my age tried to speak to me. She spoke about New York being a state of trees and open land. Not just the city that everyone knew. But conveying this bucolic information took the whole flight, and I interrupted dozens of times with the annoying phrase "how do you say . . . "

My first year at Cornell was the hardest. I realized that a language is not just words but a way to look at the world that includes dorm rooms, care packages from parents, brunches, work-study, knowledge of the proper clothing, and enough money for parkas. All of which were foreign to me. I stumbled through conversations, spent a great deal of time in my room or jogging, and wrote essays that were returned to me covered in red ink. I refused to sign up for the English as a second language type of course and instead enrolled in a freshman seminar in introductory linguistics and the second semester something called Writing from Experience. Those writing courses took enormous amounts of time.

However, most of the English I learned that year was at dinners and casual conversations in my dorm. These lessons were awkward and many included some humiliation or pretending to be meeker than I was. Of

those unforgettable moments, none are as funny or as painful as "the constipation story."

Ithaca has a tough climate and I was sick quite often. It seems I had a cold or a flu four or five times that first year.

Throughout my freshman year I frequently told my classmates and people sitting around dining tables that I was constipated. In Spanish, *constipado* means having a cold, but unlike the frequent English mistake of assuming that *embarazado* means embarrassed, no one asked me when the baby was due or if men could have children. "Constipated" has no follow-up.

One morning in my sophomore year, a friend who spoke both Spanish and English corrected my constipated mistake. I looked at him carefully. Embarrassed. I pictured a year of secret laughter and bewilderment for my bodily openness. Maybe by now, more than twenty years later, my condition is an urban legend; the constipated boy who jumped from one of those infamous Cornell bridges.

The truth is that English came slowly, imperceptibly, over a few decades. All the markers, all the stories, can't completely pinpoint how the learning happened. One day I read *Moby-Dick* and it didn't seem foreign. At Berkeley I reread Steinbeck, looking at those parched California hills I didn't understand as a kid, and the metaphors made sense.

I had thought mastering a language was understanding its grammar and vocabulary. But Spanish had been more than that. It had been the feeling of the poems of Miguel Hernández and Jorge Luis Borges, the music of Joan Manuel Serrat and the gestures of my father. In a similar way, Steinbeck was those golden hills that didn't make sense in any language when all the hills I had seen were verdant and lush. The deceptive simplicity of Robert Frost or the idea of "plainness" existed in language and the language existed in them. Learning English was learning to love the sensibility, the rustle, that connects the words.

I am still learning, and probably my English will always reflect my Spanish upbringing, not only in my accent, but in a way of thinking. A way of wanting to use the language. My Spanish has also changed. Language, it turns out, was not something to learn but something to learn through.

Studio,
Delray Beach,
Florida, 2006

Studio,
Delray Beach,
Florida, 2005

Notes

April 24 (Delray Beach FL). The mirror makes the painting hard, unmitigated. No decoration survives. Is this true? What is the purpose of painting? What is it? What is a mirror painting? A very unpleasurable object. One side says, the other side stays quiet, or questions. This is an odd condition. A mirror diptych makes part of the nature of painting explicit. Is this good? Is everything I've done just a ladder to throw away? Is there a build-up? Is there something being built? Other than my exit from art? Mirror paintings are so intractable that I must think about them. What is a diptych of a mirror and a large head portrait? Head on tar, with colors, hopeful or funereal or martyrs. Portraits moving in and out of life. Family next to L. W. Same portrait—different sizes—what is it?

July 20 (Delray Beach FL). It seems to me, many other people, when making choices, account for what others are doing. If others are staying put, they stay put. If others are leaving, they leave. Who knows what turmoil exists inside of them, but they appear content or, at least, accepting of the communal wisdom.

This attitude strikes me as sensible and, yet, I am not good at it. I change, reinvent, reexamine, change again, plan, replan, etc. Sometimes it seems like a big waste of time, a sign of immaturity, of unfinishedness. But what would finishedness be? Look like? I don't know the answer. Against the youthful facility of change, the family's need for safety seems threatened.[1]

**NOTE**
1. Notes were reproduced in *Another Show for the Leopard* (Aspen CO: Baldwin Gallery, 2007).

*From EMC's sketchbook notes.*

Introductions to Projects

The images presented in *Projects* have been compiled from snapshots, sketchbooks, professional photographs, and loose papers found in the studio. For each project I have provided a brief introduction or comment with the hope of suggesting a point of view, but these don't intend to be, or suffice as, explanations.

   In examining the materials for this section, I was at times pleased and at times dismayed that the boy who painted the pastels in 1977 was substantially the same artist I am today. We are both interested in an ethical life. We court failure and fail often. We like Giorgione and the late paintings of Edvard Munch.

*Excerpts taken from* Martínez Celaya: Early Work *(Delray Beach FL: Whale & Star). His writing served as introductions to the projects throughout his artistic career.*

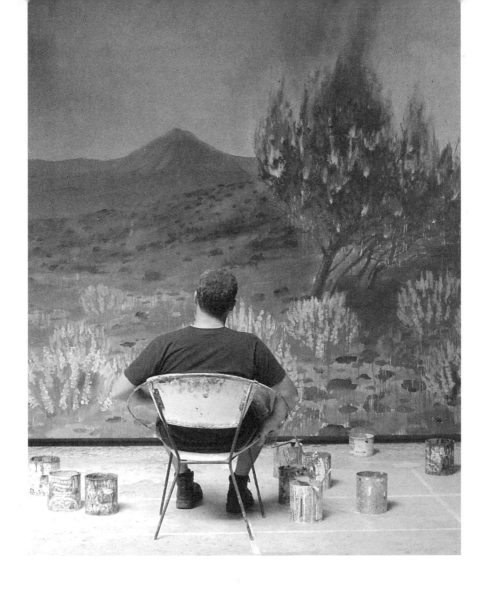

*The Burning
(Mandelstam)* in
process, Studio,
Delray Beach,
Florida, 2006

Most of my influences, however, have not been visual artists. Although many people and works have had a lasting effect on my thinking and in my view of art, in the ways that matter most, my sensibility would have been different without the writings of Miguel Hernández, Herman Melville, Leo Tolstoy, Hermann Hesse, Paul Celan, and César Vallejo; the songs of Joan Manuel Serrat and Leonard Cohen; the philosophy of Arthur Schopenhauer and John Dewey; and a childhood and adolescence in the Caribbean and Spain during the 1970s.

The idea that I was working on projects, on investigations that have a beginning and an end, did not occur to me until 1998 or 1999. But now I see that the urgency of certain interests and methods always had their moment. The projects follow the rhythms of life, often mapping my inadequacies more than my strengths. They have been endeavors with aim, with interest and investment on the outcome.

> Go, said the bird, for the leaves were full of children,
> Hidden excitedly, containing laughter.
>
> Go, go, go said the bird: human kind
> Cannot bear very much reality.
>
> Time past and time future
>
> What might have been and what has been
> Point to one end, which is always present.[1]

**Shore: "Is Today Yesterday" (2004–2006).** Some time ago, I was riding my bicycle on a road along the ocean. The sun on the water seemed permanent. My breathing was steady. My heart stable. Around a bend, the leaves of a camphor tree rustled in the sea breeze. While my eyes followed the flicker, the apparent permanence of all things faded, leaving only the present. *I will miss that yellow-green tree*, I thought.

Last year, during a bath, my three-year-old daughter asked me, "Daddy, is today yesterday?" I looked at her small body amid the expanse of porcelain. Fragile. Vibrant. I forget what I said. But I was thinking that tomorrow she would discover her bath-kingdom was small.

Her question and that camphor tree precipitated the actions and thoughts in the body of work included in this section.

**The Atlantic (2004–2005).** The Atlantic seems different than I remember. It is probably that for eighteen years I had been near the Pacific, my eyes used to hills diving into the grayish waters of the California coast.

There is no soil in Florida. Only sand. No oaks. Only pine trees and

palms. At night, the salty smell coming from the sea is not a Northern smell, like the Pacific's, but a complex Southern mixture of death and melancholia that some here call excitement.

The first few months everything in the Florida landscape seemed charged, especially the air, so full of light. The snow of *All the Field Is Ours* became sand and sea, and images of boys and skates appeared. To my surprise. Very odd those skates.

I bike along a road scented with sap from Australian pines and arrive at the entrance of my studio, which smells of moisture. Through my window I see the Florida holly trees. Different from the jacaranda in the alley of my Los Angeles studio.

All The Field Is Ours (2002–2004). After the first few writings and watercolors, it became apparent that mortality was taking the guise of lightness and that vulnerability was not represented by a boy but *presented* in him.

Two factors contributed to the lightness and the re-entering of color into my work—color with a Nordic, barren view of beauty. One was the birth of my first two children, and the other was the sustained darkness of *The October Cycle*.

The boy of *All the Field Is Ours*, like the boy in *Shore*: "Is Today Yesterday," is a composite of my childhood, my children's future and the space between the two. The boy in this project is made of nothing tangible, nothing graspable. He's destiny, regret, and remembrance.

The paintings in *All the Field Is Ours* range from the schematic to the rendered, and this ambivalence of representation comes, I think, from the boy himself.

Schneebett (2003–2004). Beethoven's music and life inspired a period of research and work concluding in exhibitions in Paris, Aspen, and, finally, *Schneebett* (Snow-bed) at the Berliner Philharmonie. *Schneebett*, which focused on Beethoven's death, was influenced by accounts of his last conversations and my inferences about Beethoven's migration from Germany. I gave this work the title of a poem by Paul Celan.

During the process of making *Schneebett*, I was troubled by the difficulty of sensing the significance of that room for Beethoven. When the work opened at the Philharmonie, I saw the public waiting in line to see it, and the orchestra playing Beethoven's late concertos in the lobby. I was humbled by the futility of *Schneebett*. I liked it more for it. On that day my mind was filled with thoughts of Beethoven as a boy.

*Schneebett* is dedicated to Dieter Rosenkranz.

The October Cycle (2000–2004). Before researching my sketchbooks and images for this section, I had thought—and said several times—that *The October Cycle* consisted only of paintings. Now, however, I see that the investigations of this cycle also included sculpture, works on paper, photographs, and writings.

*The October Cycle* began a few months before the birth of my daughter with watercolors and writings and ended just before her first birthday with a series of paintings.

Another significant influence on *The October Cycle* was my artist's book *Guide*, which was part meditation and part fiction. It was structured as a conversation between an old Franciscan named Thomas and myself as we drove north on the Pacific Coast Highway. In the book, I tried to work through some of my questions and thoughts about art and its connection to life and values.

Coming Home (1999–2001). I finished the poem "October" in 1999, when I was working on the project *The Forest*, and the ideas brought forth by the writing suggested something new: the mirror. The poem provided the imagery and feeling for *Coming Home*.

OCTOBER

Black and white birches
open
and then dissolve
in the light of morning.
A morning of feathers,
of the frail water of snow.

In the clearing
the merciful
raises his handless arm.
The architect of black bark
releases
a dove
of the lightest wood.
The wood of your exit.

All doors open to a withering garden
from which you will not return.

In the unspoken white
of the hour of angels
the remembered, bruised and restless,
collapses unheard

on icy leaves.
The mirror
that you placed on his antlers
rolls and softly etches a line and
when it comes to rest
it is all sky-unveiled, beyond mercy.
In the reflection
a dove
opens
and then dissolves
in the light of morning.
A morning of hunger,
of the coming of winter.

The Forest (1999–2001). The writings of Hegel, Heidegger, and Kierkegaard were influential in allowing the figure to reappear in the work. But it was not an easily accessible figure. It was lost or about to be lost in the forest.

Like many children, I first found the forest in fairy tales. It was the place where dangers awaited. Perhaps this first encounter with the forest made me equate it with the confusion of the psyche. In time, however, I began to trust more what I didn't know about myself than what I knew, and it was then that the forest changed for me. It never stopped being shrouded in mystery, but mystery became more meaningful. In some ways, the rest of the projects that followed The Forest can be considered subcategories, refinements of ideas and consequences outlined in its first notes and poems.

Berlin (1997–2001). In 1997, I went to Berlin in what was to be the first of many visits following the emotional, if not geographical, trail of Paul Celan.

I had been taking photographs for some time but only as reference for my paintings and drawings. In Berlin I relied on my camera and my notes to investigate ideas I had brought with me as well as new ones that emerged there. This photograph-writing approach suggested problems of time that I had not considered before. Since then, my photographs remain ambiguous about the before and after.

In 1997, the city of Berlin existed simultaneously as an idea and as a place, resigned to its history but cautiously hopeful. That summer I felt foreign and at home walking the streets looking for Kollwitz, Hegel, and Brecht. I began a long poem at the luminous dirt of the Dorotheenstädtischer Friedhof, which I completed in the bars of the Mitte. The project Berlin, like the poem, considered the end of an epoch and the consequences of displacement; it suggested a mood, a way of being, which I had not understood before, and which I still do not understand well.

The Future (1997–1999). *The Future*, whose name comes from a musical piece by Leonard Cohen, was a period of investigation on the nature of painting and remains my only project solely focused on painting on paper and canvas. As I look at these works now, they are reminders of what I can and cannot do.

There were some problems, some undesirable friction, between the human figure and the ideas I was interested in pursuing in 1997, and I found that those problems were resolved by the birds.

Violence played a significant role during this time both as reference as well as a method in the studio. I destroyed more canvases during those years than any others, and the paintings that survived carry scars. *The Future* was more brutal than *Berlin* and *The River*, but it had the sadness and loss of those projects. Unpolished feelings seemed difficult, unstable, in relation to the colors and ethereal reference of birds. I was pursuing that instability but was surprised by the way it made me feel.

In some ways, *The Future* remains, for me, the most puzzling of all of my projects. The most unfinished. Some people saw some connection between these birds and the birds of other artists. To me, the birds in *The Future* were tender, dead, and vast. Much closer in kinship, if not in reach, to the whale in *Moby-Dick* and to the earth, which became the material of *Berlin*.

The River (1995–1998). The sculpture *The Creek* was made for a hotel fair at the Chateau Marmont in Los Angeles. I wanted to understand how its relationship with the public was obscured and revealed by its context—a bed as a creek in a hotel room amid the bustle of an art fair. *The River* is more a relic than a sculpture, whatever distinction that might be. At a gallery in Santa Ana, California, I cut the stomach of a figure sculpture and filled her with roses. I brought her back to the studio and painted the mouth of a Cuban river on the plaster and wax surface.

*The River* and *The Creek* evolved into and from memory as a link between the temporary and the permanent. They touch on the erosion of affection and the elusiveness of belief. I was also interested in redemption. Everything was fragile then. Photographs of smiling couples on their wedding day reminded me of Laika, the Russian dog, looking through the round window of her spaceship.

Saints (1995–1997). In 1997, I was trying to rebuild my painting and sculpture from the bottom up, but most of what I knew about art didn't seem reliable. I found a more stable foundation in the myths and lives of Saint

Catherine and Jeanne d'Arc. The cycle of hope, loss, death, and resurrection mirrored the trajectory of my own work and gave me a way to understand my desire to destroy it.

I was not as interested in the saints as in the idea of them and what that idea suggested for a way of life. Some people thought that I was making a commentary on kitsch. I was not. I was interested in the flickering between meaning and no-meaning. The following is a note from 1997 regarding the Jeanne d'Arc works.

> About four years ago, I became interested in Jeanne d'Arc, who called herself La Pucelle. At first I only knew the surface of the story. I then read a few biographies and the trial proceedings that led to her execution, hoping that all that information would get me closer to her mystery. After the reading and the artworks that followed, I find that my ignorance of her has only deepened. I looked for the woman only to find her sunken under the myth more than I expected. To battle the myth is to engage in the fabric of mystery. To surrender to it is to lose her forever. She is about the unknowable.

Before Saints (1977–1995). The feeling that I was missing what was happening around me made me seek in art something other than drawings of battleships on school notebooks. My encounter with a battered book on Giorgione in Madrid gave me a way to measure myself and the world.

In my early teens I was making narrative paintings. Then, when physics was taking up most of my time, my work became simpler, nothing more than annotations of experience.

*Before Saints* is less a project than a collection of works from childhood drawings to the end of graduate school. As I considered these works for the book, I was tempted to repaint a few and, in a few instances, to paint and think like I did then. The process also made me realize how much I have in common with the kid and the young man who made those works. How similar our concerns. How persistent our limitations.

The Books (1998–2006). In 1998, I began Whale & Star with the idea of producing books on my work different than what museums and galleries would do and also to publish books by other artists and writers I consider relevant.

Whale & Star's main areas of interest are poetry, art, and art's relationship to other intellectual and creative fields, particularly literature and philosophy. In addition to our publications, Whale & Star offers the quinquennial Kappus Prize, which rewards poets with their first published book.

While I am solely responsible for the publishing choices, many people

have contributed their talent and effort to our books and editions. We also have been fortunate in receiving gifts and grants, without attachments, from individual patrons and foundations.

A new distribution partnership with the University of Nebraska Press and serious upcoming projects continue the evolution of Whale & Star, and of my feelings about its role in my work.

**NOTE**

1. T. S. Eliot, excerpt from "Burnt Norton" in *Collected Poems, 1907–1935* (New York: Harcourt Brace, 1936).

Studio,
Delray Beach,
Florida, 2006

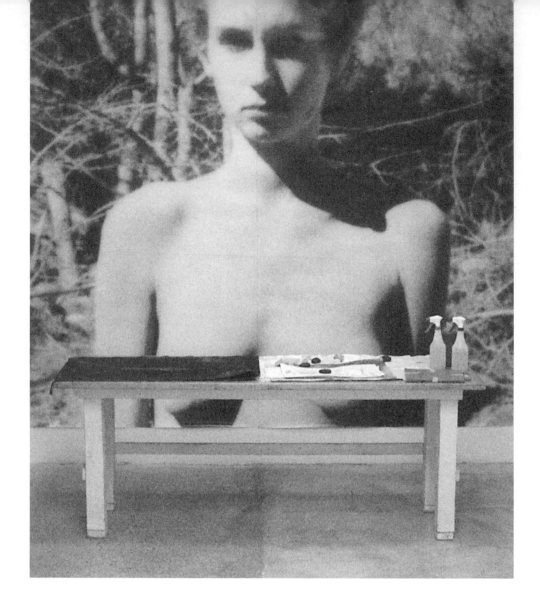

Studio,
Delray Beach,
Florida, 2006

Photography as Grief

*Time is the substance I am made of. Time is a river which sweeps me along, but I am the river; it is a tiger that devours me, but I am the tiger; it is a fire that consumes me, but I am the fire.*

JORGE LUIS BORGES, *Labyrinths: Selected Stories and Other Writings*

I

In 1997 I went to Berlin to see, write, and maybe paint. Like many other artists, I chose to stay in the Mitte, a historic borough reinvented as an arts district. From my window I could see a few of the new galleries and several buildings under construction in nearby Friedrichstrasse, and at night I joined squatters around one of the many bonfires in the abandoned buildings and took pictures. I hadn't had any luck with watercolors and my attempts to write about the city had been equally unsuccessful, so I settled on photographs, which I thought of—naïvely—as notes. It was a good time to take notes because Berlin was a changing city of contrasts: while it awaited the move of the government from Bonn, the sky was filled with tower cranes, but old buildings were still pockmarked with bullet holes from the Red Army's entry into the city, and there was right-wing extremism and delinquency in the streets.

I tried to document what was happening around me as well as the less obvious aspects of the city—the decaying courtyards, the new Jewish shops, the cemeteries, the nonthreatening colors of the new police, the fenced-in city lots with their fine linden trees. I must have taken a few hundred pictures, but I didn't develop them until I returned to Los Angeles. When I finally looked at the prints, I was surprised to discover they were not the notes I expected: In my prints everything was more elusive than I remembered. People who had been real to me looked like ghosts in my pictures, buildings I knew were solid seemed made of dust and ready to crumble, and the *now* of my photographs could have been

*Originally presented at the Sheldon Museum of Art at the University of Nebraska–Lincoln as part of the University of Nebraska Visiting Presidential Professorship. An earlier version was presented at the Miami Art Museum, December 8, 2006. Previously published as "Photography as Grief (Fragments)," artUS 24/25 (Fall/Winter 2008).*

a month or a decade earlier. Rather than being undeniable records, my photographs of Berlin were documents of questionable veracity, and the more I looked at them the more questionable they seemed. Were these even "my" memories?

Not knowing what else to do with the stack of photographs, I began cutting the prints and the negatives, then arranging them into categories and finally constructing new images with these fragments. The process was nothing new—a Berliner, John Heartfield, had pioneered photomontages seventy years earlier—but for me it was less about the making of images than about understanding what was holding those images together and what broke them apart. The photomontages had a pictorial chunkiness that revealed conventions and assumptions, which in the unaltered pictures suffered the neglect of the familiar or the invisibility of the "neutral." In tension again within the assembly of fragments, conventions and assumptions regained their unfamiliarity and in the process revealed uncanny aspects of photographs—not particularly of photomontages but of all photographs—which warranted further examination.

II

Impelled by the realization that something interesting was going on, I considered the questions raised by the photographs. In particular, I was interested in their resistance to becoming trustworthy documents, and it seemed natural to explore this resistance by inspecting the limits of photography as a classifying tool. Had I not, after all, broken down the Berlin of the summer of 1997 into constituent parts and then tried to organize those parts into categories? It seemed I was using photography to classify, and judging my photographs with classification and organization as criteria, I wondered if perhaps the reason why my photographs were unsatisfying was because I had not understood this purpose earlier.

While I assumed the failing of my photographs was likely, it became clear fairly quickly that this was not *the* problem; *a* problem, however, was the very assumption of photography as an effective classifying tool. While photography is used every day to classify—butterflies, cancers, clouds, galaxies—this usage depends on the invisibility of the photograph as a device. That is, the photograph must present its image as fact instead of a mediated experience, and the user of these photographs then looks *through* them, not *at* them. For all of this to work, the photograph must be credible in its objectivity, and whatever failures it has in that regard are usually considered limitations of the technology or the user, rather than a limitation of photography itself.

Objective assumptions notwithstanding, when engaging photographs subjectivity is always involved, and it is an involvement that has a ten-

dency to garner subjectivity rather than to settle for objectivity. The more one inspects a photograph, the more challenging it becomes to judge the separation between one as observer and the photograph as something occurring outside of oneself. The result is loss of distinction whose consequence is defamiliarization of the subject—the more one looks at "it," the less one knows "it." Meaning detaches, partly or completely, as a reaction to this distancing effect between the present of a photograph and the present of its observer. Does this distancing represent a merger or coexistence of these two moments? Or are these memories in fact the product of an alternate present, of the in-between world of ghosts? Rather than photographs being commemorations of the dead (the death of time or presence), it could be they represent memories belonging to the dead. It is not clear then that photography can function as the system of classification some people[1]—Foucault for example—have suggested it is.[2] Instead, each photograph is an instance whose instability of meaning opens interpretative possibilities, and these in turn move us up and down the perpendicular axis of observer and observed, instead of in the lateral axis of classification.

Once I recognized the immense influence of subjectivity in the "reading" of photographs, I turned my attention to the knife-edge present of the photographic subject. It seemed that if there was a blurring of distinction between observer and photograph—self and other—then there must be a related interplay between the "present" of a photograph and the "present" of its observer. Was it the case that as the distinction between self and other blurred, the respective moments in time merged, or that instead, the blurring led to "coexistence" in those two moments?

The latter appears to be the case. Photographs seem to stop time, but, at least in the commonly held view of time where the universe unfolds in step with our present, there is not any way to *guarantee* a future if time can stand still along the way. So what happens, then, when we look at a photo assuming—as we always do, consciously or not—that time stood still? I suggest what happens is that the engagement generates a dual track of time in which the observer can "coexist" in two temporal dimensions, namely, that of the photograph and his own. These two tracks result from two different interpretations of time, interpretations that occur without precise formulation and often unconsciously. In the first interpretation, which is the commonly held view to which I alluded earlier on, the universe evolves as our present moves forward. In this view, I feel separated from the *now* of the picture and also from my own death. The second interpretation of time is that the role of consciousness is to apprehend a past, present, and future that does not unfold but is. In the words of Hermann Weyl, "the objective world simply is, it does not happen. Only

to the gaze of my consciousness, crawling upward along the life line of my body, does a section of this world come to life as a fleeting image in space which continuously changes in time."[3]

The temporal duality has its repercussions within consciousness. Unlike the photograph, whose ownership of its moment is taken for granted (naïvely), my hold on *my* moment is less secure. Merleau-Ponty describes appropriately the hold on one's moment:

> My hold on the past and the future is precarious and my possession of my own time is always postponed until a stage when I may fully understand it, yet this stage can never be reached, since it would be one more moment bounded by the horizon of its future, and requiring in its turn, further developments in order to be understood.[4]

In contrast to this elusiveness of *my moment*, the *now* of photographs invites me to think it could be held. To put it another way, while the meaning of my present is not available to me in its fullness, the meaning of the photograph *ought to be* because it is fixed forever. This apparent ease of owning a fixed *now* in contrast to the difficulty of owning one's changing present seduces consciousness into shifting toward the *now* of the photograph, away from my present, and with this shift consciousness separates from identity.

However, strictly speaking (but not necessarily relevant to the machinery of perception) the *now* of photographs cannot be possessed anymore than the *now* of my present because, like my present, my comprehension of it is always incomplete. Nonetheless, the apparent stationary quality of photographic time suggests that such comprehensibility is actually possible, and it is that suggestion that opens the door to the uncanny feeling experienced with photographs. The longing conveyed by photographs through the promise of *the moment I ought to be able to have* was, for me, a pointer toward the way in which photographs work, as well as an answer to why my photographs of Berlin seemed so mysterious to me.

I had the opportunity to explore the nature of that longing while working on a reinstallation at the Sheldon Museum of Art, of an artwork called *Coming Home*.[5] In that work, I had decided to use a large photograph to envelop the room so it could appear to function as a context for the sculpture while my real objective was the defamiliarization of the location, of the museum.

As I mentioned earlier, the longing the photograph conveyed, which deeply influenced the feeling of the installation, was an outcome of the temporal gap between myself, or any other viewer, and the scene in the photograph. This gap generated an evolution in consciousness, which I will briefly outline as follows: the tension generated by the two *nows*—

the observer's and the photograph's—led consciousness to separate from identity (from its previous recognition of self) and this, in turn, affected meaning by softening its attachment to the scene, placing its image—and with it *the moment I ought to be able to have*—very close to apprehension and yet decisively out of reach.[6] This disconcerting out-of-reach feeling permeated the installation of *Coming Home*; the photograph, rather than create a context, removed context, placing the complete environment in the realm of the distant and the remembered.

### III

That final movement of the unfolding and refolding of consciousness—the nudging toward the realm of the distant and the unremembered—could be described as a whisper, which we recognize not by its content but by its tone. That recognition helps us understand what differentiates photography from painting and sculpture: the latter two embolden appearance and the former causes it to disappear. Photographs whisper that to look at them is to lose or overhear something.

But what is all this whispering? It might be useful here to use, as a guide in answering, Kant's remark about the mourning of beauty. He writes, "The pleasure we take in beauty is best understood as memorial, a remembering that is also a mourning."[7] For Kant, what is mourned in the experience of beauty is its separation from truth and goodness. I suggest we take the longing generated by the experience of a photograph as an approximation of Kant's beauty and say that what is mourned in the experience of a photograph is our irreparable separation from its now (or then). So the revelations of photography are linked to death and resurrection as the very dynamic of representation—an absent or dis(re)membered object preceding its apparition in the photograph.

The attentive engagement with a photograph expands awareness beyond the self, and this expanding awareness creates a hollowness, a vacuum, in consciousness which decenters subjectivity and blurs the distinction between inside and outside. Loss and destruction echo within that cavity created by the hollowing, and grief is their echo.

Every photograph says *this is what was* but also *what won't be again*. And if we look carefully we also find "this is not where you are," and beyond that the most perplexing revelation of photography: "I don't exist for me." "The image already announces our absence," writes Eduardo Cadava. "The photograph tells us that we will die, [that] one day we will no longer be here, or rather, we will only be here the way we have always been here, *as* images."[8]

Grief is a structural aspect of photography activated by the subject in an eternal present, living in a time outside of time—ahistorical: not

belonging to any "historical" present but part of what laid below or above (in-between the lines of) "history." A photograph in a drawer—which is the way the wall-work of my *Coming Home* installation existed when I found the negatives—is like a lake behind a dam. When the drawer is opened and the photograph engaged, grief unfolds, which like the opening of the dam transforms potential energy into motion. Whatever other information a photograph transports, it must be carried by that rush of force, which makes grief the vehicle of all other messages.

The potential of all photographs is held in its chemistry, and I think it is this chemistry that offers the most philosophically productive clue to the way in which photography is apprehended (or not) by consciousness. Photography is both threatened and enhanced by the tenuous physicality of its materials, by the friction between what is represented and the ephemeral quality of what coheres that representation—silver dust or liquid crystals, say. Photography is a conscious and unconscious construction made possible by a chemical record that is almost not there. Like the grooves of a record, the chemistry of photographs holds grief as potential and waits for ghostly release.

IV

I would like now to reconsider, and use, what I have said so far in my viewing of a specific photograph—not one of mine but one taken by Francis Sullivan in the 1950s.

I approach this photograph casually, but soon it becomes uncanny. I waver between my discovery of the details of the baby and my impression that she *is* staring back at me. Despite my knowledge to the contrary,[9] I wonder if she is really seeing me and, if so, from where? Then I search for answers on her blanket, on the ribbon around her neck, on her little hand. She appears to be calling for me from the other side of a tunnel, and as I look down the tunnel I sense myself becoming a phantom limb of her gaze. I try to get a hold of the "real" by reminding myself that Sullivan's photograph is of a dead baby and that the eyes that so piercingly look into the future have been pasted on. But what does that knowledge change? If it changes anything is to the benefit of the uncanny: knowing of her death only enhances the mystery of why I cannot ignore her stare, and in time that mystery evolves into a chilling premonition: "Whoever dies becomes the enemy of the survivor, intent upon carrying him off with him to share his new existence,"[10] said Freud.

The persistence of her stare from the other side of the tunnel slowly reveals the tunnel to be an illusion, which brings death closer, threatening my consciousness while my body remains safe.

I go back to the eyes only to discover that I am not closer to their secret.

I don't know why I cannot ignore the stare that activates the little hand and which invites me to sit next to her on the bed. Looking at the picture again, I understand that when consciousness has burnt the expanses of time, what is left behind, its trace, is the ash of grief. However, this little triumph of awareness is short lived. Before putting the picture away, I go back one last time wondering if time and consciousness are the same for her. Then I realize that while this baby exists for me I don't for her, and not only because she is dead, but because *my banishing*, the dissolution of what I am, is the nature of photography: her stare is made of consciousness held back by silver oxide which upon encountering me (her promised viewer, her phantom limb) scorches our temporal distance, and I am left to re-assemble her, and inevitably myself, from the scattered ashes of grief.

**NOTES**

1. At that time I thought that maybe this was true only of my photographs, but now I think it is the case with all photographs. Perhaps few productions made this point as clear as Bernd and Hilla Becher's work, which is frequently described as a "typological study" but is in fact nothing of the sort.
2. Photography promotes "the normalizing gaze, a surveillance that makes it possible to qualify, to classify and to punish. It establishes over individuals a visibility through which one differentiates and judges them." Michel Foucault, *Discipline and Punish: The Birth of the Prison* (New York: Pantheon, 1977).
3. Hermann Weyl, *Philosophy of Mathematics and Natural Science* (Princeton: Princeton University Press, 1949).
4. Maurice Merleau-Ponty, *Phenomenology of Perception* (London: Routledge, 2003).
5. The original environment, *Coming Home* (2000), was created for Griffin Contemporary in Venice, California. The artwork was in the Sammlung Rosenkranz (Berlin, Germany), who gifted the central sculpture (only) to the Sheldon Museum of Art (Lincoln, Nebraska).
6. I have presented this evolution of consciousness as a sequence, but it is likely that all "events" are more or less simultaneous.
7. Immanuel Kant, *Critique of Judgement* (1790; repr., Cambridge: Oxford University Press, 2008).
8. Eduardo Cadava, *Words of Light: Theses on the Photography of History* (Princeton: Princeton University Press, 1997).
9. "It seems that we ascribe the character of the uncanny to those impressions that tend to confirm the omnipotence of thoughts and animistic thinking in general, though our judgment has already turned away from such thinking." Sigmund Freud, *The Uncanny* (London: Pelican, 1938; repr., New York: Penguin, 2003).
10. Freud, *The Uncanny*.

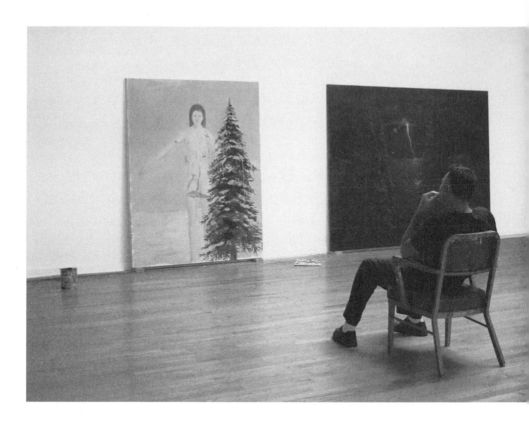

2007    ## From *The Blog: Bad Time for Poetry*

**Sunday, August 26.** *Adorno as Cliché*. The frequent reference to Adorno's pronouncement, "To write a poem after Auschwitz is barbaric," is problematic for at least four reasons:

1. The phrase is customarily presented outside of the context in which it appeared: "The critique of culture is confronted with the last stage in the dialectic of culture and barbarism: to write a poem after Auschwitz is barbaric, and that corrodes also the knowledge which expresses why it has become impossible to write poetry today."
2. The reference frequently comes with—particularly in academic contexts—a pompous undercurrent, as if seeking "ahhh" as a follow-up.

*The blog was originally on Enrique Martínez Celaya's Web site, existing from August 24, 2007, to May 25, 2009. The blog was published as a book,* The Blog: Bad Time for Poetry *(Delray Beach FL: Whale & Star, 2009).*

3. It is rarely acknowledged that Adorno reconsidered his words: "Perennial suffering has as much right to expression as the tortured have to scream . . . hence it may have been wrong to say that no poem could be written after Auschwitz."

4. If Auschwitz invalidates anything, it is poetry whose nature or quality does not measure up. Auschwitz didn't draw a line on the landscape of art that was not already there.

Saturday, September 1. *The Road*. Bolle, the main character of Harry Martinson's *The Road*, wanders through the Swedish countryside. Here is one passage:

> So I went, and all that summer I tramped round the country, heard the birds sing, bathed in quiet streams and lakes and roamed through glens and valleys where the grass was dewy and clean. Clouds drifted, winds moved in the woods, flowers bowed and gleamed, bumble-bees buzzed in the clover, girls sang in the hay-fields.

Bolle's aim is the wandering itself. It is a lifestyle for which he pays in fear and detachment, but for him it is a worthwhile trade: as a tramp, he gains nature, he resists the externally imposed, and he finds hope in what might be around the next turn of the road.

Many times I have fancied myself a Bolle, someone who chooses the road however unknown. But it is a fancy. Like Ungaretti, I am always ready for departures, but, unlike Bolle, it is "ready" as in "expectant" not as in "prepared."

Maybe no one can be prepared and maybe the road is not so much a choice. Maybe it is a reaction, which sometimes ends well and sometimes does not. When does it end well? Maybe as often as the settled life ends well, which is not often. But probably not even that much. What the road opens (irreversibly) is more sensible to keep close.

Martinson's book points at the limitations on freedom imposed by social arrangements, the oppression of machines, and the tyranny of those who hand down the rules, but it makes less of an issue of the challenge posed by the past. Maybe his approach was to tackle an idea akin to "practical freedom," but it seems to me that the most intriguing questions come in search of "pure freedom," even if such a concept proves silly upon further analysis—and it does, I think.

Every event, good or bad, narrows what's possible and enslaves us in ways we often don't want to give up; ways the road won't always release. I have events, Bolle had events, and Martinson as well; Martinson, the beautiful tramp, was ultimately disheartened by his.

And yet, who, at least sometimes, wouldn't want to wander or perhaps, to walk a mile without hypocrisy, without attachments?

*The Road* is too simple; one reason why it is touching.

**Wednesday, September 5.** *The end is important in all things (II).* The ending of a body of work is like coming to the end of a good but difficult book: I wish I could stay in the world created by the work, but the work itself expels me.

At the end of a series or a cycle, there are no victorious trumpets and no certainty, at least for me. If a trumpet were to be heard, it would be a little one, made of plastic, with a strident ironic sound. Instead of the sounds of victory, the ending of a series brings the confetti of doubt and regrets, questions about the works in the world, and ambivalence about parting with things I wish to keep.

**Thursday, September 6.** *Criticism and Imitation.* It is interesting to consider *Art's Prospect: The Challenge of Tradition in an Age of Celebrity* by Roger Kimball in relation to *Stranger Shores: Literary Essays, 1986–1999* by J. M. Coetzee. While quite different—and their difference is what I would like to highlight here—there are reasons to place them together for a moment: they are both nonaligned with the contemporary discourse—this is less true of Coetzee; both share a certain impatience with mediocrity; both writers have a considerable following; and they both feel it is reasonable to pass judgments on the work of others.

It is instructive to compare how they construct those judgments.

Roger Kimball usually makes his arguments by concatenating colorful sentences which are not always constrained by logic and that often sacrifice accuracy for energy. Here are two representative examples,

> A quick glance around our culture shows that the avant-garde assault on tradition has long since degenerated into a sclerotic orthodoxy. What established taste makers now herald as cutting-edge turns out time and again to be a stale reminder of past impotence.

> It is a good rule of thumb in the contemporary art world that the level of pretension is inversely proportional to the level of artistic achievement.

Roger Kimball is annoyed with the art world and his writings convey his annoyance through a writing style that is both ironic and bombastic. He has an extensive group of people and institutions he dislikes, and he also has a pantheon of artists he admires. The shared qualities of the former are easy to recognize—their cult of novelty, their "semi-beatified

status," their "unbearable pretentiousness"—but the latter, the pantheon, does not seem to respond to a unified philosophy; instead Kimball would most likely say they share "quality."

What I find remarkable about Roger Kimball's writing is how thin it is. Once the exaggerated adjectives, the insults, the condescension, and the many occurrences of "undoubtedly" and "it is clear" are removed, there is very little left; and what's left over is neither interesting nor new. This scarcity of substance is surprising considering Kimball stands for quality and lack of artifice above novelty and pretentiousness.

While I share much of Roger Kimball's dislike for the art world, I find *Art's Prospect* to be a weak argument in favor of or against anything. J. M. Coetzee's *Stranger Shores*, on the other hand, is an impressive example of what is possible when seriousness, quality, and originality of thought combine.

The best case against the pretentious obscurity of Rosalind Krauss's writing is not Kimball's essay "Feeling Sorry for Rosalind Krauss" but the lucidity and intelligence of Coetzee's writings. Unlike Krauss or Kimball, Coetzee downplays rather than exaggerates his intellectuality, and his judgments on the work of others seem carefully assessed and measured in his effort to not be petty or arrogant. Coetzee's writing has a distinct voice without the need for the decorative flair, and it comes across as profoundly knowledgeable without pedantic poses or fancy terminology.

Although other claims are voiced, we like to imitate, and in an environment like art and academia, imitating intellectual stars (who Kimball is not but Coetzee and Krauss are) has significant rewards. It is easy to figure out how to write and think like Kimball. The reason we don't read more Kimball-like writings is because the people who write like him are usually standing on soapboxes, not, unlike him, editing intellectual journals. It is also easy to figure out, but harder to execute, how to write and think like Krauss, and since the Krauss-type writings fit well within the vehicles of intellectual dissemination, we often read thinkers like Krauss—for instance, in the magazine *October*, which Krauss helped found. Coetzee is a different story. It is easy to see how he writes and thinks, but he is very difficult to imitate because at the heart of his writing there is formidable intelligence, erudition, and strength of character. I expect more Coetzee imitators to continue to appear, but unlike the case of Krauss or Kimball, the Coetzee imitators are easy to distinguish from the original.

**Saturday, September 8.** *A New Body of Work.* My project, *For Two Martinson Poems, Poorly Understood*, is now finished. It consists of paintings, sculptures, and one photograph. It will be shown (it opens October 4th) at the John Berggruen Gallery in San Francisco.

In this series, like in most of the work of the past four or five years, I tried to explore (by tapping, maybe like a physician testing reflexes) the limits to holding basic questions of existence in thought or words or art; in particular, how those limits impose themselves on my efforts to consider new choices against a growing body of past choices. The concern here is not memory, as it has often been said about my work, but the past as a definite force on the present—as a comparative weight on the balance scale of meaning.

In this exploration of or inquiry about highly abstract ideas, I have used the poetry of the Russian Osip Mandelstam and the Swede Harry Martinson, both of whom, in deceivingly simple poems, traverse a lonely landscape of "the personal" while striving toward large and unwieldy concepts.

The imagery of this new body of work is dominated by trees, snow, horizon, light, soil, and figures: I have pared down the work to those elements I consider fundamental in order to manifest and understand (better but, of course, poorly) the nature of choice, regret, and possibility. As always, this work is not the result of an a priori agenda of representational painting or of a conceptual strategy. Instead, it is the CURRENT embodiment of my efforts toward making sense of the world as I want to make sense of it TODAY; tomorrow, I might work with words or empty rooms.

Neither culture (in the way "culture" is used in art writings) nor contemporary art have been considerations in this new body of work. If I had to locate this work anywhere outside of itself, it would be with poetry but poetry in its most limited use of the framework created by Mandelstam and Martinson. To be more specific, not in any way involved with the "discourse of poetry" nor with "the poetic," a term frequently used to describe affected works lacking in strength of character.

Wednesday, September 12. *In Favor of Speaking Up*. A friend sent me a note. It said that while he agreed with the comments about Rosalind Krauss, he was not sure of the value of such comments. And knowing him, a remarkable person, I think I understand where he is coming from. It is difficult to walk lightly through life when one is attacking, criticizing, and the like. It increases one's burden—one's footprint. Moreover, what has been said is difficult to take back and difficult to forget. Instead of attacking or criticizing other people's views, the focus could be in living one's beliefs. In this way, it might be possible to remain light and unmarked by the stain of public words. It seems a more elegant way to live, and it would be hard to argue against its rewards. In my book *Guide*, Thomas Hoveling lived like that.

I frequently consider the question, and while I am never completely

comfortable with my actions, I have, so far, concluded that it is important to speak up. It is important to take a visible stand against ideas one judges incorrect, misleading, or evil. It is a burden, an annoyance, one is frequently wrong, and speaking up is often a detour from other projects. But unless alternatives are heard or read, they almost don't exist, and ideas that don't exist are never rediscovered. The romantic (in the conventional use of the term) notion that greatness ultimately triumphs is the outcome of self-serving excuses and feel-good notions about life's fairness, and it is frequently justified with misunderstandings about history and misquoted biographies.

Ideas do not exist in isolation. They are refined and clarified through exchange. Weaknesses in one's position, for instance, are revealed quickly in the friction of a critique. It is easy to be pedantic about the value of one's ideas when those ideas are not tested, poked—used beyond their circle of safety. Silence, something I revere, is at certain times the greatest arrogance and has been at some key moments the greatest immorality. Moreover, many of the keepers-to-themselves are disingenuous: they feel above struggle but harbor resentment, pride, and self-importance.

There is also the issue of offering alternatives, particularly in the art world, which for all its "diversity" often appears (particularly to emerging artists and students) polarized as a whole and monolithic in the particular subspace of the relevant mainstream. If you consider the art world from their point of view, it would seem a conglomerate of sectors defined by the *Artforum* crowd or by the neoconservatives or by the gut-trusters or by one of the many other "interest groups." All these sectors have their canon, their loudspeakers, their publications.

So, if one believes something better or more authentic is possible, that belief should be shared and supported publicly. Many artists whose potential had not yet unfolded don't know what to think because they are bombarded every day with, or intimidated by, ideas they distrust but don't know why. In our age there is a tendency toward polarization and tidy worldviews, so it is important to combat this tendency by putting "out there" the view that contradictions or dissonant points of view can coexist in one mind, which makes me think of [F. Scott] Fitzgerald: "The test of a first rate intelligence is the ability to hold two opposed ideas in the mind at the same time, and still retain the ability to function." So, one good reason to speak up is to put forth ideas and attitudes that are ambitious and honest enough to retain internal conflicts, conflicts whose resolution propels investigation and inquiry.

Sunday, September 16. *Complexity and Tidy Packages*. One can appreciate the complexity of a notion and work within that complexity, or one can try

to simplify it to fit into a tidy package. Both ways have their merits, but usually only the former advances the notion in ways that can be called something other than trivial. Why then pursue the "tidy package"? There are many motivations, but I think most of them focus on the immediacy of certain rewards: tidy packages are portable, allowing application in a wide variety of situations; they usually don't require intense engagement; and they are frequently all that is required to advance socially and professionally (not only do tidy packages foster advances because they are sufficient to quench most people's thirst for knowledge and truth but also because deeper engagements are usually not welcomed).

A while back I was at a gallery with a well-known collector who considers himself quite sharp. He stopped in front of one of Sol LeWitt's numbered pictograms. He leaned into the work. He squinted and tightened his lips, as if he was in thought. After a while he turned to me with something like insight in his eyes, and he spoke of the mathematical and conceptual power of the sets of numbers arranged in boxes. I told him I didn't see it and he looked at me with contempt. What serious mathematics could there be in those drawings, really? I don't know anyone, other than "art people," who goes to LeWitt's work in order to get structural or mathematical insight. It is math lite, in the same way that some art works are politics lite and so on.

Remarkably (remarkably considering what one sees and reads) few people would admit to be interested in tidy packages.

**Thursday, September 27.** *Reflections on a Return.* It has been five days since I left Florida. I am now in Los Angeles as if I had never left and in other ways, as if I had never lived here. Undoubtedly, my mindset is different, though I don't know how or if it will affect the work. From a distance, and without whatever clarity time might bring, Florida seems an important period. It might not be inaccurate to think of it as a self-imposed exile, though I have to smirk at the idea of exiling oneself to anyplace in which there is a mall and a beach. But it was precisely that resort quality of the little town in which I lived that wiped away the romantic aspirations to self-discovery and "toughness" that inevitably come up in pilgrimages to deserts, to Alaska, or to New York. The charm of a little beach town—the homes decorated with coral, the gentle nights, and the Lily Pulitzer outfits—meant that whatever ideas I wrestled had to be my own and, frequently, foreign to the day-to-day conditions. In other words, the angst of the artist in the little beach town is felt in sharp contrast to its surroundings. There is no nasty grit of the city or garbage or frostbite, no traditionally grand landscape or historical weight to echo the brutality of living or to applaud the act of getting up in the morning.

Tuesday, December 4. *Tall Words*. I have mentioned earlier on this blog the unnecessary tall words used by galleries on press releases. But the problem is not limited to that type of advertisement. Fancy terminology and confounding statements are, more or less, de rigueur in the art world. The reasons why this is might be illustrative of collective and individual anxieties, but rather than explore those, now I just want to suggest we desist on the usage of terminology and postures that are not necessary.

At times, the need for clarity and precision requires terms and methods that might not be familiar to everyone. But arcane notions ought to be tools in the search for truths rather than veils to hide lies. It is more productive to study great thinkers to understand the mechanism of their thought than to find a quotable phrase or a hook for one's deficiencies; even minor understanding of a good mind brings forth humility. The temptation is always there to firm our soft understanding with the prop of the big word or the important framework, but these affectations tend to hide truths not only from others but from ourselves as well.

Partly because philosophy and literature have played a role in my work and are part of my vocabulary, it has been a challenge for me to avoid the failings I have just described. Whatever the excuse, I am disappointed whenever I can't find a way around fancy terminology. I think most people should avoid the embarrassment of sounding like intellectuals—particularly if they are intellectuals.

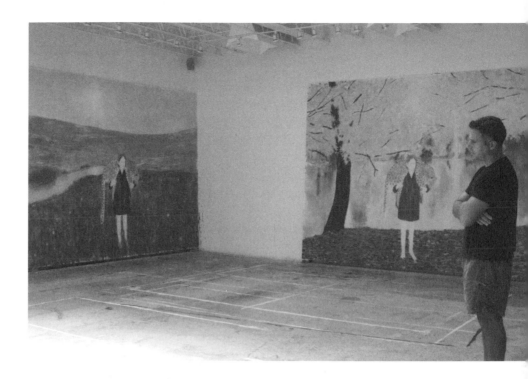

*Nomad* in process,
Delray Beach, Florida,
2007

## 2007 A Personal Note on Art and Compassion

Yesterday, after considering *Self-Portrait During the Eye Disease I*, a late painting of Edvard Munch, I walked to the 7-Eleven near my studio. The air smelled of jasmine and laundry detergent, and a sea breeze stirred the palm trees. The lady who works at the laundromat played with coins over a Formica table while talking to someone on a cell phone; a boy sat on the bench outside, his eyes fixed on the small screen of his Game Boy; and a few feet away from him a teenage girl with reddish hair looked through a celebrity magazine. As I walked back with my Super Big Gulp in my hand, my own disease of isolation cured for a moment by Munch, I noticed with comfort that I was the lady, the boy, and the girl and that there was no time to waste.

I have heard and read of many ways to expand our circle of emotional relevance and restore the dignity many of us seem to be losing despite— or because of—increased access to gadgets, status, and entertainment. But the only ways that seem to work are those that entail compassion

*Originally published in* works + conversations *14 (May 2007).*

157

and commitment to personal sacrifice as well as awareness of universal responsibility; moral demands that are challenging and often impossible, especially without examples.

Teachings are almost examples, but understanding teachings is not a substitute for seeing. In my own life I have sought order and clarity through science and philosophy, but only art actualized the bond between self and world and offered the possibility of compassion.

I recognize the concept of compassion in the arts has acquired an antiquated quality, as if it belonged to the days when ecclesiastical commissions defined the role of art. Perhaps, this is why instead of seeking compassion, the informed public visits contemporary art venues for the pleasures of fashion, social visibility, accumulation, and self-importance; activities and strategies in which allusions to someone else are often opportunistic, ironic, or coded into abstractions. It might be that the need for so much diversion and consensus reveals the extent of our loneliness, dissimulated or temporarily relieved by the jolt of novelty, the authority of intellectualism and/or the validation of profits—loneliness that gives rise to internal turmoil and, our denial notwithstanding, evinces our need for compassion, for feeling part of something larger.

For art to show us a way out of loneliness, it must transcend jolts, authority, and validation, and it must go beyond good intentions and illustrations of compassion. The truth of compassion in art only comes from—and in—the sublime and authentic work. The experience of the sublime—not the discourse—dissolves the illusion of isolation, leaving us open to the dignity of human nature. And the inherent authority of authenticity frees us from the enslavement of external confirmation, which in turn allows us to involve others, not as targets of our status anxiety, but as subjects of our love.

There are several approaches to the sublime and the authentic, some luminous, some dark, but they all arrive at the same end. Unlike a work of novelty or fashion, a sublime and authentic work offers the alternative of communion to loneliness, closing the separation not only between me and others but also between me and myself, and me and the world. A sublime and authentic artwork—if we are prepared to engage it—reconnects us with the world and puts our attention in the present, away from banality, entertainment, and insecurities.

*Verano (Summer)*
in process,
Delray Beach,
Florida, 2006

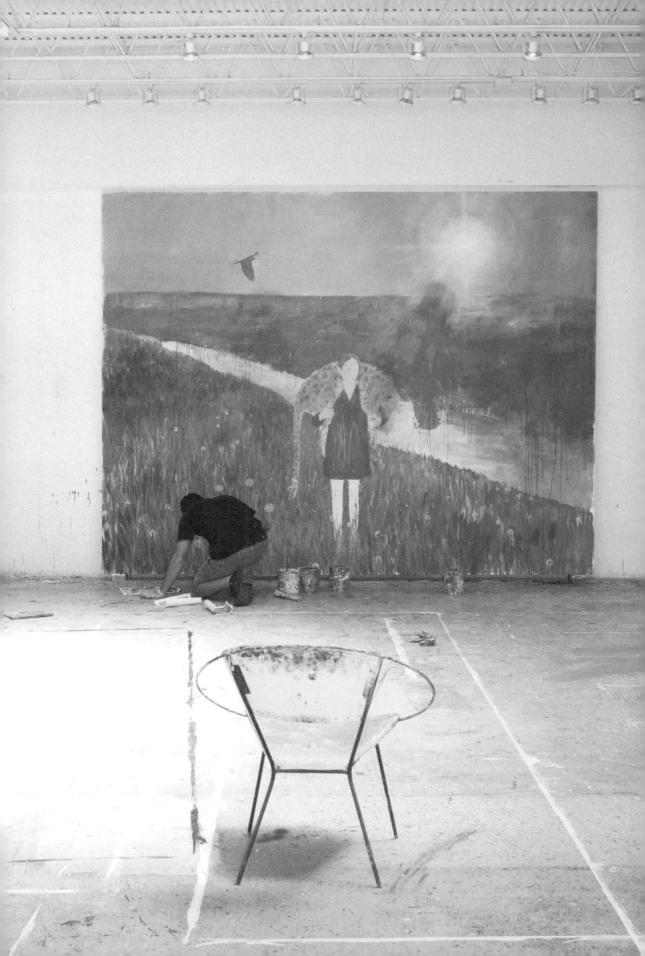

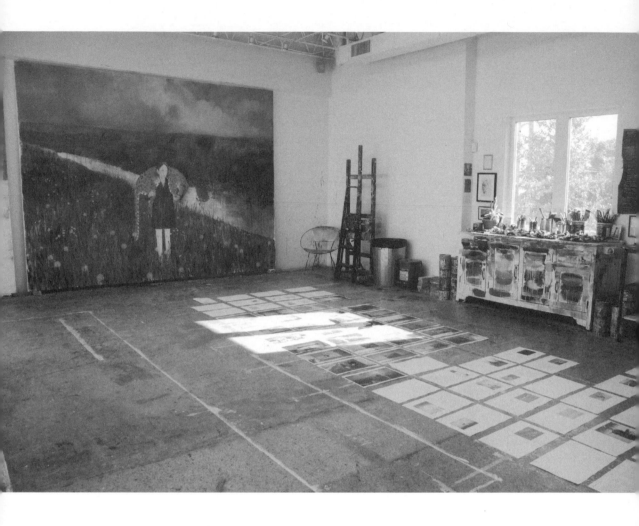

*Nomad* in process,
Delray Beach,
Florida, 2007

2007     Notes

February (Delray Beach FL). The thought about the book [*The Year of the Moth*]. It has been hard to find the structure of this story. Partly because I am sorting out how Gabriel interacts with the world. Gabriel's arc is of decay. Yes? I can't think![1]

March (Delray Beach FL). What, exactly, is in those eyes? [The eyes of Nadezhda Mandelstam]. Perhaps, the shock of horrors no longer registering. Eyes used to look in the dark at small unremarkable objects on a small wooden dresser. Eyes that measured the milk and shoes—wooden, misshapen. Her eyes leave nothing for me. Good thing we never met. I would have felt very light, trivial. I do now, anyway.

I like to think of [Osip] Mandelstam as a boy, and yet, he never seems like a boy to me. All that was boy in him seems lost, forgotten in a snow landscape made with bruises and fear.

*From sketchbook notes dated March, April, July, and August.*

161

Nonetheless, I hear the boy as a whisper in between words like here:

Bees are humming noisily . . .
His cockroach whiskers . . .

maybe not this one,
maybe this one is old.

Foxholes: even that word reminds me of a landscape, although I've never been in—of a boy (or a girl, a girl like Gabriela).

No choir of the "settled" will ever sing Mandelstam's song. That is clear. But nothing else is.

Today an angel, tomorrow a worm in the tomb.
The next day just an outline, nothing more.
Tattoo that face into my daughter's back.[2]

March (Delray Beach FL). Everything is always for grabs except when it ought to be, then it is still for grabs but no longer accessible. By the time it "drops-down" it is lifeless. Family is always for grabs. Perhaps, Kierkegaard's Regina only was up for grabs when he gave her up—when she became only an idea.

What a bunch of nonsense. Kierkegaard bet it all on a ghostly horse and lost. But what a horse it was![3]

March 20 (Delray Beach FL). Woke up and read this: "How can we be just in a world that needs mercy and merciful in a world that needs justice?"

Had I been prudent, I would have gone back to bed. Instead I read more of Frost's poems. Who suggested that Robert Frost is heart-warming? His poems leave on their path the barren beauty of having seen things clearly—even dualities. To make paintings like that is very difficult. But so is to make poems.

We all got the hibby-jibbies hearing of John Kerry's poetry because we suspected its softness. I don't think it would be as funny if we imagined he wrote like T. S. Eliot or Martinson.

Martinson is an idea. An idea of beauty and strength compressed into an iceberg. If it would be possible to compress an iceberg into a "diamond-like" x-tal and have that x-tal always at risk of melting, that would be Martinson's unity. That's cumbersome to say in writing. Easy to make in a painting.[4]

Thank god there is or was a guy like [Joseph] Brodsky around to remind me how long the road is and how high is the bar of quality. Otherwise it could be easy to think of myself as something other than a hack.

It is disgusting to think of modesty here. It is clear that there are worst hacks than me, but where does that leave me? Two deadly qualities:

1. self-awe
2. self-tolerance of one's weakness

Those who are impressed with themselves don't know much.[5]

April (Delray Beach FL). Art as a public experience has, more or less, always followed semi-static relationships between its elements as well as the space of the observer. Surprisingly this has not been discussed much—maybe [Rem] Koolhaas. This limitation of the discourse may have his source on "visuality" as well as a tradition of "unfolding." Both of these attributes have created a "grammar of expectation" that is difficult to disrupt. Even "wild" installations, like Rhoades, are still profoundly static—quaint in their dynamic force. Minor thinking like the one used by the critics of curators who write: "the work forces the viewer to" or "the artist questions. . . ." Writings like that always expose the idea of "comprehended" demarcations of information boundaries. But there really is no "question" of "forcing" anyone who is mentally able. Their "challenges" are, at best, nudges.

There is much to be said in agreement with Craig Owens that figuration—'80s as well as today—speaks in the present as if made in the past. The popularity of representation—again—is an acknowledgment of the debased thinking of collectors and curators. Like the decorator's impulse to collect "nonfigurative" work, the new lovers of figuration miss the point. One big point: most figurative work sucks. It represents temporal arbitrage. They are pastiches of earlier work no longer mentally or commercially accessible.

Freud's idea that artists seek "honor, power and the love of women" proves that he didn't understand artists. At least none that were good.

Schnabel said some things that sounded good, at first, and that might even have simplistic applications. He said something like: "Most paintings become familiar when you see them, and then it is too late."

This is a reinterpretation of the modernist search for originality. It seems to me that most things, especially paintings, are ultimately familiar, particularly in attitude. And this condition can't be changed by "surprise" or any new twist.

The possibility of art begins, in fact, when it is familiar but upon further examination becomes increasingly unfamiliar. Only then, It seems, it grips, it engages, and it measures up to deep religious or philosophic engagement.

I remember. But it is not much in the larger scheme of things: Six or seven butterflies circled a lighting. Below them, a birch, so long and thin as to

seem a lightning rod, grew by the river. A boy, standing by a young fir, with a tumor under his rib.

Maybe they seem charming to others, but to me they are fearsome, coagulated air, which reminds me of the transient-ness of states, of what I think I hold. The flight of butterflies by our gardenias compresses my past and my death—in them I can remember being no longer around.

Today I saw a truck of Van Gogh vodkas. It was a sight to behold, far superior to any art commentary at the fancy museum. Art is either religion or nothing at all.

### The Butterfly

Born to be a butterfly my cool flame flutters on the heavy velvet of
    the grass. Children chase me. Beyond the mallows and tussocks
    the sun is setting. I manage to escape into the night. The moon
    rises: it is far away. I am not afraid.
I listen to its rays. For their protection my eyes film over.
The dew makes my wings stick together. I sit on the nettle.

HARRY MARTINSON[6]

### Birch Heart

The heart out in birch bark has swollen with time. From the tree's sap
    it drew life and became like a beam.
A few more years in the woods and it will start to beat.

HARRY MARTINSON[7]

Properly speaking, it is not a story. It has no narrative. It is a constellation of events, impressions, and a few questions. To map it, I would have to scatter a few pictures, a few memories, notes that seem unrelated. How many times do people ask to read my writings to "understand art" (there's nothing to understand and my notes make everything worse). Despite this problem of the notes they are still the basis of my point of view. The pictures of the studio and the work in process say more of and about the problems, the approach, than the essays, the writings.

What is it that matters here?
Becoming-shaping → boy/girl
Danger: truncated, derailed
Absolutes → landscapes, light, winter

People ask me about biography but this question always points the wrong way. If it is biography, it is not about its instances but the armature underneath. The skeleton. This is what I wish to see better.

Not to mean "depth"; appearance, in fact, is most of the time all there is. It is about interstitial, friction, props. It is about the nature of life and art, which are, after all, a mapping of each other.

The problem with the Hegelian-Greenberg trajectory is that it is not complex enough. The problem with post-structuralists is that they allow too much psychology. But they were right about the destability of meaning.

A universe mapped out by a simple basis. That is: the space to investigate has only a few independent variables.

Becoming
Absolute
Dirt (which includes plants)
Light (which includes air)
Distraction
Smallness of spirit (includes envy, pettiness, and pretension)
VS
Smallness and confusion and hearsay and "importance"
Use antidotes:
Martinson
Mandelstam
Kierkegaard
L.W. (?)
Brodsky[8]

July 18 (Delray Beach FL). Much has been said about the idea of "nomad"— spatial movement—and its influence in thought, particularly the arts. After all, a great deal of modernism is the result of "nomads" bringing their experience in to a new land and generating new "crops."

However, what interests me is temporal nomadism. Say, for instance, how did the child end up living the life of the man. Bruce called my work "intellectual" and the words sounded wrong. Ultimately, much of my effort to speak a certain way about the work has been to avoid the trappings of pseudo-intellectualizing and glib pop-talk, but in fact I might have failed. Misinterpreted. In an effort to be precise—undoubtedly, a lousy effort—all I've done is leave a trail of misinformation behind me. All that reading has served to steer me clear of nonsense—some of it—and to exercise my mental/emotional ambition. The rest—the "intellectualism"—is insignificant.[9]

July 20 (Delray Beach FL). It would be tempting to make MAM's show civilized: sparse. But it must be dense, it must offer the possibility of substance. Much of that "careful installation" so alluring and common is the high-end. Pottery Barn. Theirs is an antiseptic view of art, which is less because of love of art than love of the "lifestyle" afforded by art. It usually points at not very nimble minds. The kind of people that in the Pottery Barn of the '60s would have gone for the formed plastic table.

I would like to "start again" in the MAM works. Of course, not in any fundamental way—after all, there would be no MAM works without *The October Cycle* or *Berlin* or *Guide* or *Schneebett*. But it would be mine if I could resist the past, the attributes that might had seen mine, and begin again. Above all, I would like to not say much about the ideas. It only leads to confusion. Martinson—yes, an influence, but let's not say why. If I tried I would be lying, anyway. Let's say Brodsky, but let's also say that I invent him. And the same with all the others. I learn to invent, to justify, something that has always been there. The work is fundamentally impenetrable to me. Why shouldn't it be so to someone else?[10]

August 2 (Delray Beach FL). Everything that seems to matter, matters against a landscape of change or of either insignificance or huge significance. The scale of what matters is always off.[11]

**NOTES**

1. Sketchbook notes originally reproduced in *Another Show for the Leopard* (Aspen CO: Baldwin Gallery, 2007).
2. *Another Show for the Leopard*.
3. *Another Show for the Leopard*.
4. *Another Show for the Leopard*; also reproduced in *Nomad* (Delray Beach FL: Whale & Star in association with Miami Art Museum, 2007).
5. *Another Show for the Leopard*.
6. Appeared in *Wild Bouquet: Nature Poems* (Kansas City: BKMK Press, College of Arts and Sciences, University of Missouri–Kansas City, 1985).
7. Appeared in *Wild Bouquet*.
8. *Another Show for the Leopard*.
9. *Nomad*.
10. *Nomad*.
11. *Nomad*.

*The Unwilled*
in process,
Santa Monica,
California, 2007

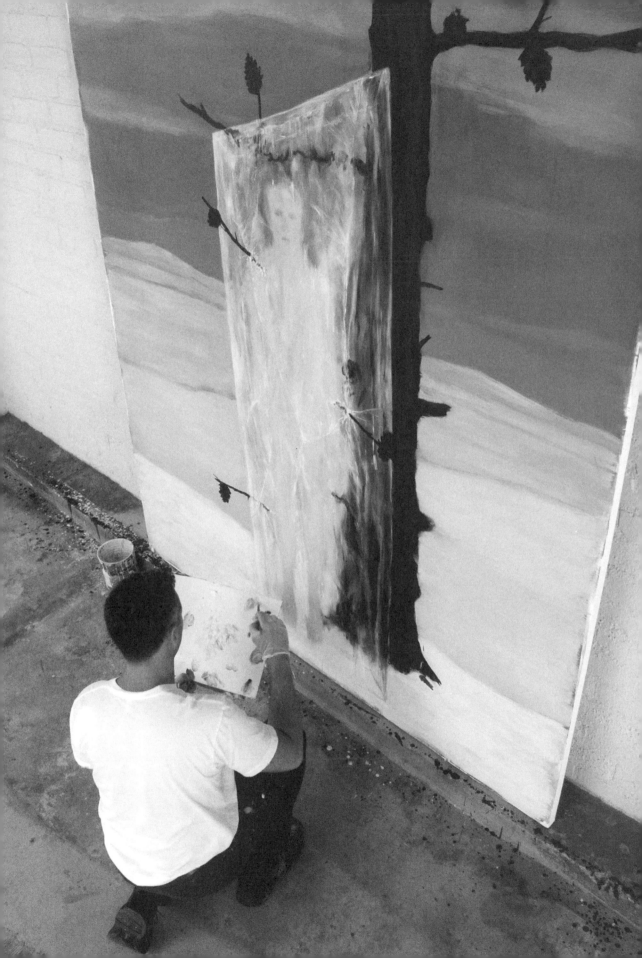

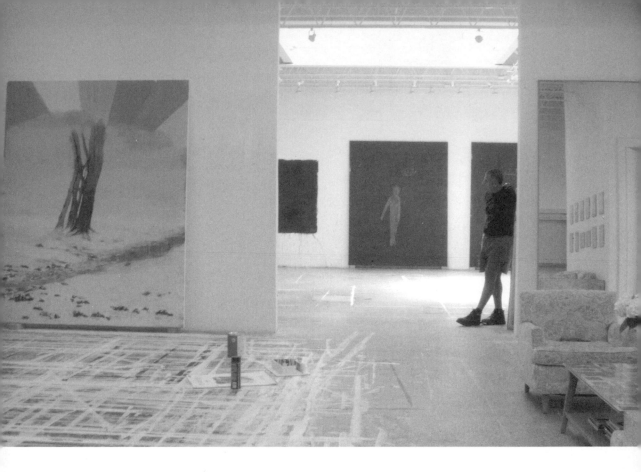

Studio,
Delray Beach,
Florida, 2006

From Considering Painting and Meaning

The first question is why paint? Exploring possible answers usually offers direction. There are two main ways to think of painting: as a verb or as a noun. Those who view painting as a verb tend to approach it in terms of what you do to it—strokes, gestures, movement. Those who view painting as a noun tend to see the work as a mental state. In this view, anything can be a painting.

Seventeen Thoughts:

1. Painting = timelessness + distance.
2. All great paintings are the same.
3. Good paintings are never what they seem.
4. In good paintings, what we think we recognize soon becomes mysterious. In lesser paintings, what at first seems mysterious we soon recognize.

*This writing originated from a workshop on painting at the Anderson Ranch Arts Center at Snowmass Village, in Colorado, July 2–13, 2007. The complete notes for the workshop were originally published as a Whale & Star Working Book. The book also included selections by Jose Ortega y Gasset, Gerhard Richer, Leo Tolstoy, Andy Warhol, Lucian Freud, and a conversation with Enrique Martínez Celaya and Richard Whittaker.*

5. The bridge between painting and meaning is courage. Lack of courage is a common problem.
6. Many problems in painting are the by-product of confusions introduced by language.
7. Specificity allows for painting.
8. In art the objective usually comes through the subjective.
9. Effort and quality are unrelated variables. Many bad paintings represent a great deal of effort.
10. Art needs no apology, so make no apologies. To try to appear intellectually fancy can be a form of apology.
11. It is useful to begin a work at a point of disadvantage.
12. The visual embodiment in a painting is just an instance of how the spirit is manifested.
13. There are two common problems in making paintings: problems that are obvious to the painter and problems the painter doesn't know. Solutions for the second type of problem require a fundamental, sometimes paradigmatic, shift.
14. Much time is devoted to talking about freedom in art, but art is mostly about boundaries. Constraints. Freedom only seems to exist within those confines, and only to an extent.
15. Form vs. content is a tiresome polarity. Do away with it. The friction between more interesting dualities is the source of painting: hand/distance, sublime/earthly, reference/presence, concept/object. Heidegger . . . content: human (references, mind, idea) and world (earth, soil); material and world.
16. Don't rely on "The Theory of the Additional": Ten misunderstood things added to each other do not equal one clear thing.
17. It does not matter how many things are working in a painting if the painting is not good.

Studio,
Delray Beach,
Florida, 2008

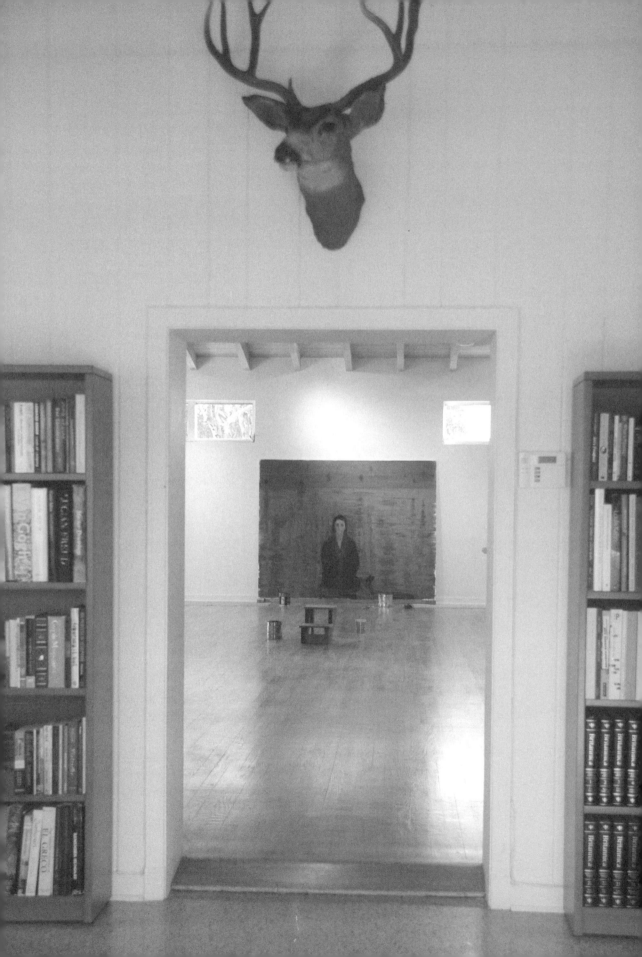

## 2007 Boy Raising His Arm

The slight raise of the arm, in contrast to his face looking down, is a stand, a position—an assertion. The boy seems to be asserting himself in the world beyond himself, establishing a sphere of influence, of effect.

I am interested in seeing the friction between the philosophical foundation of my work and the spiritual framework of a church. My work is secular, and yet it is frequently seen connotative of a religious point of view. Undoubtedly, this is the result of the ethical imperative in the work that directs my inquiries into explorations of time, fragility, consciousness, and remembrance.

I would like for the church context to be a circumstance capable of generating new insights into the interpretation and understanding of the artwork. That is, the installation would re-create the work of art.

*Excerpt from a statement to curator Klaus Ottmann for the work* Boy Raising His Arm *on display at OPEN e v⁺a—a sense of place, March 30–June 24 in Limerick, Ireland.*

Studio,
Santa Monica,
California, 2008

2008   From *The Blog: Bad Time for Poetry*

Thursday, February 7. *Santa Monica Studio.* We have finished the construction on the Santa Monica studio, and seeing the effort, some people have asked me if the project takes away from my work.

The question seems to point at a more definite understanding of my work than the one I have. To me, "the work" is always shifting and always feeding on that shift. The question also underestimates the value of this particular "detour." It would be hard for me to make a categorical distinction between the process that generates a painting and the process that decides I should hang the deer head in the studio's library. In each gesture I am trying to sort myself in relation to it and to find something refuge-like in the final assembly. Space and furniture, for instance, are something quite

*The blog was originally on Enrique Martínez Celaya's Web site, existing from August 24, 2007, to May 25, 2009. It now exists as a book containing all of Martínez Celaya's entries.* The Blog: Bad Time for Poetry *(Delray Beach FL: Whale & Star, 2009).*

distinct from the position one takes toward painting only if the purpose itself is quite distinct. For me, the studio is an embodiment of the same point of view that generates the artwork.

The artwork and the studio have many (though not all) of the same aims and provide me with similar comfort and discomfort, so what is the meaning of lost time or interruption of the work? I gain energy by using it.

Tuesday, February 12. *Soul Searching*. "A great nation deserves great art" is the slogan of the National Endowment for the Arts. It is catchy, but what does it mean?

A nation inches toward greatness, in part, by assuming it doesn't deserve much, and it maintains its greatness, in part, by understanding "greatness" is not a coronation or a title but a reflection of the quality of becoming.

Moreover, the relationship between great art and great nations is by no means tidy. Spain in the seventeenth century, for instance, was losing its hold on the empire and was burdened by disease. It was also entrenched in the Inquisition and abusing the American provinces. So did it deserve Velázquez, Zurbarán, Lope de Vega, Luis de Góngora, etc.?

Perhaps it is more accurate to say—in the case of Spain as well as in many others—that nations get the soul-searching they deserve in the work of their artists. Art is the mirror in which nations who think of themselves as great must see themselves, often, as otherwise. But that is a less catchy slogan.

Monday, March 17. *A Witty Age*. The moralists are running to the microphones, their chests inflamed with indignation. They make an example of Eliot Spitzer, and their theatrics remind me of that other Eliot, who thought the world would end with a whimper rather than a bang. If only some would avoid speech, as in that other line of "The Hollow Men."

"What an age," Thomas Hoveling once said, and then, when I didn't say anything, he added, "Wit. Don't forget the wit."

Here is a little fantasy: I settle for smelling the orange blossoms as the powdered wigs walk by. Everyone looks so good under the glass tears of the chandeliers. Everyone but me, I say to Thomas, and with a finger smeared in saliva, I remove the dirt from my shoes. I sit in a corner trying to fit in. Experts in irony, the moralists, with their flaring cuffs, hold the little hands of the academics as they glide on the dance floor. The entertainers and the financiers talk about their retirement accounts while the rebels listen in.

I do fit in. And where are the arts?

They wave at me from the other side of the room where a small auction is being held. All of them, even the critics, are wearing Hirst's Manolo Blahniks. On the men, the Manolos seem a bit puffy.

Thursday, May 13. *Being Cuban*. For some time questions and bewilderment about my "Cubanness" have hovered around my work and me. From what I gather, it seems to some people that my influences, my behavior and public choices, and the way I go about presenting my work do not easily conform to notions of being Cuban, or even Latin American.

Today I will contribute my opinion to this minor debate.

I have often thought that Tolstoy's first line in *Anna Karenina*, "Happy families are all alike; every unhappy family is unhappy in its own way," is not only a fine remark on the specificity of misery but also a warning against the tendency to trust generalizations.

Undoubtedly, ethnicity and nationality contribute to self-definition, but are they as relevant in day-to-day living as our individual experiences of class, family, exile, disease, and books, and our happenstance of epoch, encounters, and genetics? Furthermore, if we are heirs to values and assumptions that influence the manner in which experiences are lived and perceived, how do the experiences, in turn, influence those values and assumptions? And in the arts, where does heritage begin and end? For instance, in the question of Joseph Conrad's "Russianness," where is Poland, orphanhood, lost nobility, the sea, sickness, exile, and language? Is Conrad's Russianness something more than an aroma perfuming the man and his writing? And what in T. S. Eliot is American? Is Pablo Picasso's work Spanish? Is Jorge Luis Borges a traitor for preferring English and German?

I won't attempt to answer any of these questions. Instead I offer them as disclaimers to what follows.

For me, being Cuban is about the tone of my childhood and subsequent exile and, less important, some values and fears that colored the way I was raised.

My childhood is a childhood of images I still don't understand and hence, to be Cuban, for me, is to not have been in Cuba long enough to understand them: poorly lit rooms decorated with furniture that couldn't be bought anymore and therefore couldn't be used, standing in dilapidated yards on bright hot days, watching adults mourn our impending departure, talks of "El Norte," talks of Fidel, surreal juxtapositions of old toy soldiers and caged birds and billboards of the Revolution, suffocating asthma attacks on a sweaty bed, leaving on an Iberia plane knowing we will never go back. To be Cuban is also to have lived in Spain as a foreigner; to have endured the jokes; to have learned to speak with a Castilian accent; to have gone to Mass only to look at the girls; to have been poor in Madrid in winter; to have sought country in my family, compatriots in my brothers, and fistfights in school.

To be Cuban is also the Cuban writers who I read as a kid: Guillermo

Cabrera Infante, Nicolás Guillén, José Martí, Reinaldo Arenas, and Alejo Carpentier; it was the Spanish translations of Kafka and Tolstoy and my mother's choice of reading to me a story about the sinking of the *Andrea Doria* at nighttime.

I did most of my reading in Puerto Rico, however, where being Cuban meant being an outsider but also a fellow Caribeño. Caribeño, in the 1970s (and probably still), was being part of the sea, colonialism, humor, food, and a collective sense of inferiority. It was also reading Kant in junior high school hoping we were smart enough (we weren't) to understand it, but free of the idea that the German philosopher wasn't speaking for us.

To be Cuban, for me, means more letters than country, more a way of looking at things than memories. It also means nothing really "is," everything is becoming, including self-definition; every idea can be my own and every failing possible. To be Cuban, for me, is to be thrown into the recognition, as Kristeva has suggested, that the foreigner is within us and that, consequently, what some people don't understand about me and my work—German and Scandinavian influences, American literary references, physics, concerns with time, Jewish parallels—is nothing but an attempt to make sense of that foreigner.

**Thursday, June 12.** *On Looking at the Work Done.* Nietzsche wrote in regards to his book *The Birth of Tragedy*:

> I find it an impossible book: I consider it badly written, ponderous, embarrassing, image-mad and image-confused, sentimental, in places saccharine to the point of effeminacy, uneven in tempo, without the will to logical cleanliness, very convinced and therefore disdainful of proof, mistrustful even of the propriety of proof, a book for initiates, "music" for those dedicated to music, those who are closely related to begin with on the basis of common and rare aesthetic experiences, "music" meant as a sign of recognition for close relatives in arbitus [in the arts]—an arrogant and rhapsodic book that ought to exclude right from the beginning the *profanum vulgus* [the profane crowd] of "the educated" even more than "the mass" or "folk."[1]

But despite his accusations and reservations, Nietzsche found value in his book because he trusted the intent and the merits of its subject (the history of Greek tragedy and the psychological/philosophical distinction between the Dionysian and Apollonian spirits), and also because Nietzsche had an ability (coming from clarity, arrogance, or both) to see his own personal enterprise in a historical perspective: "This audacious book dared to tackle for the first time: to look at science in the perspective of the artist, but at art in that of life."[2]

For two years my studio has been working on a series of books documenting the work I have done since my days as an apprentice. It is not a work for publication. Nonetheless, seeing it in the world, even in its limited visibility, makes me consider the value of much of what I have done, and in turn, much of what I am doing. Looking at these books I have feelings not unlike the ones Nietzsche had in regards to *The Birth of Tragedy*, with the exception of his conviction of the work's importance.

There is one argument the books make very convincingly: some things won't be again.

*EMC in response to a comment:* In response to Gawalt's comment to the previous blog entry. No. I was trying to distinguish my ambivalence toward the value of work I've done with Nietzsche's certainty. But your question regarding the underpinnings to my aesthetic ideal is interesting.

It might be Nietzschean, but it is difficult to say, particularly because Nietzsche's aesthetics and his views about the function of art changed throughout his life.

When I was younger I read Nietzsche and other authors influenced by his ideas. Those readings had an impact on me, among other things because they came at the right time and because I didn't have a well-developed frame of reference. So I think it is likely that to some extent Nietzsche has influenced my work—possibly to a large extent—but the way in which his ideas influenced my work and thought are indistinguishable now from the foundation of my point of view. I probably read him too early.

It makes me think of an old friend who, regarding the books of Hermann Hesse, said: *Demian* is a book that should only be read when you are starting your life, and *Steppenwolf* a book that should only be read when you are coming back from life. I am not sure what he meant but it sounds right.

As a youth it is easier to feel comfortable with adoring Nietzsche.

**Wednesday, July 16.** *The Hand*. When I cut my left hand, the words from the *Hagakure*, "At that time is right now," came to mind. As I looked at the hand, life was both—and not contradictorily—more factual and more dreamlike, and what was happening was no longer in the future but right there. The first part, the taking off the glove, was the hardest. Once I had seen it, there was nothing but coming to terms with things.

It happened while I was carving a large wood sculpture. I was going back and forth between a chainsaw and a high-speed grinder equipped with a chainsaw blade, which allowed me to move quickly through the wood. I almost remember the moment when my hand touched the blade, but I remember better the moment just before and just after.

My life will soon continue, more or less, as it was. The turn, however,

did happen; in my case a minor turn, for which I am grateful. The turn has been worse for others. In the ambulance I couldn't stop thinking about the people losing body parts in Iraq—the American soldiers, the Iraqis, the children. The images that came to my mind seemed then—as they do now—unjustifiable by any policy or by any excuse.

Right now, someone, somewhere, holds on to his or her dismembered leg, arm, or hand, or to the dismembered part of a daughter, a father, or a friend. That we can know that and continue on with our banal lives clearly says something about the machinery of survival.

Tuesday, October 14. *Unreasonable Pursuits: Moby-Dick.* The reasonableness of most pursuits is arguable, especially pursuits carried consciously or unconsciously as affronts to reasonableness. In the arts, but not just in the arts, these reasonableness-challenging pursuits tend to lead far from certainty. The mighty and the ones who like to appear mighty or who don't know any better, suggest trusting, advice that has kept many in foolish voyages from which they never returned. The prudent and the cowards suggest retreating and the results of this advice are plain to see.

It is not easy to be a good judge of time and circumstance, which is what is called for here. The following are excerpts from contemporary reviews of *Moby-Dick* and from a note on Melville's death (from www.melville.org, a useful Web site). I find it interesting to read these from a distance of 150 years, which we don't (usually) have in our own pursuits.

> The more careful, therefore, should he [Herman Melville] be to maintain the fame he so rapidly acquired, and not waste his strength on such purposeless and unequal doings as these rambling volumes about spermaceti whales.
> —*London Literary Gazette,* December 6, 1851

> In all other aspects, the book is sad stuff, dull and dreary, or ridiculous. Mr. Melville's Quakers are the wretchedest dolts and drivellers, and his Mad Captain . . . is a monstrous bore.
> —*Charleston Southern Quarterly Review,* January 1852

> We have no intention of quoting any passages just now from Moby Dick . . . But if there are any of our readers who wish to find examples of bad rhetoric, involved syntax, stilted sentiment and incoherent English, we will take the liberty of recommending to them this precious volume of Mr. Melville's.
> —*New York United States Magazine and Democratic Review,* January 1852

> It is strange how he persists—and has persisted ever since I knew him, and probably long before—in wandering to-and-fro over these deserts,

as dismal and monotonous as the sand hills amid which we were sitting. He can neither believe, nor be comfortable in his unbelief; and he is too honest and courageous not to try to do one or the other. If he were a religious man, he would be one of the most truly religious and reverential; he has a very high and noble nature, and better worth immortality than most of us.
—Nathaniel Hawthorne, notebook entry, November 20, 1856

The sum and substance of our fault-finding with Herman Melville is this. He has indulged himself in a trick of metaphysical and morbid meditations until he has almost perverted his fine mind from its healthy productive tendencies.
—Fitz-James O'Brien, "Our Authors and Authorship, Melville and Curtis," *Putnam's Monthly Magazine*, April 1857

Herman Melville, one of the most original and virile of American literary men, died at his home on Twenty-sixth street, New York, a few days ago, at the age of 72. He had long been forgotten, and was no doubt unknown to the most of those who are reading the magazine literature and the novels of the day. Nevertheless, it is probable that no work of imagination more powerful and often poetic has been written by an American than Melville's romance of Moby Dick; or the Whale, published just 40 years ago [ . . . ] Certainly it is hard to find a more wonderful book than this Moby Dick, and it ought to be read by this generation, amid whose feeble mental food, furnished by the small realists and fantasts of the day, it would appear as Hercules among the pygmies, or as Moby Dick himself among a school of minnows.
—*Springfield (MA) Republican*, October 4, 1891.

**Tuesday, October 21.** *A Sentimental Education.* Sometimes I am asked about my influences or my education, and I sometimes ask others for the same. I am not sure what we expect to find. Causes and effects are usually separated by years and events; a bend here; a twist there; a fear, for instance, that reacts with an image or a song to make a new emotional compound and part of a personality. The stories we build to make sense of what happens or happened are fictions, always oversimplified and often misunderstood.

In 1978, Pablo and I had a sleepover and as part of the rituals we ate late, talked—mostly lied—about girls, and played records. I think Pablo had gotten the records from his father. Through the night Paco Ibañez, Silvio Rodríguez, and Joan Manuel Serrat sang and we listened, pretending to be more mature than we were; at fourteen we could still take ourselves seriously. At some point we played Serrat's record devoted to the poems of Miguel Hernández and laid on the floor looking up at the ceiling, in

silence. Since then "Umbrío por la Pena" ("Shadowed by Sorrow") has been an ongoing education.

*Shadowed by Sorrow*

Shadowed by sorrow, nearly black
because sorrow soots when it bursts,
where I am not, it is not
the most sorrowed man.

I sleep alone and one on the sorrow,
sorrow is my peace and sorrow my battle;
a dog that neither leaves nor lies quiet,
always faithful, but inopportune.

Thistles and pain I carry as a crown,
thistles and pain sow leopards
that do not leave a bone uncrushed.

Surrounded by sorrow and thistles
my body can bear no more.
So much sorrow only to die![3]

**Tuesday, December 2.** *Radical Doubting.* People vary in their capacity for accepting doubt, especially of cherished beliefs, and they also vary in how much of themselves they are willing to doubt.

The belief that our experience, our education, our status, and our upbringing are proofs and guarantees is vanity. Although never easy, it seems clear that erasing some aspect of attributes-of-self is necessary. In *Fear and Trembling*, Kierkegaard quotes Luke 14:26: "If anyone comes to me and does not hate his father and mother, his wife and children, his brothers and sisters—yes, even his own life—he cannot be my disciple."[4]

What does one trust? I have considered this question for a long time, but neither the question nor its implications have become easier. Some time ago I read Alan Watts: "To have faith is to trust yourself to the water. When you swim you don't grab hold of the water, because if you do, you will sink and drown. Instead you relax, and float."

Relax and float.

Yet, while relaxing and floating are necessary, they are not sufficient; at least not for doing something interesting and meaningful—admittedly values. To do, and perhaps also to be, something interesting and meaningful, passion and faith must exist as well. Art, like life, depends in part on desperate passion and faith amid unshakable doubts. A leap of faith must not only be taken despite doubts but in fact depends on those doubts. There is no leap without doubts.

While faith—the confidence of a better condition—is probably always spiritual in essence, it ought not be religious in practice, in discipline. Of course, without religious doctrine, as is the case in art, passion and faith often become soft and end up being more attributes of vanity. In my view, the crucial word in the previous paragraph is "desperate."

Radical doubting.

Tuesday, November 11, 2008; Wednesday, December 17, 2008; Tuesday, December 23, 2008; Friday, January 9, 2009. *Painting and Structure.* Why does an image work in a painting while another (a similar one, say) does not? What is the balance between presence and reference and on what does that balance depend? How is distance created in the interaction between viewer and painting, and is it possible to speak of the autonomy of a painting?

Usually, painting is seen mostly for the amalgam of attributes that it is, such as treatment, imagery, scale, etc.—painting as a sum of sorts. However, if instead of seeing painting as sum we look at it singularly as a state of thought, our view of painting and how it is achieved can change in significant ways. Most of the issues that matter, for instance, will quickly show themselves to be related to structure. That is, related to the underlying supports that give shape to the state of thought, and by thought here I mean the entire force of the spirit: reason, emotion, intuition, etc.

Some artists consider structure the most exciting aspect of art and while others might not go that far, it is hard to imagine a musician, artist, or writer who is not frequently puzzled by an aspect of structure. To consider structure in the visual arts, literature, dance, and music means to take on the relationship between parts and whole, between forces and constraints, between the "in" and "out" of the work. That is, to consider structure is to consider why something works or doesn't, and since art is only that which works, to consider its working is to consider its essence.

This might be why many visual artists have tried to make structure more explicit in their artwork and why frankness about structure has become expected in most intellectual circles. In fact, structure is one of the foci around which the 250-year-old modern project revolves. In the last century, the desire to make structure more explicit led a significant number of artists to take structure—somewhat isolated from other aspects of art—as the subject of their work. The effort of the isolationists has, at times, produced work of subtlety and insight and, other times, the work has been mired by cleverness. In either case, the results  for the most part—only have the appearance of art.

It is probably the crudest but also the truest approximation to say what matters in art is Heart. If we were Tilman Riemenschneider, Heart will bring forth and organize, heighten and shape, as it should be. If we are not

Tilman Riemenschneider, Heart might not be the fountain or the guide we wish it to be and, for the most part, little can be done about that.

Which might be why anything I say about art or its making often sounds like nonsense to me. In *Philosophical Investigations*, Wittgenstein wrote,

> We have got onto slippery ice where there is no friction and so in a certain sense the conditions are ideal, but also, just because of that, we are unable to walk. We want to walk so we need friction. Back to the rough ground![5]

The pull toward objective understanding is the fool's effort. The Heart, however, is slippery ice. No work can be done there. The nonsense is the rough ground. Most of my own efforts to understand are centered on concerns with structure, and the main problem I have with the isolationists I mentioned in the previous entry is their structures are seldom complex enough.

A particular structure is a state of the work of art, a state that can be changed by content, purpose, and failure. The tensions and points of support in the painting "of an apple" have to be different than those "of a horizon" and then they have to be different if it is "this apple" or "that apple," handled "like this" or "like that," and so on. For instance, an apple painted by Cézanne exerts less "outward" pressure on the surface than one by de Heem, and therefore brings about an entirely different armature or structure; a green apple is different than a red one; a mythic one is different than a "factual" one. Which is why there is little chance of doing anything useful with general ideas about structure or simplifying its "physics" to perceptual illusions and formal aspects, particularly aspects imagined to be invariant to content, purpose, and failure. Structure is the ensemble of forces and parts in the work of art and these forces and parts are remade by perturbations of everything that matters to the work and its experience.

Perturbations are the type of elusive thing Heart can account for. There is also some sort of "dark matter," invisible to most of us, in the ensemble of forces and parts. Heart finds itself in this uncertainty and this finding reorganizes both.

"I am interested then only in the problem of painting, of how to make a better painting according to certain laws that are inherent in the making of a good picture and not at all in private extraversions or introversions of specific individuals,"[6] wrote Marsden Hartley in his 1928 essay "Art and the Personal Life," and for the rest of his career he would claim disdain for the personal, the confessional, and the emotional.

But anyone who considers a Marsden Hartley painting with some attention recognizes the man, not just the intellect—personally, emotionally, and as a confession. What Hartley might be doing is playing a hide-and-

seek game most artists play. Thomas once told me the key to an artist's work is in what he or she denies. It is also possible, though unlikely, that Hartley could have underestimated how much the irrational and rational depend on each other. Whatever the case was, his words exaggerate the opposition of emotion and intellect and of content and form. In contrast, Hartley's paintings make a great argument for—and are—a reconciliation of imagination and the world, of form and content and of the rational and irrational. The structure of his work owes its intelligence not only to a great intellect but to a profound emotional sensitivity that can be perceived throughout.

He concluded his essay in an appropriately confusing and reconciliatory manner.

> Underlying all sensible works of art, there must be somewhere in evidence the particular problems understood. It was so with those artists of the great past who had the intellectual knowledge of structure upon which to place their emotions. It is this structural beauty that makes the old painting valuable. And so it becomes to me a problem. I would rather be sure that I had placed two colors in true relationship to each other than to have exposed a wealth of emotionalism gone wrong in the name of richness of personal expression. For this reason I believe that it is more significant to keep one's painting in a condition of severe experimentalism than to become a quick success by means of cheap repetition.
>
> The real artists have always been interested in this problem, and you feel it strongly in the work of da Vinci, Piero della Francesca, Courbet, Pissarro, Seurat, and Cézanne. Art is not a matter of slavery to the emotion or even a matter of slavery to nature or to the aesthetic principles. It is a tempered and happy union of them all.[7]

### NOTES

1. Friedrich Nietzsche, *The Birth of Tragedy*, trans. Douglas Smith (New York: Oxford University Press, 2000).
2. Nietzsche, *The Birth of Tragedy*.
3. In translating this poem, EMC used Ted Genoways's translation as a starting point.
4. Søren Kierkegaard, *Fear and Trembling*, trans. Sylvia Walsh and ed. C. Stephen Evans and Sylvia Walsh (New York: Cambridge University Press, 2006).
5. Ludwig Wittgenstein, *Philosophical Investigations*, trans. G. E. M. Anscombe (New York: Macmillan, 1953).
6. Marsden Hartley, "Art and the Personal Life" (1928), http://www.artchive.com/artchive/H/hartley.html (accessed January 9, 2009).
7. Hartley, "Art and the Personal Life."

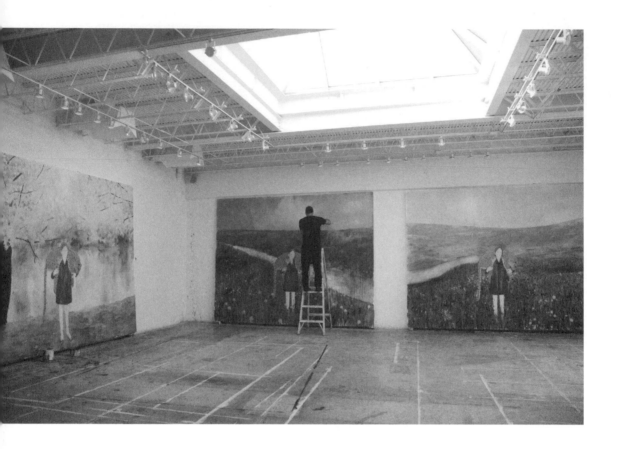

## 2008 Art and Museums

*Authority in the middle of the twentieth century has changed its character; it is not overt authority, but anonymous, invisible, alienated authority. Nobody makes a demand, neither a person, nor an idea, nor a moral law. Yet we all conform as much or more than people in an intensely authoritarian society would. Indeed, nobody is an authority except "It." What is It? Profit, economic necessities, the market, common sense, public opinion, what "one" does, thinks, feels.*

ERICH FROMM, *The Sane Society*

Studio, Delray Beach, Florida, 2007

*Originally presented at the Sheldon Museum of Art at the University of Nebraska–Lincoln as part of the University of Nebraska Visiting Presidential Professorship. Originally published as "Now What?" Journal of Aesthetic Education 41, no. 2 (Summer 2007); and as "The Parting of the Exemplary Museum," works + conversations 15 (November 2007).*

In 1976 there were approximately six thousand museums in the United States. Today that number is close to eighteen thousand. This rate of growth is three times higher than the growth in our per capita income, five times higher than the population growth, and six times higher than the growth in the percentage of high school graduates. This threefold expansion of the museum is comparable to the growth in the number of movie screens in the United States and can be explained, in part, by the increase in the number of cultural consumers as well as by the effort on the part of museums to become more inclusive and welcoming institutions. The museum boom, especially the art museum boom, which is the focus of this talk, has also benefited from the unprecedented economic growth of the last three decades, which encouraged the proliferation of master of fine arts programs, generated renewed interest in urban areas, and created many fortunes capable of supporting the construction of new cultural institutions.

It is not difficult to see why many people have argued that the proliferation of art museums is good. Museums embody the belief that something worth experiencing should be accessible to the public rather than being reserved for the lucky few. Museums also preserve objects and ideas we value and help our understanding of them. And museums represent, along with colleges and universities, the highest level of scholarship at the service of the public good. However, it is difficult to unreservedly endorse the recent art museum expansion because, among other things, the boom has exacerbated the confusion between consensus and quality.

To better understand this confusion, as well as other problems that have risen around it, let's begin by considering why wealthy patrons and politicians might like to build museums.

Although the reason for each major financial contribution is seldom clear, these gifts make sense as a collective gesture. Many Americans are ambivalent about religion and suspicious of the heroism of recent wars, so it doesn't seem surprising they would uphold the museum as a sign of vitality, enlightenment, and reinvention. In addition, the museum is an effective way to create a visible legacy. What is less apparent, and more troublesome, is why even relatively poor cities have been eager to secure funds to pay for not just any museum but for massive cultural cathedrals.

Perhaps the motivations behind the puzzling actions of these cities are revealed by the architecture of these enormous undertakings. In recent museum designs the temple aesthetic of the neoclassical building has been replaced by cutting-edge architecture distinguished by a flair for the fantastic. The new buildings suggest an institution that wishes to be welcoming and which is willing to offer glamour and entertainment in exchange for attention and, hopefully, the public's embrace. It seems that

to the museum, to the politicians, and, perhaps, to the public, the fantastic building represents the best the city has to offer.

The new architectural paradigm is a collective dream and a public strategy, but it is also a reflection of how quality is understood within the institution. In some cases, administrators, builders, and donors are able to maintain very high standards. They might be the exception. For the others, two centuries of modernist revisions have yielded a simplified version of greatness that amounts to little more than consensus and awe. Thus, for some museum staffers, size, prestige, and novelty are not only catchwords to use in capital campaigns but appropriate stand-ins for greatness. The erosion of aesthetic and ethical aspirations, however, does not end with the fanciful architecture. Moral and qualitative adjustments start before construction and continue after the museum is finished.

Many museums are built despite strong opposition, and even museums that are widely supported face social and economic challenges. It is in the handling of these challenges that some hidden contradictions become apparent. When social or economic confrontations arise, however, museum champions frequently deal with them with a Machiavellian eye and/or with seemingly naïve disregard of the truth—as well as the dangers—embedded in the challenges.

Here, for instance, are Santiago Calatrava's words, from the museum's Web site, regarding his architectural commission for the Milwaukee Art Museum:

> In the trustees of the Milwaukee Art Museum, I had clients who truly wanted from me the best architecture that I could do. Their ambition was to create something exceptional for their community.
>
> I hope that when the new Milwaukee Art Museum opens and people see its fully realized form, that they will feel we have designed not a building, but a piece of the city.

And here is a passage from an article in the *Journal Sentinel*:

> Poverty in Wisconsin increased faster than in any other state in 2003 and 2004, the U.S. Census Bureau reported Tuesday, and Milwaukee climbed last year into the top 10 of the nation's poorest cities, reaching seventh. In Milwaukee, more than 62,000 of those living in poverty were children—41.3% of all the children in the city. That poverty rate for children ranks the city fourth in the nation, tied with Miami.[1]

This apparent disconnect between social realities and museum hopes has significant, if not always immediately perceived, consequences. While museum supporters might like for it to be otherwise, a large building of fanciful, and often hostile, architecture tends to harden rather than soften

resentments about wealth and privilege and whatever other social tensions exist prior to construction. Perhaps it is not so much that the museum supporters and staffers are blind to the criticism, but that they are not willing or able to respond concretely to social and economic challenges, because their answers might jeopardize "the vision." Which might be why many museums choose to remain silent with regard to their reason for being and the concentration of capital they embody.

This silence is not atypical but is in keeping with the institution's preference for secrecy. Rather than presented by the museum as a strategy for maintaining its aura, secrecy is framed as a necessary methodology for the objective examination of the material under study. Secrecy is also closely linked to the increasingly important role of the specialist in modern society, whose rarefied knowledge reinforces the unquestionable value of the institution as an informed and, in the case of museums, impartial arbiter of taste. As I see it, this aura of secrecy is a counterpoint to the simplified version of greatness that concerns me here. The image of an impartial and knowledgeable museum is necessary for legitimizing whatever comes after the fantastic building: the adoption of mass media strategies, popular anthropological exhibitions with little artistic merit, and policies of inclusion.

It is in those programs of inclusion that the idea of greatness suffers its next blow: the so-called democratization of the institution. As small as they seem, gestures like family days, concerts, and public input are often enough to create the perception that the museum is *for everyone*, and there is, usually, an equivalent dismantling of authority on behalf of democracy inside the galleries. This dismantling takes many forms, but most of them revolve around identity-based experience and challenges to the cultural hegemony. These strategies inside and outside the galleries seem to suggest the demystification of the museum as well as inclusion of previously ignored points of view. However, when I look at their implementation, I frequently find agendas aimed at controlling the public's experience through what is shown and what is not shown, by what is said about what is shown, and by the way the public is included and guided through exhibitions and funneled to gift shops and restaurants. Rather than being motivated by an authentic desire to liberate the public from the oppressiveness of rigid ideas about quality, the museum's actions are often guided by self-preservation and, particularly, by the preservation of the power structures that allow the staff its authority, its titles, and its privileges. These undercurrents of convenience might be why the changes and revisions at the museums seem to degrade from serious intellectual discussions to merely a perception of the museum as a populist institution. This perception, reinforced by the reinvention of the museum as a place

to gather, play, and learn, pleases the community and deflects criticisms of institutional doting on the affluent and the important.

In a similar way the authority legitimizes questionable programming, inclusiveness softens the elitist image of the museum. Nonetheless, exclusivity remains an important aspect of the behind-the-scenes operations of museums, and this simultaneous embrace of exclusivity and inclusivity has been an important doctrine of the art museum boom. Exclusivity has brought private funding, influence, and authority, while inclusivity has facilitated public funding, land, and attendance.

This doctrine has implications for the quality of the museum's offerings. In trying to justify and finance their existence, many museums rely on spectacle and entertainment and in the process sacrifice some of the intensity of the public's engagement with art. Trickle-down and bring-the-public-in-by-whatever-means-necessary arguments are put forward by the museum defenders, arguments that echo many of the public policies of the last thirty years; compromises and losses visible in politics, cultural institutions, and universities but that perhaps are most damaging in the museum.

Tellingly, although culture is a battlefield, the public face of the museum is frequently devoid of struggle. Whatever anxieties and contradictions exist inside the institution remain within it, which is another example of how the museum consciously maintains its aura of authority. If problems exist at the museum, they usually have to be inferred through the firing of directors, the familiarity of curatorial choices, the sanity-defying exhibitions, and the failure of outreach programs. In the rare case an operational quibble becomes public, it is quickly reframed by the institution as the outcome—and cost—of implementing mission ideals or operating, as it is often said, in *the real world*.

Rather than engage in public debates about operational or budgetary concerns, most museums focus their attention on fund-raising, networking, acquisitions, and especially, exhibitions.

Ironically, the financial growth that has fueled the art museum boom has had a shrinking effect on the latter. For many major museums, the blockbuster exhibition became an important marketing strategy in the 1970s and 1980s, but as the value of artwork increased dramatically in the last three decades and insurance prices climbed, they have been forced to shift their attention to other ways to attract audiences, such as thematically bound group exhibitions, thereby shrinking not only the scale of exhibitions but also their intellectual ambition.

Similar market forces have affected collections with similar consequences. The exorbitant prices of art by dead and established artists, as well as the collecting frenzy of recent years, have led many museums to compete with collectors for artwork. Since collectors usually win these competitions, the

museums have become dependent, almost exclusively, on gifts of varied quality, thereby diluting the caliber of the museum's collection.

## II

The art museum is a product—like many of our other institutions—of the aspirations of the Enlightenment, and it seems to me that like many other ideas of the Enlightenment it is now in decay.

I am not trying to suggest that early museums, such as the Hermitage, the Louvre, and the Uffizi, were devoid of shortcomings. The collections of most of the early museums were obtained through conquests or bought with funds frequently raised through oppression and abuse, and monarchs and politicians often used—and still use—these collections to manipulate public opinion and inflame nationalistic beliefs. This history notwithstanding, the decay I am referring to is a decay of imagination and intellectual ambition. The thoughts and accidents that led to the first art museums did not set up a perfect institution, but they pointed to an ideal museum where greatness and access were not exclusive of each other. That ideal museum, as I envision it, would avoid compromises that undermine its central mission, and it would not be a hub for nervous marketers or a retreat for dull administrators. The optimistic philosophies of the Enlightenment seemed to propose the ideal museum as an arena for wrestling with greatness and subjectivity independent of the scale of the building or the amount of people who come through the museum doors. The decay I see is a decay in those ideals.

## III

It makes sense the museum staff would seek rewards on the status of the institution, and it also makes sense that there would be an inclination within the museum toward programming and acquisitions, which are, while not always morally intact, exciting. Perhaps it is also human nature to forgo transcendence in exchange for—or at least sprinkle that transcendence with—attention in our own time. However, the art entrusted to or engaged by museums *ought* to create a framework of seriousness and honesty, and such a spirit *should* exert a demand upon the institution, its administrators, and staff to be better.

But for *ought* and *should* to be something other than idealism, art has to be in an environment where quality is an ethical imperative, and the art involved must itself be of a certain quality. Undoubtedly there is an inherent friction between the exigency and individualism of art and the preservative and aggregate nature of a museum. This friction has always been there and has never been comfortable. However, the discomfort is aggravated when status and entertainment threaten to suffocate most other aims.

Without clearly visible alternatives to status and entertainment, and

a sincere desire to pursue those alternatives—quality or greatness, for instance—the museum risks becoming inconsequential; flawed in a way that can't be fixed with an architectural icon, by courting exciting lifestyles, or by hoping the museum can function as a music club, movie theater, or family park.

Perhaps the concrete challenge of the museum—and its second biggest obstacle after a shortage of intellectual ambition—is resolving the duality of wishing to be a social reformer while being financially dependent. It is disingenuous to think the art museum staff can generate social change from their seat of privilege, particularly while keeping their hands in various compromising pockets.

Despite the moral flexibility of many museum administrators and trustees, some of our most troubled museums must make choices. At the moment, they seem to want it all: the fantastic buildings, generous gifts, authority, populism, peer consensus, fame, importance, and legacy. Greatness, however, does not seem to be in their list of desires.

### NOTE

1. Tom Held, "State's Poverty Rate Rises Fastest in Nation, Survey Ranks Milwaukee as 7th Poorest City in the U.S.," *Milwaukee Journal Sentinel*, August 31, 2005.

*The Rail* in process,
Santa Monica,
California, 2008

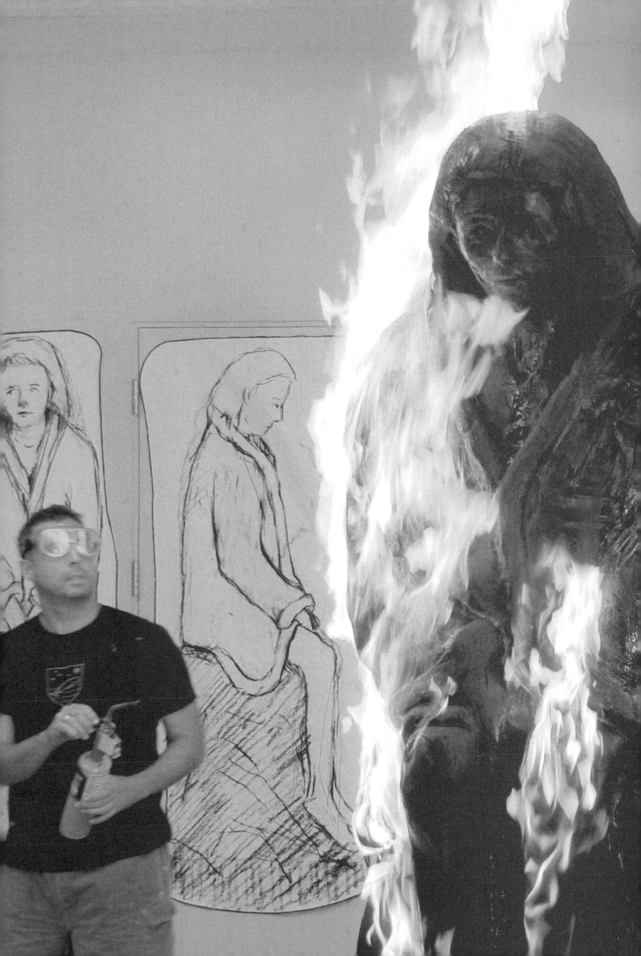

Studio,
Santa Monica,
California, 2008

## 2008    From an Interview with Gillian Serisier

Gillian Serisier: Your previous work has been characterized by a somber dark-
ness and introspection, so I was very surprised by the work exhibited in
*The Lovely Season*. This work has an incredible brightness and radiance,
even a feeling of optimism. Is this a conscious change?

Enrique Martínez Celaya: Some previous cycles were mostly black; when figures
appeared they were in profile. There was little engagement or invitations
to interact. The coming of these colorful paintings and world-life scenes
is something I resisted for years. I often see the landscapes as indifferent
to the horrors and beauty of human concerns. I think my interest is in
the temporary in relation to the absolute, and the world-life scenes play
a role in that.

*Originally published as "Painting Himself Out of the Picture," in* Artist Profile *4. Gillian Serisier is
an arts writer, private curator, collector, and enthusiast based in Sydney, Australia.*

GS: The first painting encountered in the exhibition *The Valley* engages this idea of uncertainty of existence via displaced layers and the cropping of the trees into a composition of line rather than a figurative depiction. Yet there is nothing smug or academic in the painting or what you have referred to as "the wink." Can you elaborate on this?

EMC: There is a tendency in modernism and postmodernism to be in cahoots with the audience about rarefied knowledge—to wink—a wink of recognition that is less about secrets than about codes; codes that once decoded make the audience feel smart. For instance, Jeff Koons's wink is saying, "I'm not as tacky as all that . . . I'm 'in' on the joke." I'm aware the gesture of the sprouts coming out of my birch tree might be seen as charming or tacky, but it is not a wink. I might be the joke but I am not "in" on the joke.

GS: The physical layering interests me. It is much more apparent in the reality of the paintings, which in turn makes the metaphor of time's progression more palpable. It seems that each painting contains a progression of seasons with winter occupying the proximal layers without denying the past seasons or life.

EMC: Time is in the layering of translucent wax and oil; in the materials and images being recovered and destroyed; in the reworking and reworking. Concerning the question of seasons, paintings are timeless but can be used to explore time. They bring time into the landscape and that—connecting time and the landscape—has been one of my main concerns. Particularly winter, which is purifying; its starkness fits my own expectations of painting.

GS: "The Lovely Season"?

EMC: Lovely is a word I hardly use. After something has happened one chooses a word, "lovely," to reinterpret meaning. The season—a period of time, an event—might not have been lovely at all. "Lovely" is a revision, a reinvention of what happened. Imposing the word "lovely" colors memory but that color brings up contention; whenever you see or remember something not so lovely, you have to rethink it—rejudge it, maybe find something that might have gone unobserved. Once you say "a lovely season" we are forced to reassess: was it actually a lovely season when this or that event occurred? "Lovely" is an imposition onto experience.

GS: Umberto Eco uses semiotics to explore the disparity between memory and the past in a similar way; each layer is a shimmering version rather than a solid fact, is this the way your paintings interpret humanity's ability to adapt and move forward?

EMC: This is important and difficult. Most comments on my work are about the content and the implied narrative, but what mostly concerns me in my paintings has to do with small shifts in the painting itself. I'm interested in

painting as inquiry and in the distinction between painting as a noun and as a verb. Paintings are objects whose meaning is unstable, undermined, and I'm interested in those paintings who acknowledge their apparent stability is not so sound.

GS: Are you dismayed by how literally people interpret your work?

EMC: Yes. I'm often surprised by how convinced people are of the images in my paintings and sculptures. For me they are less reliable. I use materials as tools to frame traces and instability—for me, to paint is to dislocate. That might be why the images you see in this exhibition—the boy or the birches—might not be here for the next show. My loyalty is to the thinking, the dislocation, not to the imagery. I have no allegiance to symbols.

GS: You have a background in science, yet unlike someone like Olafur Eliasson, your work isn't about science per se, but does your background in science reveal itself in your work?

EMC: Coming from the world of science into art, it's hard to be excited about art influenced by science. Working in physics I had the opportunity to see serious people at work and see firsthand what a certain kind of intelligence looks like. After that, I'm not inclined to describe science-influenced entertainment as particularly visionary. I think art is most exciting when it's more than paraphrasing something that can be said better in another way, in another field.

GS: *The Longed-for Sun* seems to be a painting of that intersection. There is an incredible luminosity in the sun that shifts through the painting's layers and breaks the picture plane despite the extreme frontality of the figure.

EMC: The light coming through a window in a Vermeer is still there when you see it from six inches away. In *The Longed-for Sun*, the light becomes a smear as you approach the painting; it is no longer light, just paint. It's unsatisfying as light and that dissatisfaction is revealing about paint and painting in general. Also the halo of the sun in that painting is reversed: the red is in reversed position, yet one reads it as familiar. It's inverted to work properly in the painting.

GS: Are you deliberately evoking Freud's theories of the uncanny when you change the spectrum around?

EMC: Freud's idea of the uncanny has been influential to my thinking. The sky going over the boy's skin confuses the "before" and "after." But this is not a strategy. The reason I don't like surrealism is because it uses—with bad results—the uncanny as a strategy. The uncanny arises only in the friction of the expected, not in the puzzling or the freakish. For instance, Vilhelm Hammershøi makes uncanny paintings—say two open doors with no apparent subject. Emptiness and boredom could be the subject of those paintings, but the uncanny arises in the flickering of the lack of subject and the insistence of the hidden. This suggests a question I think about

often in writing and painting: can a nonevent be interesting by not being interesting?—can I make meaning of a nonevent? With the painting of the stump I was interested in making it as noneventful as possible. I like to think that maybe the trajectory of my work is toward making mirrors, spaces with enough room for a stage where someone else can play a part.

GS: And what part will you play?

EMC: I will play the part of painting myself out of the painting.

## 2008 Systems, Time, and Daybreak

Talks related to culture, and perhaps not just of those related to culture, are often not much more than a fog of allusions standing in for knowledge and insight. These talks are given and listened to with an attitude similar to how Stepan Arkadyevitch read his newspaper. Tolstoy describes him in *Anna Karenina*: "He liked his newspaper, as he did his cigar after dinner, for the slight fog it diffused in his brain."[1] My talk probably won't be any different.

*The Rail* in process,
Santa Monica,
California, 2008

*Originally presented at* KANEKO, *Omaha, Nebraska, as part of the University of Nebraska Visiting Presidential Professorship.*

196

I will try to suggest the role systems had in my upbringing, the way in which time defines experience, the reasons why artists should try to be prophets, and how these ideas influence my work.

I

The Cuba of the late '60s, the Cuba of my childhood, was a country of structures, of systems. There was the big structure of Socialism in which the whole society fit; everyone and everything was a little part, a little wheel, in the complex mechanism of the Revolution. Within this big structure there were smaller structures and systems that ensured the proper functioning of markets, schools, sugar cane fields, and so on. The country was, in broad terms, a system aimed at bringing forth an envisioned future. But despite the order promoted in roadside billboards, our daily life was chaotic. It consisted of non-idealistic black markets, small insurrections against the committees of the Revolution, political hypocrisy, and, ultimately, migration—disparate malfunctions that evolved into a system with rules and structure. It was the system, as we were called, of *Worms*.

After our exile, we arrived in Franco's Spain, and then, five years later, we immigrated to an economically depressed Puerto Rico. The Caribbean of the '70s shared with Spain a feeling of despair and lost hope—I think some of these feelings existed in the United States as well. Unlike Cuba, in Spain and Puerto Rico there was no system to bring about an envisioned future, and the very idea of envisioning a future seemed, for many, out of reach. It was a time of waning faith in systems, a time of selfishness and ornamental altruism; it was the beginning of a new age of narcissism.

It was also a time when—probably because the faith in systems, objective by nature, had dwindled—subjectivity thrived. Small private observations of one seemed interesting to many, and unexplored paths as well as unfamiliar, often exotic or abject points of view, were popular. And so, the age of narcissism—which, properly speaking, started in the '60s—with its attention on the individual in the face of crumbling systems, gave rise to new literature, cinema, and art. It was not a heroic period of grand gestures but a time when despair and having nothing to lose led to the heroics of the small and the discarded. This was the time of writers William S. Burroughs, Camilo José Cela, Seamus Heaney, Gabriel García Márquez, Nadine Gordimer; of movies like *American Graffiti*, *Saturday Night Fever*, *The Deer Hunter*, and *The French Connection*; and of artists Andy Warhol, Anselm Kiefer, Robert Smithson, and Gerhard Richter. Although I was only a teenager during the '70s, the spirit of that time was and continues to be an influence on my work.

For me, exile was also a dislocation of time and space. It is probably not far off to say that back in the '70s my family and I lived mostly in what

*had been*, recalling memories of the country we left behind, and often of projecting ourselves onto a dreamy period before the Revolution—before I was born. Time, rather than being an impulse forward, was the means by which we cataloged the past in an attempt to create some sort of system using the remnants of our history. Although the grown-ups publicly had the grand system of religion to give purpose to their lives, privately they trusted the assembly of memories we used to call ourselves in those days. Of course, being naïve, foreign, and poor, there were practical reasons to avoid the present. The present represented an unfamiliar space: the landscape and cityscapes of the new countries were populated with strange images—snow remains the most vivid—as well as rent collectors, teachers, and policemen.

I could have reacted to those conditions by making artwork that echoed the disintegration of trust and the fragmentary nature of contemporary experience; perhaps a play on popular culture or an ironic, even cynical, take on the human condition. After all, I have good reasons to be cynical. But we all do. Most of us, at one point or another, have seen the trick behind a system we trusted and have been betrayed, held back, by our own histories. I have found irony, however, not to be an exciting destination but the tiresome quicksand from which I must always depart. Irony and suspicion are embedded in the spiritual foundation of many of us; therefore it takes effort to build anything trustworthy and, particularly, anything resembling ethics and beliefs capable of surviving the erosion of time; time that toys with our convictions and renders our present into memories.

II

When compared to the concreteness of the world, memories seem ethereal. The world of what is and the world we remember are not, however, as easy to distinguish as they might at first seem; not because memories are particularly tangible but because the concreteness of the world is unreliable. What appears concrete becomes abstract as we try to hold it; the subjects of our love and fears soon become dreams; and before long we recognize our own reflection as a stranger. The current of time dissolves the certainty of things, until we are only left with traces and stains—ghosts haunting our convictions. Unsatisfied with dissolving certainty, time and consciousness erase distinctions between aspects of reality we consider quite different: a landscape, a glance, a scent. With distinctions dissolved and traces and dreams moving around and through what we estimate as real, the world shows itself to be a haze where nothing is certain and nothing completely uncertain, nothing always true or always false, and no thing is definitely separated from another thing.

Art might be a source of stability and clarification in this haze. It offers

something that, for sake of brevity, I will call truth, which is why I approach art with great hope but also fearsome of the haze and my own wit—with mistrust in the artwork to be anything but records of passage and flourish. I always wish art to be more, yet I am suspicious about the authenticity of my gestures, an ambivalence of feeling that might be why the surfaces of my paintings and sculptures are often scarred with doubts.

To eliminate, or at least diminish, these doubts, I don't look away—although I frequently want to do just that—but instead work in a religious manner.

I should explain what I mean by religious. It is not an issue of being convinced of the existence of a deity or of my righteousness, but almost the opposite. I work to discover my consciousness and whatever might be beyond it, and also to see more clearly the world around me as well as my moral failings. I use the term *religious* partly to acknowledge my hope for emotional ambition and seriousness and to signal the subjects and problems that concern me. It is also a way to frame the efforts and shortcomings in my work, not as cultural successes and aesthetic failures, but as judgments on who I am.

I have not been trying to make art into life, as a Fluxus artist might consider doing, nor have I been interested in ethics as it pertains to content and its morality. In the process of discovering the realm of value—something I have done clumsily at best—restraint, resistance, and self-denial have been helpful to keep in mind, if not always adhered to. They warded off some temptations of vanity and, in terms of what can be seen, for a decade they led me to sparse paintings and rough, solemn sculptures that reined in my psychological excesses. In time, however, I found that to remain at least half honest, non-formulaic, my work had to incorporate approaches I have put aside.

Restraint, resistance, and self-denial—the monastic creed—have been pivotal tenets of many other modern artists, particularly of minimalists and, perhaps less obviously, of artists whose work is usually called conceptual, light and space, and earthworks. In many of these instances the monastic creed has come across as an extraneous imposition on the artwork, an a priori demand for less. For me, it has been a demand imposed on who I am, rather than on the appearance of the work. By keeping this monastic creed present, I have made art in an effort to better understand its nature and to gain clarity about life (not unrelated aims), desires that come from my own sense of being ill-prepared to make judgments about the choices that matter.

A mark on a painting, decisions on materials, the willingness to hold back on a gesture, these types of actions—frequently lumped together as "style"—if they are not done trivially, cannot be explained in a satisfying

way. Of course, much can be said about them, which is why many people have made careers by appearing to know something about art. But art is not the mannerism, or the politics of content, or the knowledge of whom and what. E. M. Forster's warning about the pseudo-scholar should be heeded by people in the arts: "Everything he says may be accurate but all is useless, because he is moving round books instead of through them, he either has not read them or cannot read them properly."[2]

If it seems difficult to put one's finger on what makes art meaningful, it is because it's difficult. Many collectors, curators, dealers, and artists pride themselves on a body of knowledge that doesn't amount to much; they have formulas—if this then that. For instance, they know that when de Kooning was looking at Gorky, the paintings have certain marks; they know Richard Tuttle is a post-minimalist; they know the politics of Kara Walker and the sources of her references. While there is merit in that knowledge, it is not the merit of knowing art or what brings it about. I know I don't have this knowledge myself, but I know what the knowledge is not. This negative awareness is the motivation behind my religious approach to art.

III

All artists should aspire to be prophets—minor prophets, for the most part, but that will do. Any other aim is less, and the resulting work will, in time, find its place among the decorative arts of the period, if at all.

On September 15, 2008, the same day the stock market lost more than five hundred points—partly as a result of whimsical investments in the financial field gone bad—more than two hundred pieces of new work by Damien Hirst sold through Sotheby's for more than two hundred million dollars.

The offering of pickled animals, butterflies, and dots, which were made by the more than 180 people who work for Hirst, was the first time an artist used an auction house to sell new work. Hirst's auction and its success are part of a larger condition, which Robert Hughes appropriately described in the following way:

> Where you see Hirsts you will also see Jeff Koons's balloons, Jean-Michel Basquiat's stoned scribbles, Richard Prince's feeble jokes and pin-ups of nurses and, inevitably, scads of really bad, really late Warhols. Such works of art are bound to hang out together, a uniform message from our *fin-de-siècle* decadence.[3]

Some of us feel like hypocrites when we call for ambition of spirit and authenticity in the work of art, knowing we don't ask for the same in our own lives. And so we learn to accept trivial and cowardly gestures

as significant and brave because in them we sense our own failings. We become practiced in self-serving praise of the meager and the vicious, but irrespective of these moral accommodations, when time has passed and our fears and status no longer matter, the diamond-encrusted skulls and spin paintings will become, mainly, symbols of our dishonesty and lack of clarity.

What we need in art is ambition of spirit, quality, and authenticity, not because those imperatives are abundant in our lives but precisely because they are not.

## IV

Through art I set out, often against my better judgment, to stop the erosion of certainty, to avoid being left only with stains and ghosts. In *Daybreak*, my new body of work, however, I began at the end of things, with stains and ghosts, with images that, despite seeming familiar, I couldn't hold nor dismiss, nor think my way through; images that suggest I should position myself above them only to open an abyss underneath me. It is hard to know why I began there; maybe now truth seems closer to stains and ghosts.

Referring to images in paintings and sculptures as if they were photographs is misleading. Images are inseparable from and defamiliarized by the presence of the artwork as well as the artwork's inherent resistance to the way images are painted and sculpted. The meanings attached to images, particularly the historically ascribed meanings, are not of great concern to me, nor is the psychological interpretation of images. The rush to interpretation tends to miss the emotional and philosophical resonance of artworks. This resonance partly depends on remaining at the surface while experiencing a strong invitation to interpret, to go *into* the work. The images I leave in my work—that I don't paint over or chip away—are those which remain inviting, mysterious, while at the same time possessing a presence that resists the meddling of interpretation.

*Daybreak* is, partly, approaches and sensibilities I had rejected in the past. But I should not exaggerate the changes. While as recent as five years ago it would have been hard for me to imagine making paintings of landscapes with the narrative undertone found in *Daybreak*, the motivations that concern me daily remain the same. Whatever appears different has changed to sustain the integrity of the work and its aim, which is letting art show the realm of value and provide me with a much-needed guide. My desire is to know something about the order of things, a search perhaps similar to what Herman Dooyeweerd calls the heart: "The heart as our selfhood stands under a law of religious concentration, which makes it restlessly search for its own Origin and that of the whole cosmos."[4]

The boy and the girl represented in several of the *Daybreak* works seem to insist they are part of a narrative, which they inhabit in the present while simultaneously seeming to belong to an undefined but almost recognizable past. As those figures flicker in time, the landscapes in which they claim to stand suggest locations. However, before those locations can be recognized, the work returns to paint—to a material Nothingness closer to ruins and garbage than to anything artistic, divine, or intellectual. Then it all starts again, the appearance and disappearance, the temporal shifts, in eternal recurrence. When the interaction between reference, perception, and material is right, the artwork embodies *thereness*, simultaneously palpable and evanescent. Unable to hold the palpable and the evanescent at once, consciousness beats between one and the other and recognizes in this beat the heart shared by artwork and viewer. This heart is the root of ethics.

Reality is change, and art stands in opposition to change. The artist tries to build certainty from the unreliable and in his or her apparent preoccupation with culture and psychology dissimulates—often against his or her will—the main motivation for art: longing. Longing that manifests as longing for certainty and longing for self. The artist is or should be the prophet of longing. As I see it, the aspiration of the artist's work is to dissolve the distance between self and the cosmos, thereby uniting Being and language, memory and Nothingness, life and death. These are, perhaps, lofty claims on behalf of pigments, metal, and wood, but the disparity between the aims and means of art is its essence.

**NOTES**

1. Leo Tolstoy, *Anna Karenina* (Pleasantville NY: VAI, 2004).
2. E. M. Forster, *Aspects of the Novel* (London: E. Arnold, 1927).
3. Robert Hughes, "Day of the Dead." *The Guardian*, September 13, 2008. guardian .co.uk.
4. Herman Dooyeweerd, *Philosophia Reformata* 1 (1936).

Studio,
Santa Monica,
California, 2008

## 2008    From an Interview with Greg McComb

Greg McComb: Could you fill our readers in on your early (childhood/pre-college) background?

Enrique Martínez Celaya: I was born in Cuba in 1964, six years after the Cuban Revolution. I spent most of my childhood in the small southern beach town of Caimito because it was thought that salt-air would be beneficial for my asthma. There was not much to do there other than catching crabs and poking the sharks that washed ashore, but I liked that town. My family and I left Cuba for Spain when I was eight. Spain was a difficult place for foreigners without money, and it was my first of several exiles. We moved

*Originally published as "Enrique Martínez Celaya: Artist of Many Hues,"* Latin Business 6/6. *Greg McComb is the editor and publisher of* Latin Business *magazine.*

from Madrid to Puerto Rico in 1976, and it was in Puerto Rico I had the opportunity to become an apprentice for a painter. That apprenticeship and my childhood and teenage years in the Caribbean and Spain during the 1970s have had a profound influence in my work and my way of thinking.

GM: As is the case with many artists, you started out in a totally (seemingly?) unrelated field. What factors played a role in your switching from science to the world of art?

EMC: I was interested in physics and math since middle school. The sciences gave shape to things I saw, and they allowed me to be in a world less burdened by emotions, regrets, and so on. In high school I built a laser and, with the arrogant innocence of a fifteen-year-old, decided to become a laser physicist. I continued painting as a hobby during my time at Cornell, Brookhaven, and Berkeley, but the hobby grew over time, and at some point in graduate school I realized I had reached an impasse between my studies and my desire to be an artist. Leaving physics was a hard thing to do. I disappointed many people, including myself. But I did not want to wonder what could've been.

GM: Were your initial forays into art somewhat tentative, i.e., did you "keep your day job," or did you throw yourself into it unreservedly?

EMC: It was somewhat tentative, although it did not feel that way. I left graduate school and went to work for a laser company as a researcher. After I had been there a while, I requested to work part-time. They reluctantly agreed and I worked on painting every free moment I had. After a year of working like that, I left the company and had to sell my work in the parks of San Francisco to survive. It was an ugly transition, but it got me out of the "considering" and into the "doing."

GM: You are involved in multiple disciplines of artistic endeavor, including painting, sculpture, and photography. Which came first, and what was the progression?

EMC: Painting came first. The conceptual problems of painting brought forth my interest in photography and sculpture. Writing has been there all along, and it continues to be the activity that connects most of my other efforts.

GM: Your works are quite large in scale. Did "thinking big" just come naturally, or was it a conscious decision?

EMC: I am most comfortable with large-scale work, but it is less about "thinking big" than about contending with a situation where material and idea have the right amount of friction. The "equilibrium," if we can call it that, between the qualities I seek in a painting or a sculpture is easier to achieve in a larger scale. But in regards to the

spirit of your question, intellectual and moral ambition should be big. It is better to fall flat on one's face while reaching, than to achieve something by bending. To achieve something meaningful, along with "thinking big," one must also be desperate.

GM: The transportation and installation of these large art pieces must be an exacting procedure in its own right. Do you oversee the installations personally?

EMC: I am involved in every aspect of the work. In fact, it is often hard to distinguish between "the installation" and "the work." Some installations have been frustrating and time-consuming because of the scale and complexity of what's involved. For instance, the installation at the Berliner Philharmonie, which then went to Leipzig, took hundreds of hours of difficult work, and several times during that period, I thought it wouldn't work.

GM: Your work has a deeply philosophical grounding, interwoven with many disciplines. Would you care to illustrate this aspect of your creative process?

EMC: In my early twenties, philosophy and science seemed to be appropriate guides. However, when things became more complex, when my questions resisted metaphysics and logic, I gave art a chance. Or, considering the confusion of those years, maybe it is better to say art gave me a chance. Art was then, and remains, a method of clarifying life. Unpopular an idea as it might be, for me, aesthetics and ethics are the same. Of course, I am not virtuous because I am an artist, but I would be worse without art.

GM: Do you enjoy one particular medium over another, or does moving freely among several media as you do keep your mind constantly refreshed artistically?

EMC: I like to move around. Going from photography, for instance, to painting clarifies some of my thinking about each one. I best understand the structure of ideas by perturbing them, and moving between media is one type of perturbation. But if I had to choose—which I hope I don't—I would choose painting. And writing.

GM: When did you become involved in the writing/publishing aspects of your career, and do you regard them as extensions of your art as well as promotional?

EMC: I started Whale & Star in 1998 because I love books and because I thought there could be interesting synergy between the studio of an artist and a publishing house. A few years later we were lucky to secure a good distributor, the University of Nebraska Press, which has helped our recognition around the world. We are still very small but we have garnered respect for our publications. Whale & Star is a part of my work, even when we are publishing a volume of Russian poetry. The work is a way of being in the world.

GM: Many otherwise-capable artists fail to realize their full potential due to a grave lack of business acumen. Are you also gifted with an innate business sense, or do you assign that necessary tedium to others?

EMC: In the popular imagination, as well as in the minds of many artists, the myth of the unsuccessful genius has perpetuated the opposition between business and art. Of course, we have seen and are afraid of being that self-promoting unsubstantial artist, but contrary to the myth, many artists I respect have made successful efforts in both business and art. And not only have they been able to keep the integrity of their work while being aware of business, but often it has been their ability to be aware of their business that has allowed them to maintain the integrity of their art. Frequently, artists seek success by making work that's similar to what's popular. But I wanted, and want, to make the work I want to make without regard for "the buzz." This means I have to work harder than if I made what's trendy. So, being attentive to business, which usually means being attentive to details, has afforded me the freedom to do what I want—the work that moves me, the work for which I quit physics. I think in art, like in most things, the "giftedness" you mentioned has to be sustained and harnessed by discipline—and challenged. I think many artists—and not just artists—are too enamored of their achievements and their story to sustain the questioning, the challenging that keeps oneself and the work growing. It is not easy but it doesn't have to be easy.

GM: What proportion of your art creations are commission work, as compared to gallery sales?

EMC: I do very few commissions. Commissions are tricky. The commissions I have done have been for institutions or collectors who know the work enough to give me the freedom I need. A commission has to have its own justification. It can't be because someone couldn't find a piece he or she liked.

GM: At what point did you feel the calling to share your knowledge and insight through teaching?

EMC: I always enjoyed teaching. As a student I benefited from some good teachers, and I would like to give something in return for what I got. I am fortunate that in my position as Visiting Presidential Professor at the University of Nebraska, I can be involved in teaching while maintaining my studio work and life. Also, for two weeks in the summers I go to the Anderson Ranch in Snowmass, Colorado, which is a unique environment because most of my students are working artists.

GM: You have created works for many prominent venues, both national and international. Which ones are you particularly proud of?

EMC: The work I did for the Berliner Philharmonie is important to me. I also remember the work I did at St. Pancras Chambers in London with affec-

tion. Of the museum shows, I think the paintings for the Miami Art Museum remain influential to what I am doing today, and, although smaller in scope, when the boy sculpture was installed in St. Mary's Cathedral in Limerick, Ireland, I felt that some loose end had been tied up.

GM: Many artistic professionals experience an occasional need to get away from it all, taking a time-out to recharge their creative juices. Do you have a favored outlet in this regard, or do you prefer a "busman's holiday"?

EMC: I often think of getting away from it all but where does one go to do that? What is the "it all," really? A few years back, partly following that impulse, I left Los Angeles for the small beach town of Delray Beach, Florida. So, in some ways, I got away from some of the "it all," and yet I am in the middle of it. Getting away might always be a work in progress.

GM: In closing, what do you think the future holds for you career-wise? Will you explore additional, perhaps emerging, media, or is there a facet of your current artistic repertoire that you'd like to take further?

EMC: The current economic climate is an opportunity to redefine what one is doing in the world and how one is doing it. In this period of temporary capitulation of greed and fraud, new attention will be given to substance, which is a welcome change. In the arts, I hope it will mean less fluff, less trading, less hype—at least for a while. I will continue with the museum and gallery projects I have planned, and I am trying to make better work than what I have made. I am in the process of buying a large building, and I hope the new facility will help reconcile the intellectual growth I need with a new model of an artist in the world. Probably, in some ways, each new studio is also an attempt to get away from it all.

## 2009    From an Interview with Prue Gibson

**Prue Gibson:** I've enjoyed thinking about the idea of making ethical choices in relation to your art (and wonder if the same choices must be made when looking at art). These questions you ask yourself—are they not also moral or righteous questions, i.e., good or evil, as well as right or wrong? Do you become a religious artist by virtue of making these choices (despite not having a religious faith)?

**Enrique Martínez Celaya:** The questions I ask myself are in fact moral questions. Thinking of art as an ethical inquiry in itself, rather than an illustration of an ethical inquiry, does require the observation of moral questions. I think this is true of the artist as well as the audience, but the latter needs to be familiar with and inclined to considering art as ethics. Otherwise, art

*Interview conducted as research for an article in* Art Monthly Australia, *August 2010. Prue Gibson is a Sydney-based writer of visual art and art history for Australian and international art magazines and journals.*

could not aspire to feel like anything more than a charming concern for moral questions. In my view, art *ought* to create a framework of seriousness and honesty, and such a spirit *should* exert a demand upon whoever experiences it.

PG: I know your landscapes are imaginary, but they refer to northern European winter scenes. Is that a result of the influence of German romantic painting or of Swedish Martinson's homeland?

EMC: These landscapes are familiar to me. They seem to embody the notions of isolation and hardship that I find resonant with my view of life and the choices I make.

PG: In *The Burnt* is the boy's face black to avoid sentimentality?

EMC: That is an interesting way of thinking about it. It never occurred to me but it might be right. The boy's face is black because it is burnt. Burnt not in the literal sense but in being a skin with a long and troublesome history, like most of ours.

PG: The vulnerable and fragile boy figures strike me as having attributes of a martyr (almost Christlike in their symbolism of humanity). Are these suffering characters related to the tradition of Christianity? Or is it more ambiguous than that?

EMC: Thinking of them as martyrs is not all that off, although it was not my intention. They share with martyrs the condition of vacillating between hurt and belief. Of course, the figures are never the complete story in paintings.

PG: Do you still feel a sense of loss having fled Cuba as a child? Does this alienation still affect your work, even after having children?

EMC: I do feel a sense of loss. I lost my past, more than anything else.

PG: Some of the literary figures who have affected your thinking, e.g., Kierkegaard and Martinson, had lonely and dispirited lives in part (despite successes with their writing). Are these elements of their lives part of the paintings, or do they just contribute to the intellectual atmosphere? Is that too literal?

EMC: I think what they did is most remarkable when considered against their human condition—loneliness, menial concerns, family, getting a haircut.

PG: When I met you it sounded like most of your work comprised the intellectual and literary process before you began painting, i.e., reading and thinking and working in your notebooks. But having seen the full catalogs and books, the painting process sounds extremely arduous and complex too. Is that right?

EMC: Yes. I go back and forth between words and visual work, and rarely is anything easy. Maybe if I was better.

PG: Gabriel García Márquez said he learned the narrative writing process through his childhood dabbling in cartoon drawings. Writing and art seem to bounce back and forth for many artists and writers. Have your paintings had an impact on the fiction you are currently writing? Can you tell me a bit about your novel in progress?

EMC: Writing and visual work are extremely connected in my mind; they serve the same purpose in different ways. In the visual work I avoid narratives, and when a narrative is suggested it is always truncated. In the writing I tend to avoid visual imagery, though it finds its way in.

The novel I have been writing, which I might never finish, has helped me eliminate many narrative desires from my visual work. I think it also influences the landscapes that have emerged in the last three years. The novel doesn't share these types of landscapes, but language, spare in comparison to paint, seems to resonate with the open, desolated spaces I have been painting.

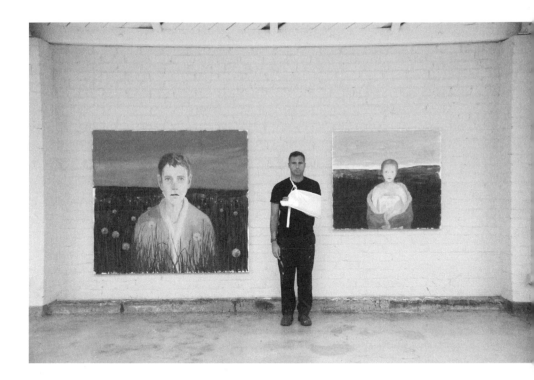

2009 ## From *The Blog: Bad Time for Poetry*

Friday, January 23; Friday, January 30. *Failure*. In the depressed Puerto Rico of the late '70s, no event was as anticipated as the visit of tightrope walker Karl Wallenda; except perhaps Lou Ferrigno's promised appearance at Safari Park. But since Ferrigno never showed up (the Hulk had to be impersonated by El Tigre Pérez), Wallenda's visit remains the key event of the end of that dreamy decade.

Karl Wallenda, then seventy-three years old, tried to walk, without a safety net, on a tightrope stretched between two towers in Condado, a hotel area near San Juan. My brothers and I watched him on live TV as he began his act, and we kept on watching when he tried to get a grip on the tightrope and when he fell. Every part of that walk and his attempt at a grip had a different quality than anything we had seen before. For us, kids at the time, Wallenda's struggle meant more because he had no safety net.

*The blog was originally on Enrique Martínez Celaya's Web site, existing from August 24, 2007, to May 25, 2009. It now exists as a book containing all of Martínez Celaya's entries.* The Blog: Bad Time for Poetry *(Delray Beach FL: Whale & Star).*

In recent years, it has become fashionable among certain circles, particularly of academic, crafty, and self-help-inclined artists, to speak of failure as a welcomed part of the studio practice. What is often meant by failure here is the loose mental amalgam of it's-okay-if-it-doesn't-work philosophy, some fetishistic concern with process and an excuse for not doing better. Although it is camouflaged as freedom, failure, in this view, is more often than not a form of preciousness, a walk on the tightrope when the risk is small. Failures when the rope is only a few feet from the ground or when there is a safety net are but refreshing winds. These winds, of course, become something else when the rope is raised.

What is failure without desperateness?

From the *Hagakure* (best read if under a portrait of Søren Kierkegaard):

> Lord Naoshige said, "The Way of the Samurai is in desperateness. Ten men or more cannot kill such a man. Common sense will not accomplish great things. Simply become insane and desperate.
>
> In the Way of the Samurai, if one uses discrimination, he will fall behind. One needs neither loyalty nor devotion, but simply to become desperate in the Way. Loyalty and devotion are of themselves within desperation."

> In the judgment of the elders, a samurai's obstinacy should be excessive. A thing done with moderation may later be judged to be insufficient. I have heard that when one thinks he has gone too far, he will not have erred. This sort of rule should not be forgotten.[1]

And one more, also from the *Hagakure*:

> When someone is giving you his opinion, you should receive it with deep gratitude even though it is worthless.[2]

**Tuesday, February 3.** *Meltingly sweet, in autumn.* The meek and fluffy and beautiful world of ours, this world of contrasts, has best been summarized in a recent article about birds in the *Economist*:

> Four decades after the campaign, sparrows remained scarcer in Beijing than they should have been (though they could reliably be found being grilled on bamboo skewers in the night markets, along with yellow-breasted buntings, meltingly sweet, in autumn).[3]

I think in the last few entries I have been circumnavigating my discomfort with the whininess, arrogance, and fraud that has so pervasively invaded our lives. Many of us have a ready justification for why we are

less than we could be and a way to look at things that makes us think we are really more than what we have become.

The effort of much of growing up seems to be the search for a little tool we can use not to carve our way out of our hole but to dig ourselves deeper. In this narrowing effort we are open-minded in the help we recruit, which we find in religion; in the way we were raised; in our power in the world; in our powerlessness; in the pity we feel for ourselves; in the pride we feel for what we have done; in the busyness of our affairs and our job and our lives. We find it in the angelic conversion offered by tattooed wings. Maybe we especially find it there.

But all that is foolish talk. That master or charlatan of extreme wakefulness, G. Gurdjieff, wrote:

> Everything is dependent on everything else, everything is connected, nothing is separate. Therefore everything is going in the only way it can go. If people were different everything would be different. They are what they are, so everything is as it is.[4]

So we are left with this (and it could be worse): "They could reliably be found being grilled on bamboo skewers in the night markets, along with yellow-breasted buntings, meltingly sweet, in autumn."

Thursday, February 5. *Innocent Fraud*. Paul Krugman, last year's Nobel Prize winner in economics, has been critical of the late, noted economist John Kenneth Galbraith because, among other things, Galbraith wrote for the public rather than for other economists and because Galbraith's economic insights were, at times, oversimplified. These criticisms seem curious to me. Paul Krugman is not only a Princeton professor, but also a columnist for the *New York Times*, a public venue, and a blogger, also a public venue. In addition, Krugman is a frequent contributor to CNN and MSNBC, where the public sound bite is necessarily more oversimplified than anything Galbraith ever wrote. While I agree with much of what Krugman has to say about economics and policy, I detect something akin to ethical envy in his suspicious criticism of Galbraith. Paul Krugman appears to be a man of integrity (his brief role as advisor to Enron can be discounted), however, I think—and Krugman might feel—that it is hard for most of us to measure up to John Kenneth Galbraith. Few can deny that catering to the public is often done at the expense of quality. Yet, Galbraith was not a caterer. In relation to the public, he was an educator and a conscience whose ethics were maintained at a cost to himself and his reputation.

The criticism of writing for the public rather than for the professionals is not merely snobbery, but there is a lot of snobbery in it, which is often

misguided and shortsighted. I am reminded of the criticism Wittgenstein—in whom I am interested—launched on Bertrand Russell for wasting his talent by writing books like *The Conquest of Happiness*.[5] While it might be true *The Conquest of Happiness* is not exactly *Principia Mathematica*,[6] it is a gift to be able to observe a good mind like Russell's tackle something mundane but relevant to our lives. We have a long way to go until all we need to think about is the foundation of mathematics or the economics of trade, and if the thinking of the everyday is left only to Dr. Phil, Joel Osteen, and Britney Spears, we are in trouble.

Moreover, the world would have benefited from some "public" writing by Wittgenstein, particularly on his moral struggles, which never saw print, academic or otherwise. The problem of talking about something versus showing it notwithstanding, the opportunity to see the mind of *The Philosophical Investigations*[7] deal with the cumbersome challenges of living and making choices would have been wonderful.

Snobbery is an aspect of any community of experts—including the arts—and it must be understood as the result of educated judgment, convention, and self-validation. It would be difficult to argue that the popular appeal of Peter Max or Thomas Kinkade is some sort of confirmation of their greatness. But it is also difficult to argue—although many have tried—that the unpopularity of something or its popularity is diagnostic of its quality. Take, for instance, the complicated case of Andrew Wyeth. The late pictures, particularly the Helga series, are not great, but he was undoubtedly a better—and arguably more innovative—painter than most of the celebrated titans of the last fifty years. But it is hard for the art world experts to get excited about an artist whose images have been made into posters for college dorms.

Tuesday, April 28. *You and the Kindle*. It is not surprising that factors influencing status anxiety dominated the goofy article about the Kindle written by someone named Joanne Kaufman in the *New York Times* on April 24. The article revolved around different versions of the following paragraph:

> The practice of judging people by the covers of their books is old and time-honored. And the Kindle, which looks kind of like a giant white calculator, is the technology equivalent of a plain brown wrapper. If people jettison their book collections or stop buying new volumes, it will grow increasingly hard to form snap opinions about them by wandering casually into their living rooms.[8]

Yet there are other issues beyond Kaufman's article—beyond status anxiety—to consider regarding the Kindle. The most important is whether or not the Kindle will succeed, because of what its success will mean to publishing and to reading.

It seems certain that—even with that name—the Kindle or another Kindle-like reader will succeed. There are at least four reasons why the Kindle will be unstoppable: (1) it celebrates you (user customization); (2) it celebrates money (new products, new markets); (3) it celebrates democracy (softens the barriers of publishing); (4) it celebrates convenience. For these and other reasons, all but the most obscure books will soon be available for the Kindle.

For some, this triumph will be a confirmation of the righteousness of the electronic reader—the future is written by the winners. But to me the certainty of this success, like the success of many other things of doubtful merit, is only a prediction of the way things go. I love books. I like to understand the moment and the context in which they were printed—a war, a failed state, a surge of revolutionary fervor. I like to see that moment and that context in the paper, in the typeface. My library is not something to show someone else but a useful mirror. When I look at my books, I see my history, choices, and accidents. I see the worn edges of books I kept in my pockets in high school. I see my teachers. I see random events that brought a book to me or I see a book I shared with someone else. I see special editions of a novel I sought out because of its etchings; I open my books to find notes in the cover sheets, paint and ink stains on the pages, loose pieces of paper with drawings, or hotel receipts. I see effort. I also like that books are someone else's vision. Not just the vision of the writer but the vision of the publisher, the designer, the printer, the age, the tyrants who tried to stop them, the old bookstore that tried to sell them, and so on. Books are content in context.

The Kindle is about content. Content that is convenient and customizable. Freedom to customize and interact (undoubtedly, a form of electronic context will be available at some point) is at the center of the Internet creed, which is part of what makes the Kindle appealing. The Kindle also facilitates content distribution by eliminating the cost and restrictions of publishing, and it is likely most books will soon be published without a gatekeeper (such as I am doing now)—directly from author to Kindle. You will determine what gets published, and you will be able to modify the content *you* like to *your* liking.

Those attributes of the Kindle are supposed to be good things.

The invisible hand of those who make money from *you being you* notwithstanding, I find the contemporary importance of YOU, silly, manipulative, and encouraging of mediocrity. Much of what's underneath this self-preoccupation is the infantile desire to be pleased—all the time—as well as the notion that our opinions and desires have particular importance, even if we know very little. Knowledge is increasingly becoming something that comes from the gut and/or opinions.

Perhaps not surprisingly, the YOU that made the cover of *Time* magazine a few years back and that is in the mouth of so many is nothing too deep. For the most part it is a shell of cravings, prejudices, and hang-ups that—as many who had tried know—resist dismantling. This *you* is a farce, but trying to dismantle it is painful and, almost always, futile.

Which might be why we are moving in the other direction. In our age we are stressing the importance of *you*. You know better. You choose. You define. You tell. You decide. Perhaps, as some contemporary thinkers argue, this concentration on *you* is the only way to transcend *you*. They are hoping for a Big Bang. One outcome of this emphasis on *you* is the suspicion of external expertise. Warhol might have missed the point: we all want—and now can have—our fifteen minutes of expertise. Everyone has a say. Everyone is an expert.

As it relates to books, this democratization and celebration of *you* will generate a few nuggets of value—mostly those now in regular books—lost in a thick soup of insignificant knowledge and waste. The search engines will then let you find the parts of the soup that appeal not to some snobbish New York publisher but to *you*. *You* will suck these soup-parts into *your* Kindle and maybe write a blog for the world to know what parts are most important to *you*. Maybe *you* will hope the parts *you* found will be important also to *your* readers—to those who follow *you*. *You* might argue this is not the force-feeding of authority but the sharing of peers; not the tyranny of the oppressor but the democratization of knowledge. *You* have something to say.

*You* also know best what *you* need. The Kindle.

**Tuesday, May 12; Wednesday, May 13.** *Get Rid of Your Excuse.* In the last two years—the two years of this blog—I have seen artists who claim authenticity copy my work, my Web site, and my sketchbooks. Once a month someone attacks me through my e-mail, usually hiding in the attack his or her shortcomings and lack of integrity—sometimes they go farther and vandalize something.

I have criticized the mainstream art world, but my intention has not been to validate bad artists. If things are not happening for you, it's mostly your fault. You might have justifications. If you believe them, it's best to come to peace with what and where you are. If you don't believe them, do something about it.

All artists should assume they have—at best—a tiny talent, and this reality doesn't have to be entirely sad. If you are doing better work today than two years ago then things are looking up.

Stop treading water. Stop diffusing your sadness. Stop being small.

Get rid of your excuse.

《《《

As a kid—before moral philosophy and its convolutions—I wanted to understand what lobotomy suggests about happiness. I had seen a Russian movie where someone, after being lobotomized, smiled and got along with everyone. This impressed me. I didn't know anyone who was that happy. Yet, something bothered me about the lobotomy, and I spent many hours trying to find what it was. Although none of the insights I had or have—or have read about—are entirely satisfying, I am certain the answer revolves around the fulfillment of a quality we can call "humanity." This quality is an aim rather than a condition. It is the pearl of the moral/spirit oyster and it might also be an imperative of the species. Humanity is the limit of the spirit, an unreachable reminder of the best we could be, and the *better happiness* moves toward it. This indefensible statement is either self-apparent to you or it is not.

Whatever the case might be, it is clear that humanity is a difficult aim, and so, most of us—as [Hermann] Hesse wrote—are half-human and half-worm or half-monkey or half-pig. There are many excuses for why we fall short, and there are also many internal failures we don't know about. The latter can only be seen through our effect on the world, so they are difficult to resolve. The former—the excuses—are what I want to address here.

Excuses come in many categories, usually manifested in combination: self-loathing ("I'm stupid," "I'm ugly," I'm fat"), victim ("my life is so hard," "the worst happens to me," "I just didn't have the opportunities"), unlucky ("I've the worst luck," "the world dealt me a bad hand"), lone wolf ("I didn't care about that, anyway," "who needs that"), time miser ("I'm too busy," "I did my best," "I tried"), religion ("the meek will inherit the Earth"), and so on. What all these excuses have in common is laziness. They are ways to avoid doing what needs to be done.

But what do people do with their time if they are not working toward the fulfillment of their humanity? Day to day, they are watching television, dabbling at their work, talking on the phone, feeling sorry for themselves, taking it easy, wasting time. In the long run, they are busy fabricating the lie of why they are not who they could have been. This takes a lot of work, but it is the type of work that comes naturally to us. It requires affection for the dressed-up game we call "being ourselves," self-satisfaction with our petty choices, and weakness for easy pleasure. Inevitably, while snuggling in that mud pen, we engage in self-loathing, maybe victim and some lone wolf, for good measure. (The brutality of self-loathing is not the same as being self-critical with aim toward action. Self-loathing is self-feeding; being self-critical with aim toward action is life-feeding.)

In the case of artists, the excuses apply to their life as well as their art. The problem in both endeavors is the same: it is hard to sustain the imperative of humanity. Most people can get excited to be better by watching a movie, reading a book, or having a session of alcohol-induced throw-up. Some can keep that excitement for a week and some for a year, but in the long run, integrity and a higher standard are harder to sustain than it is to fabricate the myth of delightful mediocrity.

If you want to aim higher, the odds are against you. Most likely, you—like me and everyone else—will fail because our tendency is to be superficial and lazy.

A good place to begin is finding people who you admire and who are aiming or have aimed high. Then follow that example by eliminating ideas like, "I am doing the best I can," "I have no time," "I tried." Also, complicate things a little bit for yourself. If, for instance, you find yourself attracted to the model of "the meek will inherit the world," you might want to layer on it the model of the *via crucis*.

### NOTES

1. Yamamoto Tsunetomo, *Hagakure: The Book of the Samurai*, trans. William Scott Wilson (Tokyo: Kodansha International, 2002).
2. Tsunetomo, *Hagakure*.
3. "The Loneliness of the Chinese Birdwatcher," *Economist*, December 18, 2008.
4. Statement by G. I. Gurdjieff in P. D. Ouspensky, *In Search of the Miraculous: Fragments of an Unknown Teaching* (New York: Harcourt, Brace, 1949).
5. Bertrand Russell, *The Conquest of Happiness* (New York: Bantam, 1968).
6. Alfred North Whitehead and Bertrand Russell, *Principia Mathematica* (Cambridge, Great Britain: The University Press, 1950).
7. Ludwig Wittgenstein, *The Philosophical Investigations*, trans. G. E. M. Anscombe (New York: Macmillan, 1953).
8. Joanne Kaufman, "With Kindle, Can You Tell It's Proust?" *New York Times*, April 24, 2009, Fashion and Style section.

EMC and his three
children, Gabriela,
Adrián, and Sebastián,
Studio, Delray Beach,
Florida, 2009

## 2009    Art and the University

I

One Saturday morning in 1976, I rang the doorbell of Bartolomé Mayol.
Three reasons had brought me there: my mother was trying to find some-
thing to do with my time, I liked to draw, and I was trying to escape doing
weekend inventory at my father's jewelry business. For the three years
that followed that morning, I worked in Bart's studio. Sometimes I did
copies of old master paintings and sometimes my own, but mostly I drew
dusty still lifes. It was tedious work, and yet his studio was a place where
something meaningful didn't seem completely out of the question, which
is why I liked being there. The biggest attraction was not the studio or the
work but my teacher.

Years later, when facing my own students, I wondered what Bart would
or could have done in a university program. But few people seemed further
from the university culture than Bart. Until I learned he had graduated

*Originally presented at the University of Nebraska at Omaha as part of the University of Nebraska
Visiting Presidential Professorship.*

219

from the Maryland Institute College of Art. At first, the image of Bart living in a dorm or taking tests or eating at a cafeteria seemed ridiculous. I couldn't fit him into those roles.

As I have come to see it, Bart's poor fit is one of the best attributes of higher education. Colleges and universities educate people with different histories and goals, and the best of these institutions find ways to enrich rather than impoverish their aspirations through tolerance and inclusion. It is usually within higher education that we find the best examples of democracy and fair rewards. Of the large institutions in our society, colleges and universities remain most loyal to ideals and also most willing to question and rework those ideals, if necessary. Without forgetting these merits, or I should say, in keeping with my understanding of them, I want to address some questions raised by the arts within the university, specifically the visual arts.

As I see it, the most troublesome aspects of the visual arts in and from academia are their lack of purpose and their detachment; detachment from the broader intellectual community and detachment from the needs and concerns of life—life not as lived in the minds of academics but in the living world. I think the university is not doing its best job in supporting the arts and educating artists because, at least how it pertains to the visual arts, it is unsure of its purpose and its nature. A confusion that has led artists and art programs to be detached not only from the university but also from what the former president of Yale, A. Barlett Giamatti, called "others beyond it." He wrote, "To wish only to be removed from the culture, and not to be part of its renewal, is to long for the atrophy, not the exercise, of the imagination and its works [ . . . ] no university is strong if it is unsure of its purpose and nature, and is unwilling or unable to make vital that nature and purpose for others beyond it. We lose our public trust when we treat as only private our principal obligations."[1]

The problems of the visual arts at the university seem to begin with the effectiveness of the curriculum and the self-image of art departments. "The unwilling student has long been provided for or against," wrote Robert Frost. "He has to do something however little. The question, the only question in education that is a question, is how to provide for the willing student so that he shall feel free to do simply everything."[2] The urgency of the topic at hand arises then not only in the abstract idea of what the irrelevance of the visual arts suggest about us but also in the concrete imperative of educating the current student. Because, unlike more forgiving activities, artists who waste or are wasted by their training rarely recover. "School and college," warned Frost, "have been conducted with the almost express purpose of keeping him busy with something else till the danger of his ever creating anything is past."[3]

## II

The majority of American artists prefer to be trained at the university, and art programs have proliferated to meet the demand. The College Art Association claims two thousand university art and art history departments. The typical art department has been built around Bauhaus ideas, and in the last three decades there also has been a significant influence from programs that have been successful in the marketplace, like Goldsmiths and Cal Arts. Most art programs move the undergraduate through foundation classes as well as through—or by—some general university-wide required courses, followed by a few courses on his or her field of interest. Graduate students usually concentrate in one area, and their training includes reviews, theory courses, and a final exhibition. There is such a consistent methodology among these programs that, aside from regional flavors and slight differences in combination of media, art departments within universities tend to be fairly uniform, and the art majors—whether in New York, Nebraska, or California—quite similar. The similarity between art programs is not limited to their offerings, structure, and ideals but extends to their uncomfortable relationship to the larger university community.

I think the discomfort begins with visual art's conflicted position toward its own discourse in relation to the academic expectation of publications and conferences. However it begins, the discomfort between the arts and the university ends in estrangement. What I have observed is that artists at the university harbor antiestablishment illusions that they try to balance with their dependency on the institution for degrees, tenure, and promotion. The balance is usually reached through submission to the hierarchy of the university and its expectations, often at the cost of resentment and isolation.

The submission also means conforming to two major shifts occurring in higher education: the diminishing popularity of the great books tradition and the growing pressure for vocational training. Recently, even colleges with liberal arts traditions have seen or encouraged their students move toward the most vocational programs, such as engineering, premed, business, and finance. For instance, in 1970, 5 percent of the men graduating from Harvard University went into finance; in 2007 that number had jumped to 20 percent of the men and 10 percent of the women.[4] Undoubtedly, the greatest loser in these shifts is the humanistic tradition, which might ultimately have been the only justification for training an artist at the university.

Willingly or unwillingly then, art departments have had to become more practical. One way in which they conform is by adopting an attitude of faith in art as a profession whose mastery requires only a brief period of study. While central to the university, the faith in a two- to three-year

timetable for competence is quite different from the open-ended Bauhaus or Beaux Art models, where it was the quality of the work itself that determined the end of the period of study, and also different from the opinion of many artists and art educators.

Walter Gropius, the founder of Bauhaus, wrote in 1923, "But lately the artist has been misled by the fatal and arrogant fallacy, fostered by the state, that art is a profession which can be mastered by study. Schooling alone can never produce art! Whether the finished product is an exercise in ingenuity or a work of art depends on the talent of the individual who creates it. This quality cannot be taught and cannot be learned."[5] The poet Rainer Maria Rilke also did not believe in the prescribed timetable for competence. He wrote, "To be an artist means not to compute or count; it means to ripen as the tree, which does not force its sap, but stands unshaken in the storms of spring with no fear that summer might not follow. It will come regardless. But it comes only to those who live as though eternity stretches before them, carefree, silent, and endless. I learn it daily, learn it with many pains, for which I am grateful: *Patience* is all!"[6] While making a university program around Rilke's view might not be practical, it seems also impractical to expect that, after only a few years, students can "exhibit the highest level of accomplishment," as the C A A guidelines prescribe in its Web site.

The view that the formation of an artist should and can be scheduled is not only the outcome of an art department's submission to university policies, but it is also related to the evolution of the idea of an artist in the last two hundred years, a period when the spheres of art, science, and ethics have become, more or less, self-contained. In addition to the expectation of scheduled competence, these ruptures between art and ethics, between art and theology, have helped make the artist irrelevant. Unlike graduates from other departments, artists have no clear role to play in society. Without other guidance and with very few skills—artistic or otherwise—they usually settle for the role provided for them by academia or the market.

III

The scenario I have briefly outlined is symptomatic of our age, an age in which art has more kinship with entertainment and leisure than with religion and science. The age sets the tone. But most of us are unaware of the way in which the age affects our actions and our dreams.

We artists believe in our free will as we hurry to become jesters in the minor court of the art world. Looking around faculty or student exhibitions, or, say, at the Saatchi collection in London, we convince ourselves their eclecticism is proof that will and whimsy matter more than the age.

Visual art departments trust this conviction implicitly while explicitly they mimic each other's programs. Yet, the age is there.

The reason we see variety is because we are so thoroughly imbedded in our age it has become indistinguishable from ourselves. One hundred years from now, those personal and media variations will be less visible, and two hundred years after that most artworks will lay dormant under the blanket of their age. If it is partly true that, as Max Weber wrote, a work of art "is never rendered obsolete by a subsequent work of art,"[7] as is the case in science, it is also true that most works of art rarely transcend the time and the place in which they were made. Weber's work, for instance, seems well anchored in its time.

In my view, art education today offers students an understanding of the intellectual frame around the making of art as well as the mechanisms through which art disseminates in the culture and the market. This understanding—which I will call the *macropractice*—is useful, particularly within the modernist's sensitivity to the non-neutrality of cultural assumptions and limits. It is also useful in wedging oneself in the marketplace. This training in the macropractice of art amounts to training the student in being an artist more than in art, a distinction that for many has become inconsequential, or old-fashioned. In an environment where Damien Hirst, for example, orders his assistants to make over six hundred spot paintings and one of them sells for $1.5 million, art seems considerably less important than, or indistinguishable from, an artist branding.

Upon graduation, if not earlier, artists settle into their irrelevant and isolating role as jesters. This isolation is not a temporary condition of conflicted artists within academia but the normative state of most artists today, and it is this isolation which is most effectively transmitted by the university. Students learn quickly that we live in an age when artists are not essential members of society and are perceived as either parasites living off the public good, annoying jerks, or flamboyant hustlers.

Of course, artists have always modeled themselves after their idea of an artist and often twisted that idea to fit the expectations of others. Winslow Homer, for instance, whose heroic work matched the American business spirit at the end of the nineteenth century, was perceived as a big, rugged individual, though the real Winslow Homer was a small man with a keen sense of supply and demand. So, the problem is not so much that artists are modeled after an image, but that the current image is pathetic and—unlike Homer's case—accompanied by very few concrete skills.

The viable artist needs—in addition to the macropractice—the intellectual and technical tools to make art as well as the moral fortitude to give it life force. Unfortunately, higher education has fared poorly in these lessons, which I will call the *micropractice* of art. Howard Singerman, an

art theorist, writes, "The failure of the MFA lies, not in any decline of art or crisis of culture, but in the lives of individual students who are neither disciplined nor skilled."[8] Eric Fischl, a contemporary artist, recalls his education: "Half the people were covered with paint. . . . The two models were sitting in the corner absolutely still, bored to tears. Everyone else was throwing stuff around and had climbed up into the roof and jumped into buckets of paint. It was an absolute zoo. . . . They didn't teach technique at Cal Arts."[9]

Since skills have become a matter of opinion, many art departments seek objectivity in art theory and criticism. However, it is not easy to craft effective theory courses within departments that don't have properly trained faculty. Frequently, then, intellectual aspirations become ornamental; our modern version of the exotic feathers and tigers of the nineteenth-century studio.

I am not proposing, however, a return to the "old ways." The solution to the problem of art education is not, as it might seem at first, to create a school based on studies of plaster casts and the like. Those institutions exist. They are called traditional schools or academies and they seldom achieve anything beyond mannerisms. The solution is also not progressive art schools either, which while better than traditional academies at nurturing serious artists, their students often suffer from built-in obsolescence and, therefore, must achieve recognition quickly, before the applicability of their knowledge expires.

Our best option for the training of artists is the university, and so we must address its problems. Many disappointed reformers and artists respond with apathy or irony, which is rarely productive. Solutions will come from intense reevaluation of requirements for a degree, including timelines, and honesty about the lack of skills in both the faculty and the students.

Undoubtedly, the greatest change would come from a training based as much on courage, defiance, and grace, as in visual awareness. Courage, defiance, and grace are ways to approach the moral murkiness inherent in art and society. Rather than submit to a false balance or work at hiding poor skills, the artist within academia needs conflict as well as the search for authentic knowledge, which often requires challenging the rhetoric common in sophisticated circles and the provincialism of conservatives. This training—in addition to courage, defiance, and grace—demands intense intellectual engagement. Not the intellect of pretension but the capacity for making the necessary fine distinctions that create the conditions for art.

This intellect, which facilitates art inspiration, is frequently neglected in university art programs today through the distraction of poorly taught

theory courses. Knowing blurbs from Derrida or Lacan, as it has become fashionable, is not the same thing as understanding the thinking practice that gave life to those blurbs, and it is that practice that has any bearing on the work of art. Independent of his or her intelligence, the artist with some intellectual training can better handle the conflicting nature of art. If many art programs are not effective in teaching students to think, it is because their idea of theory has devolved into formulas rather than mechanisms for judgment.

## IV

I began this essay by saying the most troublesome aspects of the visual arts in and from academia are their lack of purpose and their detachment. So far I have spoken mostly of detachment. Let me now say something about purpose.

What distinguishes a great work of art from a good one are details of execution and concept. In other words, greatness in art exists at the fringes of the work, fringes that tend to elude the most sensitive and sophisticated of judgments, which might be why great artists cannot produce great works of art every time. When art happens, however, truth arises in the artwork, and it is delivered in the audience's response and interpretation— that is, in communion.

John Dewey, in *Art as Experience*, argues that processes of inquiry, looking, and finding meaning are transformative, extending connections with what is good and right and that expanded perceptions open venues for understanding and action. Judgment in art is actualized in awareness of purpose.

By purpose here I don't mean strategy, which has been a popular concept in visual art programs for the past three decades. Purpose, as I mean it here, leads to the alignment of artist and work, which, unlike a strategy, requires the artist to have a *working knowledge* of who he or she is. What this implies is not only a psychological question of knowing oneself but an ontological inquiry that informs and is informed by judgment. Higher education should encourage this line of inquiry. The capacity for it, and not the blurbs or formulas, is the most important intellectual skill students and artists need to move from what is known to the edge of the unknown, which is the movement of creation. Beyond the boundary between the known and the unknown there is only the leap, and it is only in that leap—and not before—that art begins. There is no theorizing beyond that boundary. The only useful things are skills, courage, grace, and defiance. That is, the only things that matter in the realm of art are skills and character.

Neither is emphasized in art education today.

Skills and character are hard to quantify and their development resists scheduling, but the right teachers with the right commitment can lead students in the right direction. If the university finds ways to teach skills and character to students, it will produce prophets instead of jesters.

It is not unusual for artists to seek certainty, even at the expense of the excitement that brought them to art initially. This is how artists and teachers who had nimble minds in the early stage of their careers become either experts on their own work or tired and cease to be relevant. The artist-prophets, however, seek authentic knowledge in, from, and through the work of art. They won't look for—or find—a place to rest in their expertise or claim to be above life. For them being a certain kind of artist means being a certain kind of person. These artists are not prophets because they are better than the rest of us but because they are more committed to showing us the struggle between what we are and what we could become.

We need prophets.

The dawn of a new age might be upon us as our society reconsiders the excess of recent times and takes measurement of the damage of excess upon our natural as well as internal world. If it is too optimistic to imagine the end of the art jester, at least it will be easier to laugh knowing it is not at the expense of our artistic prophets.

## NOTES

1. A. Bartlett Giamatti, *A Free and Ordered Space* (New York: W. W. Norton & Company, 1976).
2. Robert Frost, "Marion Leroy Burton and Education," in *The Collected Prose of Robert Frost*, ed. March Richardson (1925; repr., Cambridge: Harvard University Press, 2007).
3. Robert Frost, "Introduction to The Arts Anthology: Dartmouth Verse," in *The Collected Prose of Robert Frost*, ed. March Richardson (1925; repr., Cambridge: Harvard University Press, 2007).
4. Niall Ferguson, *The Ascent of Money: A Financial History of the World* (New York: The Penguin Press, 2008).
5. Walter Gropius, "The Theory and Organization of the Bauhaus," 1923, pamphlet.
6. Rainer Maria Rilke, *Letters to a Young Poet* (1929; repr., New York: Fine Communications, 2002).
7. Max Weber, *Max Weber on Universities: The Power of the State and the Dignity of Academic Calling in Imperial Germany*, ed. and trans. Edward Shils (Chicago: University of Chicago Press, 1973).
8. Howard Singerman, *Art Subjects* (Berkeley: University of California Press, 1999).
9. Robert Hughes, *Nothing If Not Critical* (New York: Penguin, 1990).

2009 Notes

July 25 (Delray Beach FL). Distinctions between arts and crafts matter
to the extent they shine light on the nature of art. Unfortunately, distin-
guishing between arts and crafts usually becomes a matter of opinions
and beliefs. Nonetheless, it might be possible to briefly mention a few
distinctions between arts and crafts.

Let me first clarify what I mean by art. There seem to be two views of
it. One, art as an activity defined simply by engagement, i.e., if I apply
paint to a canvas I am making art. The other view, the one I prefer, is
that art is a possible experience within engagement but by no means a
guaranteed experience, i.e., if I apply paint to a canvas, the work might
unveil a heightened experience—art—but not only is this experience not

*From EMC's sketchbook notes.*

guaranteed, it is unlikely. Following the latter view, distinctions between arts and crafts then have nothing to do with the type of engagement or the materials, which are the usual distinctions, but with the quality of experience brought forth.

Examining art and craft from this perspective leads to six key distinctions: boundaries, audience, relation to the other, maladies, ethics, and guarantees.

BOUNDARIES. For the craftsman, the work is an end in itself, usually framed by materials and activity. For the artist, the work is a means, usually framed by uncertainty and tension against boundaries. Tradition and materials create boundaries for the craftsman but for the artist, boundaries are created by the future pressing upon the present.

AUDIENCE. The craftsman makes work for an audience and, not infrequently, is aware of what he might be offering them. The artist must necessarily be part of his audience in the experience that is art; and art is always an experience he does not know a priori.

RELATION TO THE OTHER. There are also distinctions of the practices. The artist must push craft out the way. The craftsman has no such struggle against art, other than persistent envy. As such, craft is another boundary of art.

MALADIES. Craft and art, like different animal species, are susceptible to different diseases. Craftsmen tend to be fetishistic, defined by materials, and self-referential. Those who aim at being artists tend to lack sufficient grounding in the craft to actually put it aside; they also like to attach ideas to objects to make them important and suffer from novelty anxiety. In practical terms, crafts have resisted the blurring or elimination of media definitions more than fine arts, which has led the crafts to become quaint in their preservation of obsolete frontiers. One contemporary malady that has affected craft as well as art is lateralism. That is, the idea that by adding lateral associations and allusions something profound becomes possible. Sometimes mislabeled as interdisciplinary efforts and often described as the breaking of boundaries, lateralism is but a simplistic way to compensate for initial weakness. Yet, unlike in decoration or résumés, twenty weak aspects don't make art.

ETHICS. The biggest distinction between traditional crafts and fine arts are ethics. In crafts, ethics are imbedded in the object and often also in the practice. In art, however, they must be generated by the experience.

The ethical practice of an artist is of little consequence if he or she cannot produce art. Many craftsmen, on the other hand, have made their attraction to materials, traditions, and "honesty" a form of ethics, which in their minds guarantees the ethics of their production. But for the artist, there are no such guarantees.

GUARANTEES. It might not be wrong to assume that a good thread to follow in distinguishing arts from crafts is the trust on guarantees. Perhaps there is no clearer example than in their position toward meaning. The experience of art depends on the flickering between meaning and no-meaning. Instability of meaning while facing a sublime emotional cliff is an essential aspect of art. In craft, meaning is stable, even when it seems not to be.

Studio,
Delray Beach,
Florida, 2009

# The Prophet

I

There is magnificent beauty in the world, and artists have little to add to it. The proof is the work of those who have tried. Sunsets and breezes over wheat fields and quasars are out of reach. The experience of great beauty cannot be improved or paraphrased. It invokes a gap between our consciousness and the world and invites longing to span across it.

All of that seemed apparent early on. What was not clear was what it meant for my work as an artist. I knew I wasn't going to find answers in the charming pictures I used to see growing up, and later I realized I would not find them in what was produced in cultural factories. There were many opinions, many books, and many artists, but guiding answers were hard to find. My goal was not to be an independent thinker or a contrarian. In fact, I would have followed any convincing fool. Fortunately, before that happened I ran across a mentor and several writers who helped me trust what I had known intuitively. Namely that art, which is many things to many people, is just one thing to me: a whisper of the order of things that dismantles consciousness and suggests my place in the world. Although art has nothing to add to the great beauty of sunsets or breezes over wheat fields, it can suggest the order in which their vast scale fits.

This whisper of the order of things is not meaning, but it offers a point of reference from which the measurement of meaning makes sense; meaning that has answers to questions of my place in the world, of the choices

*Originally presented at the Joslyn Art Museum, Omaha, Nebraska, October 22, as part of the University of Nebraska Visiting Presidential Professorship.*

I make, and of my relationship to others. The whisper is faint, but the best art helps us hear it. It has nothing to do with the realm of perceptions. Rather, the invocation of a great order in the face of nothingness is fundamentally an ethical experience.

Is there a clearer whisper elsewhere?

Not for me. Some find it in religion, others in pleasure, but I only hear it in art and nature. When I begin to distinguish it from the noise around me, my concerns move outward, to others, and with that movement the imperative to know who I am becomes urgent. These insights form a beacon that guides my movements through the world, including the world of my imagination. The realm of whispers of the nature of things, imagination and Being, is, in the final analysis, supernatural—mystical. But art, as an ethical experience, has the potential to also be part of life. Life that includes those around us, the choices we make, and often our anxious search for meaning and for ourselves. Art can inform our choices and illuminate spiritual and emotional trends that will not become apparent to the newscasters for years, maybe for decades, and in some cases, for centuries.

"The function of the artist is the revelation of reality in process, permanence in change, the place of value in a world of facts. His duty is to keep open the channels of contemplation and to discover new ones. His role is purely revelatory," wrote the poet Kenneth Rexroth in 1955.[1] Friedrich Nietzsche, writing eighty years before, envisioned an artist-mystic who "through Apollonian dream-inspiration, his own state, i.e., his oneness with the primal nature of the universe, is revealed to him in symbolical dream-pictures."[2] This "oneness with the primal nature of the universe" is why artists are sometimes described as mystics, and why their revelation depends on faith, which assists artists through the uncertain process of seeing truth out of concealment. Faith and revelation are fundamental aspects of the artistic process because in them life-meaning and the primal nature of the universe reconcile. When faith and revelation are not present, art is not present, even if the activity seems artistic.

There is a tendency to understand revelation only in religious terms and frequently through trivial visualizations. But art is not revealed *in* or *as* a stable meaning but *by* a very particular instability of meaning. Art is *that* vibration between meaning and no-meaning, whose experience renders their opposition meaningless and dissolves our separation from the primal nature of the universe. The bigger the initial apparent gap between meaning and no-meaning, the greater the art.

Since it exists only as an experience, art is brought forth not only by the artist but also by its observer. This interaction between the work of an artist and its observer creates the art through the same mechanism of faith and revelation. Imagine, for instance, being confronted with a

gold-leafed honeyed Joseph Beuys holding a dead hare in his arms. The performance is not unlike watching a priest blessing the wine at Mass, and the similarity is not only in the ritualistic nature of their actions but also in our belief that those actions mean something. What is at stake in our trust in Beuys is not only his credibility but our own belief that there is something in art—and not just in Beuys's art—other than its visible ingredients. Of course, Beuys could turn out to be a charlatan, but that is always the risk of art. The experience of art, the basis of meaning that it opens, is not only unstable but depends on instability. Any desire to make it concrete precludes the experience of art.

Which is why many of the current models of how to be an artist in the world are flawed. Of these, the most popular are the entertainer, the impresario, and the social activist. The three promise significantly more concrete gains than the experience I have just described. To follow in the footsteps of a social activist, for instance, might not be easy, but the essence of the enterprise is not elusive; the requirements might be prohibitive but they are, more or less, known; and the purpose of the activism is, in principle, knowable. This knowledge, or potential for knowledge, is attractive because it facilitates the role of those involved as well as the role of education in creating the activist and his or her audience. To put it another way, when the essence of an activity is knowable then we can understand when and how we are engaged in it, which means the engagement can be reproduced. This is not the case with art. Art does not offer a stable body of knowledge nor is it easy to shape into a sustainable activity. For art to unfold, faith must silence the noise of the unimportant, thereby allowing the rawness of fear and trembling to sense the whisper of the order of things. Any effort at holding things firmly overwhelms what in essence are ripples in the surface of nothingness.

## II

It is reasonable to assume the mysticism I am invoking would have been pushed aside by the undeniable success of science over the last 150 years. This assumption is supported by modern art theory. Like many other contemporary humanity studies, art theory tends to reject metaphysics and goes through great trouble to borrow the language and attitude of science in order to avoid the type of unsupportable claims I am making here. However, this modern emphasis on reason and scientific awe, rather than eliminate artistic mysticism, has encouraged it as an undercurrent. Along with the rise of science, the arts have broken with many standards, making technical mastery less important and forcing the judgment of quality to rely on increasingly occult virtues. Consequently, the merits of much celebrated twentieth- and twenty-first-century art are recognizable

by only a few experts capable of distinguishing the commonplace from the common-looking-but-extraordinary.

Perhaps to compensate for what seems capricious and silly to the general public, the arguments on behalf of modern and contemporary artists have developed a scientific veneer, but this veneer only points to what science is not. When examined carefully, these arguments can easily be shown to rely on obscure and otherworldly claims, often with names like dialectical materialism and semiotics. Though they long to be science, they are, in effect, mystical, though their objective longing forces mysticism to hide between the lines, in the assumptions, and in the exaggerated trust in words. Therefore, their proponents suffer what they hope to avoid with few, or none, of the benefits of the difficult work of revelation. The hidden mysticism of the pseudo-scientists lacks the honesty necessary to seek clarity and judge its usefulness.

Although it is not itself a transparent condition, some proponents of reason prefer the genius to the mystic because the idea comforts those who long for objectivity and those who suspect the mystery of greatness is out of reach. The genius transcends ordinary human knowledge without the metaphysical baggage that comes with the mystic. "Talent," wrote Schopenhauer, "hits a target no one else can hit; genius hits a target no one else can see." This spiritually uncomplicated gift is appealing, yet, as it pertains to the arts, the baggage is necessary. The necessity becomes obvious when we encounter a supposedly non-metaphysical examination of a great artwork, where the closer the analysis gets to the art itself, the more it inevitably rubs against mystical inferences and readings; and if it insists on a concrete basis, it ends up circumventing interesting problems and discoveries in order to remain untainted by metaphysics. In the end, the effort is in vain. The experience of art cannot avoid mysticism.

Kierkegaard, who considered himself a genius, did not think geniuses were essential. He wrote in his journals that what the age needed for awakening was not a genius but a martyr. Yet the martyr's awakening of society doesn't seem likely either. A martyr suffers for his belief but not necessarily for the awakening of an age. For the martyr, like for all mystics, with the exception of prophets, the age is secondary. Mystics engage with the divine or transcendental as an end in itself, and often as a way to abandon life. Their insights are not necessarily at the service of anyone but themselves and their mystical experience.

III

What the age needs is a prophet. The prophet, unlike the mystic, returns to the world. Allama Iqbal, the Persian philosopher and poet, wrote, "The Prophet's return is creative. He returns to insert himself into the sweep of time with a view to control the forces of history, and thereby creates a fresh

world of ideals. A Prophet may be defined as a type of mystic consciousness in which unitary experience tends to overflow its boundaries and seeks opportunities of redirecting or refashioning the force of collective life."

In his 1911 triangular description of the life of the spirit, Wassily Kandinsky wrote, "Where the apex was today the second segment is tomorrow; what today can be understood only by the apex and to the rest of the triangle is an incomprehensible gibberish, forms tomorrow the true thought and feeling of the second segment. At the apex of the top segment stands often one man, and only one. His joyful vision cloaks a vast sorrow. Even those who are nearest to him in sympathy do not understand him. Angrily they abuse him as charlatan or madman. So in his lifetime stood Beethoven, solitary and insulted." Then he goes on to conclude, "In every segment of the triangle are artists. Each one of them who can see beyond the limits of his segment is a prophet to those about him, and helps the advance of the obstinate whole."[3]

But who are these prophets?

In June of 1880, Dostoyevsky was hailed as a prophet during a meeting of the Society of Lovers of Russian Literature, who had gathered to listen to his speech on the prophetic significance of Pushkin, who wrote in his poem *The Prophet*:

He rooted out this tongue of mine
Fluent in lies and vanity;
He tore my fainting lips apart
And, with his right hand steeped in blood,
He armed me with a serpent's dart;
With his bright sword he split my breast;
My heart leapt to him with a bound;
A glowing livid coal he pressed
Into the hollow of the wound.
There in the desert I lay dead,
And God called out to me and said:
'Rise, prophet, rise, and hear, and see,
And let my works be seen and heard
By all who turn aside from me,
And burn them with my fiery word.'

Although the excitement of the crowd might have been transitory, it was well placed on Dostoyevsky, whose standing as a prophet has endured. For Dostoyevsky, like for Kierkegaard, wisdom given by God stood in contrast to human nature, a belief that informed his prophetic vision and allowed him to anticipate some of the horrors to come. The capacity to

foresee conditions and psychic states is not, however, exclusively a religious virtue. Nietzsche, famously nonreligious, saw the nineteenth-century European becoming a passionless creature who only sought comfort, and influenced by this vision, foretold the isolation and ethical confusion of the twentieth century.

What Kierkegaard, Dostoyevsky, Nietzsche, and most other prophets have in common is a strong ethical outlook and a heightened sensitivity to attitudes and morals—the obvious ones as well as those that lurk beneath the surface. They also share urgency. Prophets are not inclined to wait for the right time. Their prophetic vision demands action, leaving little room for calculation and diplomacy. Truth, for the prophets, is not merely a belief but a moral imperative that compels them to speak and act with little regard for convenience or gains. But prophets need to do more than speaking and acting, and it is not enough to be apocalyptic. Something must be brought forward.

Truth suggests our place in the world, and it is that place as well as the awareness of emotional particulate floating in the atmosphere of the world that the artist brings forward.

Is this too much to expect from artists? Probably. It is likely we will all break our backs trying to be artists-prophets, but this is a better fate than letting our backs calcify from lack of action or hunch over in shame. Artists are not needed for anything else. They are not needed for decoration. They are not needed to give us scientific insights. They are not needed to create political change. They are not needed to clarify sociology or linguistics. They are not needed to appease or resolve race relations. They are not needed because all of those things are better accomplished by other vocations. It may seem the role of prophet is better left to religious people, but it is artists who are best at recognizing the brewing future. To become an artist-prophet what is needed is not talent or vision but attention and desperation. Being an artist-prophet is not a place to stand but an aim. Most artists will not be great prophets, but even very minor ones will make a difference; maybe a difference in the art world, but certainly, and more importantly, in themselves and in the world.

We must be careful, however.

The Trappist monk Thomas Merton warned, "The false prophet will accept any answer provided that it is his own, provided it is not the answer of the herd. The sheep mentality, on the other hand, accepts any answer that circulates in its own flock, provided only that it is not the answer of a prophet who has not been dead for at least five hundred years . . . the honest position lies somewhere in between." Merton is right, but this "in between" is hard to maintain as our tendency is usually one of laziness and extremes. One of these extremes, and a reason why the idea of the

prophet is problematic to many, is that divine inspiration has often been used to justify the idea of an artist-prophet as hero, whose grand vision merits imposing a totalitarian view on the world. The artist-prophet that interests me, however, is not a hero but someone whose ethical scrutiny demands the recognition of moral failings in him- or herself before recognizing them in anyone else. This artist-prophet, like Kierkegaard's martyr, is defined by his devotion, and, unlike a saint, who is in certitude at all times, must search for clarity through each engagement.

## IV

To be a prophet an artist doesn't need God but clarity of purpose, character, and attention. The spiritual vapidness and shamanistic delusions put forth whenever questions of purpose are invoked are not what I am suggesting. Dancing in the forest wearing wolf masks or looking up at a gap in the ceiling does not replace purpose and attention, and no talent can take the place of character and desperation.

When I started drawing and painting and, later, at the beginning of my career, I felt it was presumptuous to assume I had anything to offer. Who would dare claim to be a Tolstoy or Dostoyevsky or Hilma af Klint? But the alternatives seem barren, especially those proposed by my artistic education. It was clear that character, which is of little concern to most curriculums, is crucial for everyone, especially for artists and writers. Of what use is it to know paint, grammar, and theory if character is not able to weigh their value or their proper use?

Ultimately, no one can perceive what his or her character cannot grasp, but character is not entirely a birthright. Although nothing can be done about one's natural limitations, something can be done about improving what can be improved; the muscles might be set at birth but their mass can be increased or atrophy through work or lack of it. The first step toward improvement is desire, the second step is action, and in the case of artists, also the full responsibility of a prophetic imperative.

Joseph Beuys, Herman Melville, Marcel Broodthaers, Ayn Rand, and Albert Pinkham Ryder were prophets not because they sat around theorizing but because they showed us something of the future and of ourselves. When the late Tolstoy went through his crisis and conversion, a new level of desperateness and clarity could be read in his writings and gleaned from his actions. Again, our lack of talent and smallness of character are not in themselves reasons to shy away from the calling. The prophet becomes a prophet through his or her work. Doubt of whether or not we are cut out for the task is a great motivator and a constant source of humility.

There is not a better time than now to respond to the call. We need prophets.

We live in a narcissistic age. We see what is convenient to see, and ethics are less important than opportunity. Some may argue it has always been this way, but it is hard to deny the combination of our insolence and our means is unprecedented. Some may cheer our whims as an aspect of our freedom, but there is no liberation in whims. Rather, they are the mechanism by which we become enslaved. The freedom that is indispensable for human completion will not be found in the voyeurism of reality television or in the indulgence of a customized lifestyle. Even if these diseases have a long standing, it does not mean we must accept them.

Yet, without awareness, we continue to fight for our whims. Without a clear sense of freedom, which almost always comes through struggle and guidance, our cravings, our inbred persuasions, are seldom unique or even rare. What we feel so strongly as ours is the typical desire of our age acting through us. The more we fight to satisfy this calling, the more we surrender ourselves to the soup of our time and to those clever enough to market to our whims. This misguided preoccupation with the "you" in our narcissistic age is by itself enough reason to follow an imperative outside of ourselves. For true freedom we must go beyond our whims, beyond our self-concerns. The prophet imperative might be tall, unrealistic, but its inhuman proportion is precisely what we need to transcend the unconscious enslavement we have so quietly accepted.

## V

In my own work, I have tried, and frequently failed, to keep present the ideas I have mentioned here. Fear does arise and I have incorporated it into my practice. My early projects, *Saints* and *The Forest*, were almost exclusively concerned with fear, failure, and the redemption that comes through them. However, it was with the project *Coming Home* that I began to envision the difference between the prophetic imperative and the more internal goal for art I have had since childhood. Art had always helped me navigate life, but my work looked to the past until the past was no longer enough. I wanted art to suggest where to go and not just where I had been. In *Coming Home*, I started from the past, but the goal was the future. The installation was my first attempt at returning the mystical experience of art to the world. *Coming Home* was made of materials of the earth—dirt, tar, metal, feathers, and burlap—and its revelation was embodied in the mirror. The works that followed *Coming Home*, *The October Cycle* and *Schneebett*, were an exploration of that revelation and its consequences. *Schneebett* also helped make an important connection between the bed-of-death and the prophetic imperative. The bed-of-death reveals the importance of present choices, which, in turn, affirm the need for clarity. Moreover, the bed-of-death insists there is no individual salvation; ethical responsibil-

ity is always to the world, thereby signaling the importance of the vision not only to oneself but to others as well. From that point on, I could not continue my work assuming it was just mine. I did not assume my work was important, but it was important to me that whatever light it collected, however insignificant, should be shone on the world.

In these efforts, which were, and are, frequently clumsy, I have been guided by the occasional whisper of the order of things. I have also been guided by my failures and insufficiencies that helped me distinguish between an artist-prophet as a lifework and an artist-prophet as a title. In this process of growing up, which is a search for increased awareness and intellectual honesty, I now feel the need to build a new studio responsive to or, better yet, constructed around, the ideas I have mentioned.

In 1998, with the help of my assistants, I started a small publishing house called Whale & Star Press. This press was created at the same time as *Coming Home* and it embodied many of the same ideas, whose evolution have served as a catalyst to reconsider the ethical responsibility of the artist to the world. This movement has so profoundly affected my practice that it seemed appropriate to name the new studio after the press. Whale & Star is a studio as well as a contemplative research and educational environment concerned with the role art has in life, spirit, and community. It compresses two very different models of such work: the scientific laboratory and the monastery. With its concepts of rigorous discipline, intense intellectual scrutiny, and service to the discovery of truth, the scientific laboratory offers a context that is precise and clear. The monastery offers a model that introduces an ethical dimension to work, making it inseparable from the worker and his or her own development as a human being. Whale & Star provides an atmosphere not only for me to work, but one in which visitors and participants are encouraged to reflect on art's ethical role free from the expectations of the marketplace and academia. The studio also educates and serves the urban poor of South Florida, especially the children. Whale & Star is the culmination of a lifelong search for a place to work meaningfully in and for the world.

**NOTES**

1. Kenneth Rexroth, *World Outside the Window: The Selected Essays of Kenneth Rexroth*, ed. Bradford Morrow (1955; repr., New York: New Directions, 1987).
2. G. Allen and Harry Clark, *Literary Criticism: Pope to Croce* (Detroit: Wayne State University Press, 1962).
3. Wassily Kandinsky, *Concerning the Spiritual in Art* (New York: Dover, 1977).

## 2010   On Painting

I

In 1921 the Russian critic Nikolai Tarabukin called Alexander Rodchenko's red monochrome "the last painting," which is a fitting response to an artist who had set out to take painting to "its logical conclusion." Now, with those heady Bolshevik days long behind us, the utopian finality of that monochrome seems more tender than foreboding; tenderness that comes from the disparity between its material modesty and its absolutist aspirations—a disparity between means and ends.

If there is something bombastic and familiar about Rodchenko's gesture, it is perhaps because all art is the making of unsustainable statements that we must then try to hold up. I made my first of those statements when I was eleven. I set out to paint a portrait of my brother. It was a modest set-up—a small canvas, his wallet-size school picture, and a box of pastels—but I wanted the portrait to be moving, with the quality of the church paintings I admired. Unlike Rodchenko, however, somewhere along the way I recognized I was going to fail, and in the end, despite the smile, my brother's painted face was lifeless.

*Originally presented at the Sheldon Museum of Art, Lincoln, Nebraska, April 21, as part of the University of Nebraska Visiting Presidential Professorship.*

EMC's son,
Sebastián, Studio,
Delray Beach,
Florida, 2007

I begrudged the failure, but it did not make me think of means or ends, or anything else other than the challenges of rendering. Then, a year or two later, I saw a great lemon still life by Édouard Manet. A lemon and the dull metallic plate on which it was placed had been painted with great attention and directness. The lumpy fruit jumped at first from the dark background then it sank into the painting, pushed by a coarse reflection on the metal plate and a highlight on the rim where one could feel the drag of an almost dry brush. The painting seemed to be saying there was not much there, but it was clearly a trick to catch me by surprise. True, it was not a fancy portrait or a massive color field, yet I wouldn't call it modest either, in the sense I might use the term for the painting of Van Gogh's shoes. How did Manet construct something which seemingly so dumb was so perfect? The parts I was seeing did not seem to add to the experience of the whole.

That was my first confrontation with the disparity between means and ends in painting. The ends themselves—maybe just the end—seem to point outward from the painting as well as inward. Outwardly, the painting suggested a great order. Inwardly, the painting pointed to the foundation of painting in a similar way that counting points to the foundation of mathematics. I had painted enough, however, to realize it was not possible for me to only make small paintings of lemons. But it took at least ten more years to understand that each artist must find the simple centrally composed flattish lemon in a different way. There is no other path to that lemon still life than through ourselves.

Paintings tend to distract us with the way they look—lemons and red monochromes, for instance. Yet, they are not what they seem. In painting we must often paint the painting that is not available to us through the one that is. Sometimes by painting the lemon we miss it. Sometimes by not painting it, we paint it. In *The Picture of Dorian Gray*, Oscar Wilde wrote, "[Dorian Gray] is never more present in my work than when no image of him is there. He is a suggestion [ . . . ] I find him in the curves of certain lines, in the loveliness and subtleties of certain colors."[1] Perhaps, then, in the same way Basil Hallward found Dorian in his painting when there was no image of him in it, we set out to find the lemon still life in every work.

What fuels that effort is the search for the inevitable painting. T. S. Eliot, in his argument of the deficiencies of Shakespeare's *Hamlet*, wrote that "artistic 'inevitability' lies in the complete adequacy of the external to the emotion."[2] In art, that adequacy is not a requirement of inevitability. In fact, it seems that in art in general and in painting in particular, a certain amount of inadequacy between the external and the emotion is not only acceptable but necessary. The inadequacy reveals a gap, and it is in that gap the potential of the painting is stored. Great paintings do not

transmute colorful dirt into spirit but instead reveal the spirit in the dirt and places the discovery alongside the means, thereby revealing a gap. The viewer engaging this revelation would do well by not thinking of painting as either the spirit or the dirt, but as both at once; or as one.

The movement of consciousness between the discovery offered by painting and its means generates meaning in the work; the wider the gap, the greater the possibility of meaning, but also the greater the instability of a meaning so dependent on the wild swings of consciousness and thus so far from cognition. In the case of a great painting, the energy of the vibrations across the nearly insurmountable gap threatens with dissolving our awareness of ourselves, a danger less to reason, as it was for Kant, than to The Dream of consciousness.

A great painting has the possibility of awaking those who can see it from Their Dream.

## II

Some people think of painting as something you do to a surface and therefore the tendency is to speak of gestures, of dynamics, of composition. Painting, when seen this way, depends on paint and what the artist does with it. Those who see painting in this way praise process, compare painting to music, and hope for the day when it finally becomes temporal; as only in the temporal can movement be reenacted. This view of painting would seem promising, since what most defines reality is change, and so our existence is best understood in terms of processes rather than things, and certainly not absolutes—nothing is; all is becoming. The attributes of the real are evolution, birth, dying, and what we consider stable, fixed, is simply a pattern of stability in the river of time, or, in the view of quantum mechanics, stabilities in probabilistic fluctuations.

The problem is that painting is not change but rather its opposite. At best, painting may be an illustration of change, but nothing announces louder what change is not than an illustration of it. Time, although not a variable in paintings as it is a variable in music, can be an attribute of painting, but only under special conditions.

What room is there for painting in a world of change?

The time-independence of painting and its orientation toward ends (what the finished piece points to) do not seem to fit in a world of activity and means. But this improper fit is very powerful. It leads to grasping without reaching, which leads to desperateness, a hunger stretching from grasp to aim; when the aim is vast and elusive, the hunger becomes homesickness we cannot contain within ourselves. Thus, the impact of all paintings begins in their uncomfortable relationship to the world.

This impact is expanded or shrunk internally by the painting. The means

of all great works of art, including Rodchenko's utopian monochromes, cannot be reconciled with their ends. Who would dare explain the relationship between means and ends in Van Gogh's *Wheat Field with Crows*? The disparity between means and ends builds tensions capable of unconcealing truths beyond the symbolic; truths capable of exorcising other important dualities as well, such as multiplicity and unity, similarity and difference, freedom and necessity. The greater the painting, the larger the disparity between means and ends. This disparity makes it very difficult to reduce painting to theories or logical propositions, which is why Rodchenko's nudging of painting to "its natural conclusion" is not convincing. Although it might seem, and perhaps he thought it was, structural, his argument was actually historical.

Perhaps the greatest problem with "logical conclusions" in painting is that they do not account for the unexpectedness and mystery that, at least for me, characterize the experience of art. The experience of art offers the possibility of reconciling painting and the world by bringing forth awareness of change and suggestions of an order where there is no unrest. This experience rarely, if ever, comes from "logical conclusions." Rather, it demands consideration of objects and events in relation to consciousness while accepting that any working knowledge of the mechanics of the experience is not an algebra of certainties.

The broader consideration I am suggesting does not evolve from a view of painting as something one does to a surface, even if this view seemed promising at first. Alternatively, one could consider painting as a noun, as a way to point to a certain category of object. In this view, meaning is not necessarily dependent on gestures, emotion, or even content. When considering painting as a noun, meaning is brought forth by the object and also undermined by the object; seen this way, painting is less the embodiment of a moment than a location of the mind.

For me, drips and slashes of paint are not signifiers of the emotion of a particular time, as they are frequently described. Instead, they are the material's resistance to becoming aspects of images, thereby rubbing against, threatening, the meaning of those images or rotating that meaning to where images alone could not go. In an interesting painting, images fight back and their meanings play hide-and-go-seek with materials as well as with the objecthood of the work of art. These meanings are not primarily symbolic and their power is not, except in the trivial cases, dependent on novelty. The relevance of images in painting consists not in showing us what is unfamiliar—novel—but rather in revealing the strangeness of what we consider familiar. That defamiliarization—de-recognition—destabilizes and expands meanings already engaged in a struggle with materials, and thus with representation.

When looking at painting as a location in the mind rather than a vessel to house my actions, my emotional agitation, some attributes cease to be important—paint and movement, for example—and other attributes become important. Of these, presence and reference are the most revealing, because in them the friction between change and permanence—time and timelessness—becomes apparent.

In most paintings made between the fifteenth and nineteenth centuries, the materiality of paint and canvas, as well as the artist's hand, are subordinated to the aim of forging an open window capable of inviting the viewers' consciousness to float into the world of the painting. *The Death of Socrates* by Jacques-Louis David, for example, would create a hole in the wall through which the Parisians visiting the salon could see the Greek philosopher about to drink the hemlock poison. That journey was, and remains, the power of reference. The same visitors, if they went around the corner of this imaginary salon, would have had a very different experience in front of Jean-Antoine Houdon's *Portrait Bust of Denis Diderot*. The mouth of the portrait would seem as if it was about to speak and the clay would resemble skin, and yet, the mind of the visitors would not go too far from the room. Confronted with the objecthood of the sculpture, and thus its presence, the experience is no longer one of just viewing but of being with the work of art. Consciousness does not float away following the reference but remains, sometimes in a fractured state, in front of the bust.

Both presence and reference are important for an ethical reading of the work of art, which depends on the awareness of "the other" as well as the visions of references. Yet welding presence and reference in any manner is difficult, and achieving equilibrium between them, even harder. The presence-reference equilibrium depends primarily on the way a painting is constructed. Although painting is usually seen for its parts, the importance of structural concerns becomes apparent when we consider it as a whole. The whole of painting is the totality of processes, and processes are structural in nature. Structure is the ensemble of activities, forces, and components, as well as qualities floating through the work without physical embodiment. Every particular structure is a state of the work of art, which can be changed by content, purpose, and failure.

It would be a mistake to confuse structure with formalism. Unlike formalism, structure cannot be freed from the baggage of our condition, of our weariness. Rather, it is an order that can only be seen, darkly, through the dense forest of ourselves (which is neither self-expression nor confessions). Although the formalist believes in "logical conclusions," "painting propositions" are always fuzzy and this fuzziness undermines causality and makes extrapolation from one painting to another—an important aspect of formalism—particularly challenging.

III

A great painting presents itself as if it has always been, as if the artist uncovered something that is, rather something that became. If we want to find him or her in the painting, we must resort to the signature or to hair trapped in the paint. But this absence of the artist comes at the end of a process.

All paintings begin with the man or woman. Somewhere along the way death must come to the personality and with that death all that he or she might have been in the world. That death is necessary. The artist who approaches the painting freed from the man or woman will only make insignificant paintings; and without dying the painting will only be a confession. The death comes not from pulling away but by surrendering. The more subjectively and the more authentically that an artist is in the work, the more he or she will be absent. Eliot, once again, wrote, "The more perfect the artist, the more completely separate in him will be the man who suffers and the mind which creates; the more perfectly will the mind digest and transmute the passions which are its material."[3]

Painting is a crucible where we place ourselves only to burn that which is ourselves. Our soot, inhuman testimony of our burning, is the material that makes the Heart of painting. The burning that is painting reveals not teachings nor politics but the instability inherent in the human condition, an awareness that is difficult to unconceal any other way than through art. The artist might have different intentions, maybe even to record his own passage or his brother's, but he or she must disappear in the revelation of art.

To articulate the destruction of the human and the appearance of the artist in the unfolding of the work of art, we must invoke ideas whose nuances are clearly metaphysical and often religious, which make some of us uncomfortable. This discomfort leads many contemporary artists to prefer historical understandings, cultural positioning, and formalist esoterics, which are, for the most part, safe; many of them would argue there is no need to invoke the shadowy world of metaphysics.

The mathematician and philosopher Alfred Whitehead wrote, "Actual entities are the final real things of which the world is made up. There is no going behind actual entities to find anything more real. The final facts are, all alike, actual entities; and these actual entities are drops of experience, complex and interdependent."[4] But the confrontation with the "final facts" is by no means factual. Encounters with great works of art always have the potential to be transformative, and these transformations frequently occur in a space I would not describe as factual. When the work of art is a painting, change and permanence collide outside of our grasp, and

we are left to contemplate mystery. This mystery of paintings reminds us that intellectual efforts were intended to get us closer to the truth rather than to comfort our fears. It is more important to play it well than to play it cool, and in the case of painting, playing it well means accepting the potential embarrassment of risk.

The *thereness* of a great painting demands authenticity and, frequently, complete surrender. "Art," wrote John Dewey, "has been the means of keeping alive the sense of purposes that outrun evidence and of meanings that transcend indurated habit."[5] Then he goes on to quote Shelley: "The great secret of morals is love, or *a going out of our nature* and the identification of ourselves with the beautiful which exists in thought, action, or person, not our own. A man to be greatly good must imagine intensely and comprehensively."[6]

To face a great painting without the artifice of mediation—intellectual or emotional—is to confront its Heart and to be burnt by it. This Heart is the space across which our consciousness must flicker. The material of this Heart is always the same: the soot of our burning; nothing of us except the sacrifice. Which is not a negligible gesture. The sacrifice maps the impassive inhuman Heart of painting into the tractable space of our condition, a mapping that doesn't happen but through love. All great paintings invite the going out of our nature while presenting us with presence of what always has been, and through them we discover something we did not know we had lost: our wholeness.

**NOTES**

1. Oscar Wilde, *The Picture of Dorian Gray* (New York: The Modern Library, 2004).
2. T. S. Eliot, *T. S. Eliot: The Poems*, ed. Martin Scofield (New York: Cambridge University Press, 1988).
3. T. S. Eliot, "Tradition and the Individual Talent," in *Selected Essays, 1917–1932* (New York: Harcourt, 1950).
4. A. N. Whitehead, *Process and Reality: An Essay in Cosmology*, ed. D. Griffin and D. Sherburne (New York: The Free Press, 1978).
5. John Dewey, *Art as Experience* (New York: Berkeley, 1980).
6. Dewey, *Art as Experience*.